The Politics of Vision

Also by Linda Nochlin
Women, Art, and Power and Other Essays

The Politics of Vision

Essays on Nineteenth-Century Art and Society

———

LINDA NOCHLIN

Icon Editions

HARPER & ROW, PUBLISHERS, New York

Grand Rapids, Philadelphia, St. Louis, San Francisco
London, Singapore, Sydney, Tokyo, Toronto

FIRST EDITION

Designed by Barbara DuPree Knowles

Library of Congress Cataloging-in-Publication Data

Nochlin, Linda.
 The politics of vision:essays on nineteenth-century art and society/by Linda Nochlin. — 1st ed.
 p. cm. — (Icon editions)
 Includes index.
 ISBN 0-06-435854-2; ISBN 0-06-430187-7 (pbk.)
 1. Art and society—History—19th century. 2. Art and
 state—History—19th century. 3. Art, Modern—19th
 century. I. Title.
N72.S6N63 1989
701'.03'09034—dc20 89-45055

89 90 91 92 93 CC/MPC 10 9 8 7 6 5 4 3 2 1
89 90 91 92 93 CC/MPC 10 9 8 7 6 5 4 3 2 1 (pbk.)

Contents

LIST OF ILLUSTRATIONS *vi*

ACKNOWLEDGMENTS *x*

INTRODUCTION *xii*

1 The Invention of the Avant-Garde: France, 1830–1880 *1*

2 Courbet, Oller, and a Sense of Place: The Regional, the Provincial, and the Picturesque in 19th-Century Art *19*

3 The Imaginary Orient *33*

4 Camille Pissarro: The Unassuming Eye *60*

5 Manet's *Masked Ball at the Opera* *75*

6 Van Gogh, Renouard, and the Weavers' Crisis in Lyons *95*

7 Léon Frédéric and *The Stages of a Worker's Life* *120*

8 Degas and the Dreyfus Affair: A Portrait of the Artist as an Anti-Semite *141*

9 Seurat's *La Grande Jatte:* An Anti-Utopian Allegory *170*

INDEX *194*

List of Illustrations

1 The Invention of the Avant-Garde: France, 1830–1880

1. Gustave Courbet, *The Painter's Studio*, 1855. 360.7 × 622.3 cm, oil on canvas. Paris, Musée d'Orsay
2. Philippe-Auguste Jeanron, *The Little Patriots: A Souvenir of July 1830*, 1830. Oil on canvas. Caen, Musée de Caen
3. Gustave Courbet, *François Sabatier*, 1854. Crayon on paper. Montpellier, Musée Fabre
4. Edouard Manet, *Déjeuner sur l'herbe*, 1863. 211 × 269 cm, oil on canvas. Paris, Musée d'Orsay
5. Edouard Manet, *The Escape of Rochefort*, 1881. 143 × 114 cm, oil on canvas. Zurich, Kunsthaus
6. Edouard Manet, *A Bar at the Folies-Bergère*, 1881–82. 97.5 × 132 cm, oil on canvas. London, Courtauld Institute Galleries

2 Courbet, Oller, and a Sense of Place: The Regional, the Provincial, and the Picturesque in 19th-Century Art

1. Gustave Courbet, *Burial at Ornans*, 1849–50. 314 × 665 cm, oil on canvas. Paris, Musée d'Orsay
2. Francisco Oller, *El velorio* (The Wake), 1893. 269.5 × 412 cm, oil on canvas. Río Piedras, Puerto Rico, Collection Museum of Anthropology, History and Art, University of Puerto Rico
3. Francisco Oller, *José Gautier Benítez*, c. 1885–86. 98.5 × 72 cm, oil on canvas. San Juan, Puerto Rico, Collection Ateneo Puertorriqueño
4. Francisco Oller, *Landscape with Royal Palms*, c. 1897. 46.9 × 34.9 cm, oil on canvas. San Juan, Puerto Rico, Collection Ateneo Puertorriqueño

5. Francisco Oller, *Mangóes*, 1901–03. 52 x 82.6 cm, oil on canvas. San Juan, Puerto Rico, Collection Eddie and Gladys Irizarry

6. Francisco Oller, *Ripe Plantains*, 1892–93. 83 x 56.1 cm, oil on canvas. San Juan, Puerto Rico, Collection Hanny Stubbe de López

3 The Imaginary Orient

1. Jean-Léon Gérôme, *Snake Charmer*, late 1860s. 83.8 x 122.1 cm, oil on canvas. Williamstown, Massachusetts, Sterling and Francine Clark Art Institute

2. "Official" tourist photo of the Bab Mansour at Meknes

3. Contemporary amateur photograph of the Bab Mansour at Meknes (photograph by Linda Nochlin)

4. Eugène Delacroix, *Death of Sardanapalus*, 1827–28. 368 x 495 cm, oil on canvas. Paris, Louvre

5. Jean-Léon Gérôme, *The Slave Market*, early 1860s. 84.3 x 63 cm, oil on canvas. Williamstown, Massachusetts, Sterling and Francine Clark Art Institute

6. Jean-Léon Gérôme, *Moorish Bath*, 1880s. 51 x 41 cm, oil on canvas. Boston, Museum of Fine Arts, Gift of Robert Jordan from the Collection of Eben D. Jordan

7. Eugène Delacroix, *Moulay-Abd-el-Rahman, Sultan of Morocco*. Oil on canvas. Toulouse, Musée des Augustins

4 Camille Pissarro: The Unassuming Eye

1. Camille Pissarro, *Bords de la Marne en hiver* (The Banks of the Marne in Winter), 1866. 91.8 x 150.2 cm, oil on canvas. Chicago, The Art Institute of Chicago, Mr. and Mrs. Lewis Larned Coburn Memorial Fund

2. Camille Pissarro, *Lordship Lane Station, Upper Norwood, London*, 1871. 43.3 x 71.3 cm, oil on canvas. London, Courtauld Institute Galleries

3. Camille Pissarro, *Poultry Market at Gisors*, 1885. 82 x 82 cm, gouache and pastel on mounted paper. Boston, Museum of Fine Arts, Bequest of John T. Spaulding

4. Camille Pissarro, *Apple Picking, Eragny-sur-Epte*, 1888. 58.4 x 72.4 cm, oil on canvas. Dallas, Museum of Art, Munger Fund

5. Camille Pissarro, *Boulevard Montmartre, mardi-gras*, 1897. 63.5 x 77.5 cm, oil on canvas. Los Angeles, The Armand Hammer Collection

6. Camille Pissarro, *The Roofs of Old Rouen, Gray Weather (The Cathedral)*, 1896. 72.3 x 91.4 cm, oil on canvas. Toledo, Ohio, The Toledo Museum of Art, Gift of Edward Drummond Libbey

7. Camille Pissarro, *Place du Théâtre Français*, 1898. 72 x 93 cm, oil on canvas. Los Angeles, Los Angeles County Museum of Art

5 Manet's *Masked Ball at the Opera*

1. Edouard Manet, *Masked Ball at the Opera*, 1873. 59 x 72.5 cm, oil on canvas. Washington, D.C., National Gallery of Art, Gift of Mrs. Horace Havemeyer in memory of her mother-in-law, Louisine W. Havemeyer

2. Gustave Doré, *Loups*, 1860. Lithograph. Paris, Bibliothèque Nationale

3. Edouard Manet, *Music in the Tuileries*, 1862. 76 x 118 cm, oil on canvas. London, The National Gallery

4. Edouard Manet, *Portrait of Emile Zola*, 1868. 148 x 111 cm, oil on canvas. Paris, Musée d'Orsay

5. Edouard Manet, *Nana*, 1877. 152.4 x 118.9 cm, oil on canvas. Hamburg, Kunsthalle

6. Edouard Manet, *A Bar at the Folies-Bergère*, 1881–82. 97.5 x 132 cm, oil on canvas. London, Courtauld Institute Galleries

6 Van Gogh, Renouard, and the Weavers' Crisis in Lyons

1. Paul Renouard, *La Crise industrielle à Lyon: Sans travail*. Wood engraving by Albert Bellenger. Paris, Bibliothèque Nationale

2. Vincent Van Gogh, *Passage at Saint Paul's Hospital*, 1889. 65 x 49 cm, black chalk, gouache on paper. New York, The Museum of Modern Art, Abby Aldrich Rockefeller Bequest

3. Paul Renouard, *Les Invalides: Les aveugles*. Wood engraving. Paris, Bibliothèque Nationale

4. Jacob Riis, *Mullen's Alley, New York City*, 1898. Photograph. New York, Museum of the City of New York

5. Paul Renouard, *Cité ouvrière*. Wood engraving. Paris, Bibliothèque Nationale

6. Paul Renouard, *Garbage*. Wood engraving. Paris, Bibliothèque Nationale

7 Léon Frédéric and *The Stages of a Worker's Life*

1. Léon Frédéric, *The Stages of a Worker's Life*, c. 1895. Triptych: side panels are 162.6 x 94 cm, central panel is 162.6 x 186.9 cm, oil on canvas. Paris, Musée d'Orsay

2. Léon Frédéric, *Chalk Vendors*, 1881–83. Triptych. Oil on canvas. Brussels, Musées royaux des Beaux-Arts

3. Léon Frédéric, *Stages of Peasant Life*, 1885–87. 5 panels, each 114.9 x 200.7 cm, oil on canvas. Brussels, Musées royaux des Beaux-Arts

4. Paula Modersohn-Becker, *Mother and Child (Kneeling)*, 1907. 113 x 74 cm, oil on canvas. Bremen, Ludwig-Roselius Sammlung

5. Léon Frédéric, *La Nature*, 1897. Central panel of triptych, 113 × 74 cm, oil on canvas. Ypres, Collection Van Raes

8 Degas and the Dreyfus Affair:
A Portrait of the Artist as an Anti-Semite

1. Edgar Degas, *Ludovic Halévy and Albert Boulanger-Cavé (Portrait of Friends in the Wings)*, 1879. 79 × 55 cm, pastel and tempera on 5 pieces of tan paper joined together. Paris, Musée d'Orsay

2. Camille Pissarro, *Capital*, from *Turpitudes sociales*, 1889. 21.3 × 17.2 cm, pen and ink on paper. Geneva, Collection Daniel Skira

3. Edgar Degas, *At the Bourse (Portraits at the Stock Exchange)*, c. 1879. 100 × 82 cm, oil on canvas. Paris, Musée d'Orsay

4. Edgar Degas, *General Mellinet and Chief Rabbi Astruc*, 1871. 16 × 22 cm, oil on canvas. Gérardmer, France, Mairie de Gérardmer

5. Edgar Degas, *Ludovic Halévy Meeting Mme Cardinal Backstage*, illustration for *La Famille Cardinal* by Ludovic Halévy, c. 1878. Monotype in black ink on paper.

6. Edgar Degas, *Elie Halévy and Mme Ludovic Halévy in Degas's Living Room*, c. 1896–97. Photograph. Paris, Bibliothèque Nationale

9 Seurat's *La Grande Jatte:*
An Anti-Utopian Allegory

1. Georges Seurat, *Sunday on the Island of La Grande Jatte*, 1884–86. 207.6 × 308 cm, oil on canvas. Chicago, The Art Institute of Chicago, Helen Birch Bartlett Memorial Collection

2. Dominique Papety, *Un Rêve de bonheur* (Dream of Happiness), 1843. Oil on canvas. Compiègne, Musée Vivenel

3. Pierre Puvis de Chavannes, *Summer*, 1873. 305 × 507 cm, oil on canvas. Chartres, Musée des Beaux-Arts

4. Paul Signac, *In the Time of Harmony (The Pleasures of Summer)*, 1895–96. 37.6 × 50.1 cm, colored lithograph for *Les Temps Nouveaux*. Cleveland, Ohio, The Cleveland Museum of Art, Dudley P. Allen Fund

5. Georges Seurat, sketch of *La Grande Jatte*, c. 1886. 70.5 × 104.1 cm, oil on canvas. New York, Metropolitan Museum of Art, Bequest of Sam A. Lewisohn

6. Georges Seurat, *Nurse with Carriage (Bonnet with Ribbons)*, c. 1884. 31 × 25 cm, conte crayon on paper. New Jersey, Collection Mr. and Mrs. Eugene V. Thaw

7. Georges Seurat, *The Circus*, 1891. 179.5 × 148 cm, oil on canvas. Paris, Musée d'Orsay

8. Franz Wilhelm Siewert, *Bauernkrieg* (Peasants' War), 1932. 102 × 149 cm, oil on panel. Wuppertal, Van der Heydt Museum der Stadt

Acknowledgments

There are many people I would like to thank for their help, their criticism, and for their ideas and information. I believe that art history, like any scholarly discipline, is basically a communal enterprise, and that every new step is inextricably bound to pre-existing discourse, whether the intention is to continue in a previously established direction, to supersede it, or to contradict and displace it. Perversely, some of those who have been most helpful to me in formulating my own ideas are those with whom I most strongly—even violently—disagree; I find working *against* a particular conceptual position both anxiety-provoking and invigorating. Nevertheless, the people I am about to thank are mostly those with whom I am in general agreement. These include Eunice Lipton, Rosalyn Krauss, Douglas Crimp, Robert Herbert, Kirk Varnedoe, Miramar Benítez, Michel Melot, Pierre Georgel, Sarah Faunce, Beatrice Farwell, Albert Boime, Carol Zemel, Stephen Eisenman, Carol Duncan, Carol Ockman, Susan Rossen, Rosalyn Deutsche, and finally, Abigail Solomon-Godeau, who offered wise counsel in the preparation of the introduction. The exemplary intellectual courage and originality of British feminist scholars like Griselda Pollock, Lisa Tickner, Tamar Garb, and Kathleen Adler must be acknowledged with deep gratitude. I should like to make special mention of the unfailing support and tactful suggestions—one could hardly use so harsh a term as "criticism"—provided by Elizabeth Baker, my good friend of thirty years, and my editor for almost as long. I should

also like to thank Cass Canfield, Jr., of Harper & Row, for his patience and encouragement in the production of this book and the preceding volume, *Women, Art, and Power and Other Essays*. At Harper & Row, I would like to thank Keonaona Peterson as well. My husband and fellow art historian, Richard Pommer, has read through most of this material and provided me with the heartfelt reassurance I needed when I was downcast and a salutary sense of proportion when I rose too high on clouds of euphoria or self-importance. Finally, some words of gratitude are due to my graduate assistants at the City University of New York Graduate Center: Thomas Wojtas, Elizabeth Marcus, and Suzanne Ramljak.

Introduction

Any attempt on the part of an art historian to deal with the issue of art and politics must first engage with the politics of art history itself. And this politics, of course, has a history, which is replicated in the career of any single practitioner in the field. In this sense, every art-historical Bildungsroman is, in microcosm, a social history of art history, and deserves examination, however cursory, in terms of the paradigms within which, or—more rarely—against which, new art-historical writing is inevitably formulated.

In my own case, starting out in the field at Vassar and New York University's Institute of Fine Arts in the late forties and early fifties, the dominant paradigm was formalism, manifested, in the case of the art history of the nineteenth and twentieth century, in the triumph of Modernism. At the Institute, Walter Friedländer, then in his eighties, taught me nineteenth-century art, and his echt-formalist *David to Delacroix* (Wölfflin recycled for the early nineteenth century, even then a revered classic) served as our text. Although issues of subject matter were touched on, serious studies of the *content* of painting and sculpture were reserved for earlier periods, where such investigations were isolated under the heading of iconography. Modern art, by definition, it would seem, was iconography-free: indeed, in its most simplistic formulation, the whole point of the Modernist effort, from Manet on, was to rid art of its encumbering subject matter, leaving the production of meaning—understood

always as an outmoded emphasis on moralism or story-telling—to Academicism and outer darkness.

This summary of the situation in the fifties is of course unfair and partial. There were art historians—at the Institute and elsewhere—who were approaching their subject from a more integrated, socially grounded viewpoint. Noteworthy in this respect was the classicist Karl Lehmann, whose course on Late Antique Art, with its emphasis on the whole grand sweep of imperial art production (a wonderful potpourri of institutional standardization, bizarre appropriation, and outrageous antinaturalism), its reading list, which featured Riegl and Wickhoff, and, above all, its insistence on a social basis—most significantly, the triumph of popular, lower-class codes of representation—for the striking formal changes marking the shift from classical to post-classical styles, provided me with a powerful model for my own work. Yet this was, of course, outside my major field of interest: the art of the nineteenth and twentieth century. Indeed, the serious study of nineteenth-century art was still, in many respects, in its infancy, and serious students were expected to focus on earlier periods. In fact, not many courses were offered dealing with art after 1800.

I came on the art history of the nineteenth century, then, at a formative moment in the field; options were still open as far as constituting a history of modern art was concerned. At this historic moment, the choice of Courbet and Realism as the subject of my dissertation was significant. It offered the possibility of dealing with content, with form, and above all, with the problematic relation of both to French politics around the time of the 1848 Revolution and drew on a varied range of methodologies and archival resources. Indeed, one might say that my approach to this project constituted a form of initiatory bricolage, a sort of scholarly and conceptual tinkering and experimentation which eventually produced the ad hoc but not unsophisticated methodological scaffolding—open to change but consistently engaged—that still supports my work, using what seemed useful and rejecting what did not. My main difficulty, bluntly stated, was putting Courbet's realist style together with his politics.

It was here that Meyer Schapiro's seminal article "Courbet and Popular Imagery"[1] played a crucial role. Schapiro demonstrated that Courbet's stylistic originality in those key monuments of realism, *The Burial at Ornans* and *The Peasants of Flagey*, owed an enormous debt to the impact of popular imagery, and that popular imagery itself was thoroughly imbricated in the complex of cultural innovations associated with the 1848

Revolution and *guarante-huitardisme* generally; further, the article suggested that the relation of the political to the pictorial need not be formulated in terms of a specifically "political" subject matter, nor thought of in terms of the consciously political intentions of the artist at all, but rather, must be conceptualized within more complex systems of mediation. In short, Schapiro's article, which I came upon in 1953 in the course of writing a graduate school paper on art and the 1848 Revolution, suggested the question animating all my efforts from that point on: how to *think* the political in art.

For the art historian, the problem of how to think the political leads inevitably to the politics of art history itself. In recent years, this politics has taken the form of revisionism: it is only within the context of a certain revised version of art-historical theory and practice that the political can be effectively conceptualized. Relevant to my project in this volume, then, is a brief consideration of the models offered by revisionism to the study of nineteenth-century art. First, of course, there is the model of the social history of art, Marxist in its orientation, most conspicuously embodied in the work of T. J. Clark, but predicted in that of Robert Herbert of Yale and Albert Boime of UCLA, and predated by such ancestor figures as Frederick Antal, Arnold Hauser, and F. J. Klingender. Second, there is what might be called the "supplementary" or "they-also-ran" model of the revisionist project: that of the revivalists, the resuscitators of dead reputations and minor achievements. Gerald Ackerman's monograph on Gérôme and Gabriel Weisberg's exhibition of minor French realists are examples of this revisionist mode, as are the monographs of certain feminist scholars, reviving forgotten women painters of the period. Third, there is the pluralist or "let-a-thousand-flowers-bloom" model, most prominently espoused by Robert Rosenblum, a model which, without completely rejecting the value judgments of the past, nevertheless attempts to incorporate a far wider range of stylistic and national possibilities within the art-historical purview.

All of these revisionist models have much to offer compared with the relatively restrictive formalist model of my youth, and I have drawn on all of them, especially that of the social history of art. Yet certain problems are posed by each as well. The social history of art, for example, seems to sidestep the crucial issue of the canon and canonicity, taking for granted that the same list of "great artists" and "major movements" sanctioned by pre-revisionist art history is to be the subject of its discourse.

Then, too, the social history of art often fails to question the status of history itself, accepting historical discourse as a given, a kind of originating or causative ground, and then positioning visual representation as a result or secondary phenomenon. The difficult or thorny issue of mediation is, understandably, often sidestepped by the social history model, leaving a heap of historical or social data on one side of the equation and a detailed analysis of pictorial structure on the other, but never really suggesting how the one implicates the other, or whether, indeed, there really is any mutual implication.

Both the "supplementary" and the pluralist models of revisionist art history—while deserving only of praise for revealing how the art production of the nineteenth century was actually much more varied and inclusive than we had been led to believe—run the risk of distorting the historical situation in a different way: by depoliticizing the art historical field of investigation. Rejecting a critical reading of the past, these branches of revisionism fail to deal with the crucial issue of ideology, both in terms of the specific significations produced by the redeemed and rediscovered works themselves, and in terms of the effects of such canon-revision on contemporary market forces directed to the provision of new, consumable masterpieces for the art-buying public.

My own response to revisionism and especially its problematic relation to the political—and I stipulate it as a response, certainly not as a solution—can be summarized, rather inelegantly, it is true, as "thinking art history Otherly." By this I mean to suggest that my commitment to feminism, both as theory and as politics, has provided me with a vantage point of Otherness, and that if one sees art history from the vantage point of the Other, politics necessarily informs the very construction of the subject; it cannot be construed as an additional element. For me, the very act of producing art history implicates the art historian politically, in a wide variety of ways.

This group of essays, written over the course of more than twenty years, raises many of the issues and problems involved in trying to think art history "Otherly." The first (and first-written) chapter questions the very formulation of the notion of the avant-garde current in the formalist paradigm and attempts to reinscribe its political meaning by investigating how the idea of a cultural vanguard was produced within a specific historical situation. The last (and most recently written) chapter, like the first, critiques the *telos* of formalism and the traditional occlusion of the social

in Seurat's *La Grande Jatte*—much less its reading as social critique—and suggests that formalism, far from merely being a *partial* construction of the art-historical problematic, actively functions to mystify and to prevent the viewer from seeing the work historically.

The chapters on the Puerto Rican painter Francisco Oller, the Belgian Léon Frédéric, and the popular French illustrator Paul Renouard are not intended primarily as "revivals" of these artists in the "supplementary" mode of revisionism but rather as a questioning of the status of the canon itself. The studies of Oller and of French nineteenth-century Orientalism demonstrate, among other things, how canon formation connects with colonialism and cultural imperialism. I, like the practitioners of "supplementary" revisionism, believe that Gérôme should indeed be dealt with as a crucial figure in the history of nineteenth-century art, but not in the sense of adding him to the canon or, in the "thousand flowers" mode, proclaiming him the pictorial peer of Degas, but rather because, like Degas himself, Gérôme gives us access to important problems of ideology and domination—of politics, in short. Examining Degas himself within the context of the Dreyfus affair and the discursive formation of nineteenth-century French anti-Semitism, on the other hand, demonstrates what happens when you look at a canonical figure against the grain, from a position outside the usual ones offered by art history, revisionist or otherwise.

Central to the project of "thinking art history Otherly," however—what really displaces, repositions, and transforms the disciplinary object itself most drastically—are the questions of sexuality raised by feminism. "If the production of meaning is inseparable from the production of power, then feminism (a political ideology addressed to relations of power) and art history (or any discourse productive of knowledge) are more intimately connected than is popularly supposed," asserts Lisa Tickner, in a searching analysis of the relation between the two. "Feminist inquiry is not the alien, bastardized or self-interested import its opponents despise, but a form of motivated scholarship that has . . . the most searching questions to address to the discipline as a whole."[2] Although not as evident in this volume as in the essays published in *Women, Art, and Power,* it is nevertheless the case that a feminist problematic lies at the heart of much of *The Politics of Vision,* underlying the questions of sexuality, subject position, difference, and subordination inherent to the production of meaning in the pictorial discourse of the nineteenth century. The feminist

vantage point is most prominent in the discussion of Manet's *Masked Ball at the Opera* and the piece on Orientalism, in both of which the demonstration of the historically imposed arbitrariness of codes of sexual difference is paramount to my analysis. Feminist art historians are often accused of not looking at the works of art in question. I believe that texts like the one on Manet or the Orientalists demonstrate that, far from diverting attention from the visual object, the insights of feminism force the committed scholar to rethink what she or he is looking at and how she or he is looking at it: to look harder, more steadily, more critically, and more self-consciously. Drawing on a wide range of models and methodologies— psychoanalytic theory (*not* psychobiography); structuralism and post-structuralism; Marxist theory; literary criticism; and yes, aspects of traditional art history and its revised modes—feminist art history reproblematizes and reconstitutes the central issue of how meaning is produced in form within the work of art.

History, including the history of one's own production, remains inert without the revivifying touch of the contingent and the circumstantial. Each of these pieces was formulated in response to specific circumstances, in answer to particular questions at a particular historical moment and within a specific intertextual context. Some account of the actual genesis of each essay, the process of its construction, and the way specific conclusions were reached seems in order.

"The Invention of the Avant-Garde" was written in 1968 for an issue of the *Art News Annual* devoted to the avant-garde. It is very much a product of its historical moment, a time when cultural revolution was in the air and the relation between politics—particularly radical politics— and cultural production, that of the past as well as the present, seemed to cry out for articulation. If I had written the piece later, I would have had to take account of Peter Bürger's crucial differentiation, in *Theory of the Avant-Garde*,[3] between the authentic historical avant-garde, which questioned art's institutional status, and the aestheticism and insistence on autonomy characteristic of Modernism. During the twenty years since the publication of "The Invention of the Avant-Garde," there has been a plethora of investigation and reinterpretation of the work of Gustave Courbet, the centerpiece of the essay, most notably by T. J. Clark,[4] and more specifically of Courbet's ambitious allegorical painting *The Painter's Studio*, which has been the focus of my own much fuller and quite

different reading in the catalogue *Courbet Reconsidered.*[5] Nevertheless, despite the Proudhonian interpretation of the work offered by James Rubin, and Hélène Toussaint's important discovery of the political identities lurking beneath the surface of many of its hitherto inscrutable characters, as well as Klaus Herding's percipient totalization of its apparently disparate and contradictory significations, not to speak of the many minor discoveries related to various iconographic details of the work, I still feel that my twenty-year-old reading has something to offer within a greatly altered discursive field. The same might be said of my reading of Manet's two marine paintings representing the escape of that wily ex-Communard, Henri Rochefort, from the French penal colony in New Caledonia, which have been considered recently, by Stephen Eisenman,[6] in far greater depth in terms of their ambiguous relation to the politics of their times and to Manet's intentions and strategies as a producer of ambitious political painting.

"Courbet, Oller, and a Sense of Place" originated as a lecture for the Francisco Oller symposium, which took place in Ponce, Puerto Rico, in October 1983. The symposium was organized in conjunction with the exhibition *Francisco Oller: A Realist-Impressionist* at the Ponce Art Museum, commemorating the one-hundred-and-fiftieth anniversary of Oller's birth. I had become interested in this extraordinary Puerto Rican painter when I came across an article about him in the journal *Americas* in 1967,[7] partly because of the intrinsic quality of his work and partly because of his relationship to Courbet, whom he knew in Paris and whose so-called "Bridal Preparations," which I was then investigating, seemed so integrally related to Oller's major achievement, *The Wake.*[8] When I was asked to contribute a lecture linking Courbet and Oller on the occasion of the Ponce symposium, I thought immediately of Eudora Welty's unforgettable meditation on "Place in Fiction," which I had heard her give at Vassar in the early 1950s: a sense of place in painting seemed to me exactly what linked these two politically engaged realists of the nineteenth century. My sense of Puerto Rico as a unique place with an extraordinarily variegated landscape and a complex political history was intensified by a voyage of discovery I took through the island while writing the lecture. I worked on the piece every morning, travelled through the countryside by day, and at night talked to a variety of articulate and politically sophisticated Puerto Rican artists and critics who helped me gain insight into the dilemmas confronting the colonial artist, who is so often forced to

choose between abandoning his or her own heritage or being consigned to the "periphery," so called, of the cultural mainstream.

"The Imaginary Orient" began life as a lecture for the Neuberger Museum in Purchase, New York, given in conjunction with an exhibition of French Orientalist painting in 1982;[9] the lecture was presented later the same year to the Society of Fellows of Columbia University. The original title, "Realism and Power, Violence and the Picturesque: The Politics of Orientalism," though cumbersome, gives a much better notion of what the piece is about than does the far catchier one it acquired when it was published in *Art in America* in 1983. I had been reading Edward Said's *Orientalism* at the time and was struck by the applicability of the author's profound and original critique of Western attitudes toward the Middle East—including the inscription of these attitudes in the presumably "objective scholarship" of Western authorities as well as in overtly fictive texts—to the visual arts. Pictorial Orientalism, apparently, was taken by most art historians concerned with this genre to be innocent of any taint of imperialist ideology and to constitute an innocent and colorful representation of an exotic reality, now due for a salutary revisionist airing. I was also struck by the prominent and stereotyped position women occupied within this visual construction of the Other, for woman, primarily the languishing harem beauty, was a preferred object of pictorial delectation within Orientalist artistic practice. Indeed, Said's critique of Orientalist representation offered many parallels with the feminist critique of the representation of women generally. This striking overlapping of the critiques of Orientalism and gender stereotyping in nineteenth-century art led me to recycle several portions of "The Imaginary Orient" in a later essay, "Women, Art, and Power," in 1988, where the material appears in a quite different context, with different political implications.

"Camille Pissarro: The Unassuming Eye" was my first published article, written for *Art News* on the occasion of an exhibition of Pissarro's work at the Wildenstein Gallery in 1965. It was expanded when I presented it as a lecture in 1980 at the Boston Museum of Fine Arts, shortly before the opening of a large-scale retrospective of Pissarro's work; it was revised again, in the sense of having all the citations from Pissarro's letters restored to their original French, when the piece was republished in *Studies on Camille Pissarro* in 1986.[10] From the beginning, I was interested in the question of how a particular political position might manifest itself—or be thought to manifest itself—in a particular

kind of pictorial language: anarchism and Impressionism, and later, neo-Impressionism, in Pissarro's case. Pissarro was committed to a certain kind of realism, dependent upon fidelity to his "sensations," yet he was never doctrinaire about this position. He criticized Gauguin, for example, not for his anti-realist aesthetic—although one senses a certain reservation on that score—but rather for his reactionary politics, and above all, for his opportunism. "I do not reproach Gauguin for having painted the ground vermillion," he wrote apropos of the latter's *Jacob Wrestling with the Angel;* "I reproach him for not applying his synthesis to our modern philosophy, which is absolutely social, anti-authoritarian and anti-mystical. . . . Gauguin is not a seer; he is a schemer who has sensed that the bourgeoisie are turning to the right."[11] In the context of the boundless adulation characteristic of most of the Gauguin criticism, and the heroization and mystification of Gauguin's life and painting, both by his contemporaries and by present-day art historians, Pissarro's skepticism comes as a refreshing antidote.

It was Roman Jakobson's classical essay, "The Metaphoric and Metonymic Poles," that led me to the issues I grapple with in "Manet's *Masked Ball at the Opera.*" Or rather, it was the intersection of my interest in Jakobson's brief but provocative study of a basic linguistic opposition, and my obsession with Manet's painting of the Opera Ball (known to me at the time only in the form of a small reproduction), that led me to speculate about one of the basic formal strategies of Impressionism—the partial or cut-off view—as it was manifested in Manet's work within the historical and political situation of Paris in the aftermath of the Franco-Prussian War and the Commune. First presented as a lecture (subtitled "Part and Whole in Later Nineteenth-Century Realism") for the Harvard Undergraduate Art History Club in the late seventies, the piece went through various metamorphoses before assuming its final form in the article "A Thoroughly Modern Masked Ball" in *Art in America* in 1983. The changes were due at least in part to the fact that I finally got to see the painting itself when it was in conservation at the National Gallery in Washington. I could make out some of the "parts" that were more or less invisible in the reproduced "whole": the scattered petals in the foreground, for instance, or the fact that one of the black-cloaked women on the right has her elbow daringly planted on the thigh of the gentleman seated on the bar. But the revisions also depended on my increasing awareness of the political dilemmas and the social complexity of the world

Manet confronted in this painting as well as the inventiveness of its pictorial structure.

In the autumn of 1977, in an art gallery in Paris, I came across an unusual drawing of an old weaver and his family by the almost forgotten French graphic artist and illustrator, Paul Renouard. "Van Gogh would have loved this," I said to the friend who accompanied me, and sure enough, when I looked up Renouard's name in the index of van Gogh's *Complete Letters,* I found many references to him. Van Gogh had indeed loved the drawing I had found so compelling and had greatly admired its maker. I began to investigate Renouard and his work at the Bibliothèque Nationale, and to look into the so-called "Industrial Crisis" of 1884 in Lyons, which the drawing illustrates. This led to questions about weavers as a specific group of workers in the nineteenth century and their status as a subject for writers and artists of the period and, more specifically, about van Gogh's problematic engagement with this theme and that of working-class subjects generally, an engagement that demanded to be cast in political rather than purely aesthetic or personal terms.[12] Finally, my involvement with Renouard's drawing led me to question the process by which art-historical status is determined, a process which—with rare exceptions—leaves popular illustrators for the mass press in obscurity and plays down the early, less aestheticized graphic work of van Gogh in favor of the more colorful and pictorially "developed" work he produced later, after contact with the advanced artists of Paris, Arles, and Saint Rémy. A single drawing, in this case, led me to speculate about the politics of artistic genius itself. The article "Van Gogh, Renouard, and the Weaver's Crisis in Lyons" was published in 1980 in the *Festschrift* honoring H. W. Janson, who had been my teacher at the Institute.

I first came on Léon Frédéric's *The Stages of a Worker's Life* in the Musée de Tokyo in Paris some time in the late seventies. I knew nothing about the Belgian painter, but his vast canvas, at once shockingly rétarditaire and uncannily ahead of its time—reminiscent at once of the Flemish Primitives and New-Deal mural painting—made an immediate impact. As I learned more about Frédéric, and Belgian painting of the late nineteenth and early twentieth centuries, an enterprise forwarded by the first-rate exhibition *Belgian Art: 1880–1914* held at the Brooklyn Museum in 1980, I became more and more involved in the political implications of Frédéric's style, with its monumental form and obsessive detail, its ambitious scale, and its focus on working-class subject matter. The usual equa-

tion of the choice to represent the wretched of the earth with staunch left-wing political commitment hardly seemed valid in the case of this prolific, near-forgotten, once popular painter. On the contrary, in many of his ambitious triptychs and cycles, Frédéric seems to have been intent on establishing an imagery in which toil and poverty appeared to be ordained by the order of Nature itself rather than due to the failure of a historically specific social system, an imagery shored up with references to the religious iconography of the past and sanctioned by the truth value provided by a hyperrealistic naturalism. Frédéric's pictorial strategy was not unusual among nonvanguard painters of the end of the century, who slid effortlessly from a metaphysically inflated realism into the transcendental effluvium of fin-de-siècle Symbolisme without changing their basic political stance: conservative, or, as in Frédéric's case, reactionary.

"Léon Frédéric and *The Stages of a Worker's Life*" was first presented as a talk at the symposium organized in Cleveland in conjunction with Gabriel Weisberg's exhibition *The Realist Tradition: French Painting and Drawing, 1830–1900* and subsequently published in *Arts Magazine* in 1980.

Norman Kleeblatt asked me to write an essay about French artists and the Dreyfus affair for the catalogue of a show he was organizing in 1987 at the Jewish Museum, *The Dreyfus Affair: Art, Truth, and Justice.* As I started work on the essay, I realized that it was Degas who had become the focus of my attention, or rather, two Degas: Degas the innovative and complex artist, whose work I greatly admired, and the other Degas, the rather simpleminded anti-Semite, whom I deplored. How does a political attitude like anti-Semitism manifest itself in visual representation in the late nineteenth century? Is it always a conscious position articulated within a recognizable pictorial code, or is anti-Semitic representation something more subtle and variable? Can one invariably read an artist's politics from his art? Degas offers an interesting model for investigation because his work and career offer no easy answer to the question of the relationship between art and politics; on the contrary, the visual evidence is ambiguous, the life apparently at odds with or irrelevant to the art. For those who aim to construct totalistic models of the project of artistic production, the case of Degas offers food for thought, because it is an apparent anomaly which challenges the whole notion of an unproblematic identity between biography and work.

The final essay, "Seurat's *La Grande Jatte:* An Anti-Utopian Alle-

gory," recently published in a special issue of the Art Institute of Chicago's *Museum Studies* devoted to the painting,[13] originated as the result of a conjunction of relatively unrelated circumstances. I had been reading the work of the critical theorist Ernst Bloch—*The Principle of Hope* and *The Utopian Function of Art and Literature*—in conjunction with a long study of Courbet's allegorical masterpiece *The Painter's Studio* I was preparing for the Brooklyn Museum's exhibition of that artist's work. Shortly after I had finished the Courbet piece, I was asked by the School of the Chicago Art Institute to give the first lecture in the Norma U. Lifton Memorial Series and to choose a topic related to a work in the collection of the Art Institute itself. It took me no time at all to settle on *La Grande Jatte*, a painting that had always interested me, as had Seurat's oeuvre in general. As I sat down to write my lecture, somewhere in the back of my mind a memory stirred of Bloch's interpretation of the painting as the representation of a kind of late nineteenth-century suburban hell, "more Hades than Sunday," "a landscape of painted suicide." How different this was from the conventional representation of *La Grande Jatte* as a nostalgic scene of enjoyable recreation on the banks of the Seine! And how much more in tune with the actual details of Seurat's innovative canvas. Repeated viewing confirmed this dark and politically charged interpretation of the painting, a reading against the grain of most prevailing art-historical wisdom. Once again, it seemed to me precisely in the formal construction of the work, the so-called "aesthetic" choices made by Seurat, that its political implications were inscribed, its significance as the pictorial critique of a specific historical and social situation was located.

Notes

1. Meyer Schapiro, "Courbet and Popular Imagery: An Essay on Realism and Naiveté," *Journal of the Warburg and Courtauld Institutes*, 4, pp. 164–191.

2. Lisa Tickner, "Feminism, Art History, and Sexual Difference," *Genders*, no. 3 (Fall 1988), p. 92.

3. Peter Bürger, *Theory of the Avant-Garde*, trans. M. Shaw, Minneapolis, University of Minnesota Press, 1984. The study first appeared in German in 1974.

4. T. J. Clark, *Image of the People: Gustave Courbet and the 1848 Revolution*, London and Princeton, Princeton University Press, 1973 and 1982.

5. Linda Nochlin, "Courbet's Real Allegory: Rereading *The Painter's Studio*," in *Courbet Reconsidered*, by Sarah Faunce and Linda Nochlin, The Brooklyn Museum, 1988, pp. 17–42.

6. See Stephen F. Eisenman, "Nonfiction Painting: Mimesis and Modernism in Manet's *Escape of Rochefort*," in *Art Journal* (The Political Unconscious in Nineteenth-Century Art), ed. L. Nochlin, 46, no. 4 (Winter 1987), pp. 278–284.

7. Emma Boehm-Oller, "Francisco Oller: Puerto Rican Impressionist," *Americas*, 19 (September 1967), pp. 24–25.

8. The unfinished and much repainted Courbet work in the Smith College Art Museum is now considered to have been conceived originally as "Funeral Preparations."

9. See Chapter 3, ns. 1 and 2 for a complete reference. This exhibition of Orientalist art was followed by a far more extensive one, accompanied by an impressive catalogue edited by Mary Anne Stevens, *The Orientalists—Delacroix to Matisse: The Allure of North Africa and the Near East*, at the National Gallery in Washington, D.C., in 1984.

10. *Studies on Camille Pissarro*, ed. by Christopher Lloyd, London and New York, Routledge and Kegan Paul, 1986, pp. 1–14.

11. See n. 11, Chapter 4, p. 74.

12. The issue of van Gogh's weavers was later explored more fully and from a different angle by Carol Zemel in "The 'Spook' in the Machine: Van Gogh's Pictures of Weavers in Brabant," *Art Bulletin*, LXVII, no. 1 (March 1985), pp. 123–137. Griselda Pollock has investigated van Gogh's representation of urban work in "Stark Encounters: Modern Life and Urban Work in van Gogh's Drawings of The Hague, 1881–1883," *Art History*, 6, no. 3 (September 1983), pp. 330–338.

13. *The Art Institute of Chicago: Museum Studies* (Special Issue: The *Grande Jatte* at 100), volume 14, no. 2, pp. 133–154.

I

The Invention of the Avant-Garde:
France, 1830–1880

"Art changes only through strong convictions, convictions strong enough to change society at the same time." So proclaimed Théophile Thoré, *quarante-huitard* critic, admirer of Théodore Rousseau, Millet, and Courbet, an art historian who discovered Vermeer and one of the spokesmen for a new, more democratic art, in 1855, in exile from Louis Napoleon's imperial France. Whether or not one agrees with Thoré's assertion, it is certainly typical in its equation of revolutionary art and revolutionary politics of progressive thought in the visual arts at the middle of the nineteenth century. Seven years earlier, in the euphoric days following the 1848 Revolution, a new dawn for art had been seriously predicated upon the progressive ideals of the February uprising. At that time the most important art journal of France, *L'Artiste,* in its issue of March 12, 1848, extolled the "genius of liberty" which had revived "the eternal flames of art" (obviously it had been less effective in reviving the rhetorical power of its writers), and the next week, Clément de Ris, writing in the same periodical, while slightly chagrined by the mediocrity of the first "liberated" Salon, nevertheless maintained that "in the realm of art, as in that of morals, social thought and politics, barriers are falling and the horizon expanding." Even Théophile Gautier, certainly not an apostle of radicalism either in art or politics, took the opportunity to sing a hymn of praise to the new era in the pages of the same periodical. The ages of Pericles, Leo X, or Louis XIV were

nothing, he maintained, compared to the present epoch. "Can a great, free people do less for art than an Attic village, a pope or a king?" The question, obviously, is rhetorical.

Delacroix was generally the painter to whom progressive critics looked for a fulfillment of the revolutionary ideals of the 1848 uprising; as early as March, Thoré, in *Le Constitutionel,* expressed the hope that Delacroix would paint *L'Egalité sur les barricades de février* as a pendant to his allegory of the revolutionary ideals of 1830, *Liberty at the Barricades,* which had been taken out of storage and placed on exhibition following the February uprising. Both Daumier and Millet entered the revolutionary government's contest for a representation of the Republic, while Courbet, who toyed with this idea, also seriously considered taking part in the national competition for a popular song.

The very term "avant-garde" was first used figuratively to designate radical or advanced activity in both the artistic and social realms. It was in this sense that it was first employed by the French Utopian socialist Henri de Saint-Simon, in the third decade of the nineteenth century, when he designated artists, scientists, and industrialists as the elite leadership of the new social order:

> It is we artists who will serve you as avant-garde [Saint-Simon has his artist proclaim, in an imaginary dialogue between the latter and a scientist] . . . the power of the arts is in fact most immediate and most rapid: when we wish to spread new ideas among men, we inscribe them on marble or on canvas. . . . What a magnificent destiny for the arts is that of exercising a positive power over society, a true priestly function, and of marching forcefully in the van of all the intellectual faculties . . . ![1]

The priority of the radical revolutionary implication of the term "avant-garde" rather than the purely esthetic one more usually applied in the twentieth century, and the relation of this political meaning to the artistic subsidiary one, is again made emphatically clear in this passage by the Fourierist art critic and theorist Laverdant, in his *De la Mission de l'art et du rôle des artistes* of 1845:

> Art, the expression of society, manifests, in its highest soaring, the most advanced social tendencies; it is the forerunner and the revealer. Therefore to know whether art worthily fulfills its proper mission as initiator, whether the artist is truly of the avant-garde, one must know where Humanity is going, know what the destiny of the human race is. . . .[2]

César Daly, editor of the *Revue générale de l'architecture*, used a similar military term, *éclaireur*, or "scout," in the 1840s, when he said that the journal must "fulfill an active mission of 'scouting the path of the future,'" a mission both socially and artistically advanced.[3] Baudelaire, after a brief flirtation with radical politics in 1848—he had actually fought on the barricades and shortly after, in 1851, had written a eulogistic introduction to the collected *Chants et chansons* of the left-wing worker-poet Pierre Dupont, condemning the "puerile utopia of the art-for-art's sake school," praising the "popular convictions" and "love of humanity" expressed in the poet's pastoral, political, and socialistic songs[4]—later mocked the politico-military implications of the term "avant-garde" in *Mon Coeur mis à nu*, written in 1862–64.[5]

Certainly the painter who best embodies the dual implications—both artistically and politically progressive—of the original usage of the term "avant-garde" is Gustave Courbet and his militantly radical Realism. "Realism," Courbet declared flatly, "is democracy in art." He saw his destiny as a continual vanguard action against the forces of academicism in art and conservatism in society. His summarizing masterpiece, *The Painter's Studio*[1], is a crucial statement of the most progressive political views in the most advanced formal and iconographic terms available in the middle of the nineteenth century.

Courbet quite naturally expected the radical artist to be at war with the ruling forces of society and at times quite overtly, belligerently, and with obvious relish challenged the Establishment to a head-on confrontation.[6] The idea of the artist as an outcast from society, rejected and misunderstood by a philistine, bourgeois social order was of course not a novelty by the middle of the nineteenth century. The advanced, independent artist as a martyr of society was a standard fixture of Romantic hagiography, apotheosized in Vigny's *Chatterton,* and he had been immortalized on canvas by at least two obscure artists by the middle of the nineteenth century; both of these paintings serve to remind us that there is no necessary connection between advanced social or political ideas and pictorial adventurousness. The sculptor Antoine Etex's unfortunate *Death of a Misunderstood Man of Genius* (now in Lyons, one of the many crosses which French provincial museums seem destined to bear) was deservedly castigated by Baudelaire in his *Salon of 1845,* and is an obvious and derivative reference both to Chatterton and the dead Christ or Christian martyr.

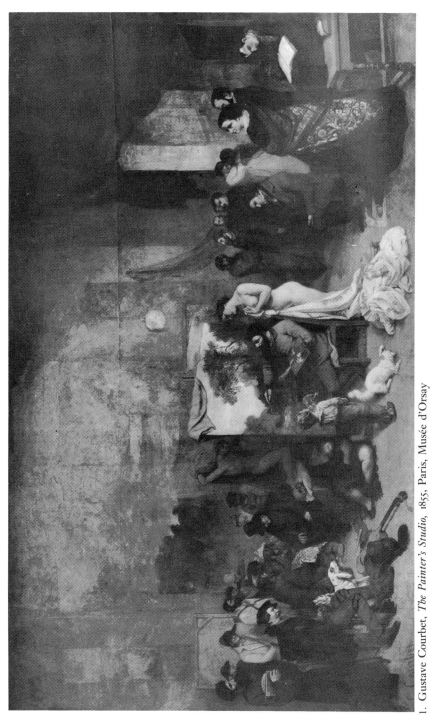

1. Gustave Courbet, *The Painter's Studio*, 1855, Paris, Musée d'Orsay

Somewhat more successful, because more concrete and straightforward, is an English variation on the theme of the artist as a social martyr, Henry Wallis's *Death of Chatterton,* an overtly sentimental and marvelously detailed costume piece, praised by Ruskin in his 1856 *Academy Notes* as "faultless and wonderful."[7]

It is not until seven years after the 1848 Revolution that the advanced social ideals of the mid-nineteenth century are given expression in appropriately advanced pictorial and iconographic form, in Courbet's *The Painter's Studio.* Its truly innovating qualities are perhaps best revealed by comparison with the "revolutionary" painting of the uprising of 1830, Delacroix's *Liberty at the Barricades,* a work conservative in both the political and the esthetic sense—that is to say, nostalgically Bonapartist in its ideology and heavily dependent upon mythological prototypes by Delacroix's Neoclassical teacher, Guérin, for its iconography and composition.[8] On the other hand, democratic and humanitarian passions seem to have been no more a guarantee of pictorial originality in the case of the Revolution of 1830 than they were to be in that of 1848. Although Philippe-Auguste Jeanron was far more politically radical than Delacroix, his *The Little Patriots: A Souvenir of July 1830* [2], which appeared in the 1831 Salon, is obviously a watered-down, sugar-coated reworking of Delacroix's romantic, Molochistic allegory *Greece Expiring on the Ruins of Missolonghi,* which had been exhibited at the Musée Colbert in Paris in 1829 and 1830. Jeanron, a close friend of Thoré, was later named director of the National Museums under the 1848 Revolutionary Government, and he accomplished miracles of reorganization and democratization during his brief incumbency. Yet, as is so often the case, good intentions are no guarantee of innovating, or even memorable, imagery. Despite contemporary and localizing references in *The Little Patriots,* such as the dome of the Panthéon in the background or the paving-stone barricade to the left, the pall of the academic *poncif* hangs heavier over the painting than the smoke of revolutionary fervor; one is made all too aware, in the pose of the little patriot in the center—reminiscent of that of Donatello's *David,* and so appropriate in its iconographic implications—that Jeanron was an art historian as well as an artist.

Certainly, there had been no dearth of paintings with socially significant, reformist, or even programmatically socialist themes in the years between the Revolution of 1830 and that of 1848. In 1835, Gleyre planned a three-part painting to be titled *The Past, the Present and the Future,*

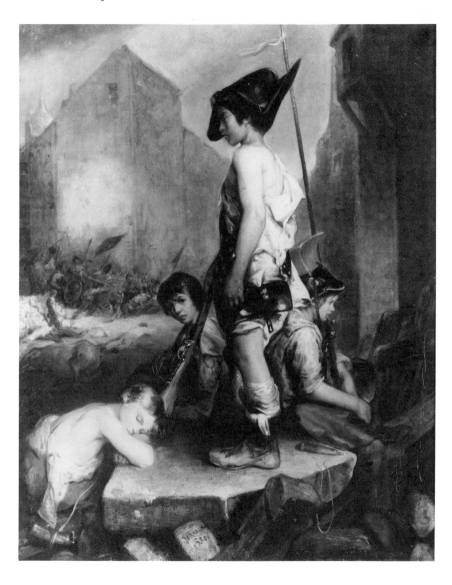

2. Philippe-Auguste Jeanron, *The Little Patriots: A Souvenir of July 1830*, 1830, Caen, France, Musée de Caen

represented by, respectively, a king and a priest signing a pact of alliance; a bourgeois, idly stretched on a divan, receiving the produce of his fields and his factories; and The People receiving the revenues of all the nation. In the Salon of 1837, Bézard exhibited a social allegory, rather transparently titled *The Race of the Wicked Rules over the Earth*, and in the 1843 Salon, the versatile (or perhaps eclectic) Papety exhibited his controversial *Dream of Happiness* (now in the Musée Vivenel in Compiègne; see Figure 2, Chapter 9). In 1845, Victor Robert exhibited *Religion, Philosophy, the Sciences and the Arts Enlightening Europe*, while in 1846, no less a figure than Baudelaire himself deigned to notice the *Universal Charity* of Laemlein, a bizarre confection representing a personification of Charity holding in her arms three children: "one is of the white race, the other red, the third black; a fourth child, a little Chinese, typifying the yellow race, walks by her side."⁹ Works such as these of course lent themselves perfectly to satire: both Musset and Balzac made fun of the ambitions of the apocalyptic and Fourierist painters, probably basing their caricatures on that learned and mystical pasticheur of universal panaceas, Paul-Joseph Chenavard.¹⁰

Yet one of these allegorical, socially progressive artists working prior to 1848 is worth examining more closely, if only to lend higher relief to the truly advanced qualities of Courbet's postrevolutionary *Studio:* this is the little-known Dominique Papety (1815–1849), for a time one of Chenavard's assistants, dismissed by Baudelaire in his 1846 *Salon* under the rubric "On Some Doubters," as "serious-minded and full of great goodwill," hence, "deserving of pity."¹¹ What is interesting about Papety is that he was a Fourierist, and Courbet's *Studio* is among other things a Fourierist as well as a Realist allegory. Yet in the difference in conception, composition, and attitude between Papety's allegory and that of Courbet lies the enormous gap between painting which is advanced in subject but conventional in every other way and that which is truly of its time, or even in advance of it (to use the term "avant-garde" in its most literal sense) and hence, a pictorial paradigm of the most adventurous attitudes of its era. Papety's Fourierist convictions were stated in a language so banal that his *Rêve de bonheur*, although Fourierist in inspiration, looks almost exactly like Ingres's apolitical *Golden Age* or Puvis de Chavannes's *Bois sacré;* the elements identifying it with contemporary social thought are completely extraneous to the basic composition. While a critic of 1843 saw "a club, a people's bank or a phalanstery" in "this dream of the gardens of Aca-

deme," and noted the unusual amalgamation of Horace's *Odes* and Plato's *Dialogues* with the steamship and the telegraph, the expendability of these contemporary elements is revealed when *L'Artiste* announces that Papety, on the basis of critical advice, has replaced his steamboat with a Greek temple, "which," remarks the anonymous critic, with unconscious irony, "is perhaps more ordinary but also more severe than socialism in painting."[12]

The link—and the gap—between Courbet and Papety is most clearly revealed by comparing the *Studio* with Papety's ambitious plan for a truly doctrinaire Fourierist painting, *The Last Evening of Slavery*, executed about 1848 for a fellow Harmonian, François Sabatier, of Montpellier, a friend and supporter of Courbet and a close associate of the latter's patron, Alfred Bruyas, himself an apostle of the New (Fourierist) Harmony. Courbet's *Studio* may be seen in part as a translation into contemporary, concrete, personal terms of the Fourierist generalizations written in red letters beneath the sketch itself, of Papety's grandiose but never completed project. Courbet doubtless had become familiar with Papety's sketch during the course of his visit of 1854 to Bruyas, an eccentric who envisioned himself as a "salesman of the New Harmony" and actually went so far as to publish an abortive Fourierist tract, *Notes d'Harmonie*.[13] During the summer of 1854 Courbet visited Sabatier on his estate at Tour de Farges near Montpellier, where he drew Sabatier's portrait in black pencil[3]. Sabatier, while highly appreciative of Papety's works, had already written a eulogistic account of Courbet's *Burial at Ornans* and *Peasants of Flagey* in his *Salon* of 1851, praising their truthfulness, dignity, and democratic spirit. Sabatier—poet, linguist, translator, and knowledgeable amateur of music and the theater—was married to Caroline Ungher, one of the great singers of the epoch. A warm friend of the arts, he was also deeply concerned with the lot of the poor and the humble; as a partisan supporter of the 1848 revolution he was forced to flee Paris during the terrible days of June, when the forces of reaction took their revenge. He practiced the doctrines of Fourierist "Association" mainly by his support and encouragement of artists such as Eugène Devéria, Chenavard, Hébert, and, above all, Papety. On his family estate, he cultivated his vineyards or drew up plans for phalansteries. No doubt, the ambitious sketch executed by Papety was at least in part suggested to him by his Harmonian patron, who in turn showed the drawing to Courbet and discussed the ideas

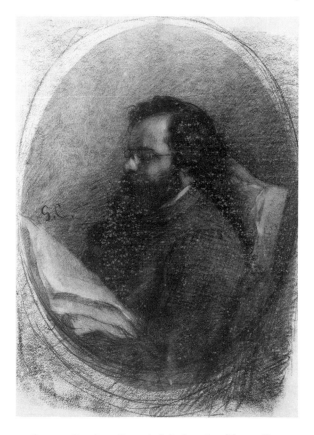

3. Gustave Courbet, *François Sabatier,* 1854, Montpellier, Musée Fabre

embodied in it with him. Courbet himself was certainly a staunch partisan of socialist thought, partly because of his close association with the anarchist revolutionary P.-J. Proudhon, who had been deeply influenced by Fourier as a young man and had supervised the printing of one of Fourier's books. More specifically, in his fragmentary autobiography of 1866 Courbet notes that by 1840 he had left behind his youthful training in order to follow socialists of all sects, and that "once arrived in Paris, he was a Fourierist."[14] In 1850, he had represented the Fourierist missionary Jean Journet going off to spread the gospel of Universal Harmony. In a sense, then, one might say that Papety's mediocre and pedantic drawing offered Courbet a challenge: whether he could translate Papety's

academic classicism into a pictorial language of his own time derived from his personal experience.

Art historians have always been hard-pressed to explain both the inspiration and specific implications of Courbet's *Studio*. It seems to me that a Fourierist interpretation, in conjunction with Papety's drawing, while it in no sense completely "explains" Courbet's allegory, at least helps to elucidate some of its otherwise inexplicable aspects: for example, just why Courbet chose to include the figures he did in his vast composition. Papety's sketch stipulates the depiction of "Scholars who have made the hour of Harmony [the final stage of Fourierist evolution] advance" and "Artists and poets swept up by enthusiasm [a specifically Fourierist term]"; the entire right-hand side of Courbet's painting consists of artists, critics, and philosophers who, in his opinion, have played an important role in the formulation of the new world. Papety mentions a "great strong man"; Courbet depicts a doughty athlete. Papety specifies a crowd of workers; Courbet, with greater economy, gives us a laborer and his wife. Papety mentions a "sick, worn-out worker"; Courbet has depicted "a poor, weather-beaten old man" in his left-hand group. Papety presents religious figures in a derogatory light; for Courbet, the rabbi and the priest in the *Studio* are personifications of self-satisfaction and hypocrisy. Papety had planned to represent "an aristocratic group surveying the scene"; Courbet placed two elegantly dressed visitors or spectators in the foreground. The Harmonian Leader, who was to have occupied the center of Papety's composition, is of course Courbet himself, the artist, busily engaged in creating a landscape in the center of his painting.

Even aside from the specific analogies between Courbet's canvas and Papety's drawing, further elements link the *Studio* with Fourierist conceptions: for example, the Fourierist ideal of the Association of Capital, of Labor, and of Talent is clearly embodied in Courbet's iconographic scheme. Fourier's system depends on a series of complex correspondences among the natural, the physical, the psychological, and the social realms. For example, the Four Affective Passions, cornerstones of the Fourierist system—Friendship, Love, Ambition, and Family Feeling—correspond to the four ages of life: Childhood, Adolescence, Maturity, and Old Age, all embodied by figures in Courbet's painting. Yet there is actually a fifth stage, to be inserted between that of adolescence (sixteen to thirty-five) and that of maturity (forty-six to sixty-five years), a phase which, according to Fourier, does not count in this system since it is the pivot, and the

pivot never counts in the calculation of movement. That is the phase of virility, from thirty-six to forty-five years, to which correspond the Affective Passions of both Love *and* Ambition—in other words, the plenitude of life. Now interestingly enough Courbet reached his thirty-sixth birthday in 1855, the year of the Universal Exposition, for which the *Studio* had been planned and in which it was completed; Courbet is indeed, quite literally, the pivot of the painting, the immovable center around which all pictorial activity takes place; in addition he is flanked by an adoring nude muse (Love?) and is looked up to by an equally admiring little boy (Ambition?). The cat, incidentally, was one of Fourier's favorite animals, although the presence of the elegant and eminently paintable animal in the foreground can hardly be accounted for in terms of doctrine.

One of the most puzzling minor sidelights of Courbet's composition is the significance of the little boy scribbling a picture, a later insertion whose presence has been accounted for both as a mere space filler—to balance the still-life objects on the left-hand side—and as a personification of the newly awakened interest in the art of children associated with the Swiss artist Rodolphe Töpffer.[15] Yet here again a Fourierist interpretation best accounts for this figure. Fourier was extraordinarily interested in the nature and development of children and in formulating an appropriate pedagogical system designed to take advantage of their innate inclinations and at the same time foster the well-being of the phalanstery as a whole. One of the five major dispositions of children observed by Fourier, and one of those most worthy of cultivation in his opinion, was *la singerie,* or "the mania for imitation." Children, according to Fourier, should have their own little tools, their own small-scaled workshops, where, under the tutelage of their elders their natural imitative propensities might best be put to productive ends. Surely the little boy diligently working away on his crude drawing is learning through imitation; initiated by a master painter, he himself will become one of the masters of the future.

Yet still another question remains to be answered about the mysterious and provocative iconography of the *Studio.* If François Sabatier was indeed a crucial figure in the conception of the painting both as a follower of Fourier and as the owner of the Papety sketch which provided at least partial inspiration for Courbet's masterpiece, why is Sabatier not represented in the work itself, as are such other crucial figures in Courbet's career and thought as Champfleury, Bruyas, Baudelaire, and Proudhon? It is my contention that Sabatier is indeed present[3], although only par-

tially; he may well be the half-hidden husband of the elegantly dressed woman in the foreground, the wealthy patron come to survey the scene. Certainly the line of hair and beard and the little tuft of hair that protrudes on the forehead are similar to these features in the black pencil drawing in the Musée Fabre in Montpellier. Further investigation would of course be necessary to establish the identity of the elegant wife in her flowered shawl with Caroline Ungher Sabatier and that of the man who accompanies her with other securely identified portraits of Sabatier. Nevertheless, even without such assurance the identification is a tempting one.

Courbet's painting is "avant-garde" if we understand the expression, in terms of its etymological derivation, as implying a union of the socially and the artistically progressive. Far from being an abstract treatise on the latest social ideas, it is a concrete emblem of what the making of art and the nature of society are to the Realist artist. It is through Courbet, the specific artist, the Harmonian demiurge, that all the figures partake of the life of this pictorial world, and all are related to his direct experience; they are not traditional, juiceless abstractions like Truth or Immortality, nor are they generalized platitudes like the Spirit of Electricity or the Nike of the Telegraph; it is, on the contrary, their concreteness which gives them credibility and conviction as tropes in a "real allegory," as Courbet subtitled the work, and which, in addition, ties them indissolubly to a particular moment in history.

While one might well reply that Ingres's *Apotheosis of Homer* is as irrevocably bound to the same historical moment as Courbet's *Studio*, even though it attempts to establish universal values and eternal verities, in the case of Ingres's work this is *despite* rather than *because* of the intentions of the artist; one might almost say that as far as Ingres was concerned, to be of one's time was a measure of failure rather than of achievement. By the middle of the nineteenth century the distinction between the contemporary and the avant-garde has already begun to make itself felt. Ingres's painting is, of course, in no sense "advanced"; it merely smells of its epoch to trained art-historical nostrils, as does all art.

Yet if we take "avant-garde" out of its quotation marks, we must come to the conclusion that what is generally implied by the term begins with Manet rather than Courbet. For implicit—and perhaps even central—to our understanding of avant-gardism is the concept of alienation—psychic, social, ontological—utterly foreign to Courbet's approach to art and to life. While Courbet may have begun his career as a rebel and ended it as

an exile, he was never an alienated man—that is, in conflict with himself internally or distanced from his true social situation externally, as were such near-contemporaries as Flaubert, Baudelaire, and Manet. For them, their very existence as members of the bourgeoisie was problematic, isolating them not merely from existing social and artistic institutions but creating deeply felt internal dichotomies as well.

In other words, their birth into the middle class was a source of internal as well as external alienation. Such a situation would have been utterly foreign to Courbet, who proudly accepted and even exaggerated his provincial petty-bourgeois background into something overtly plebeian and rustic, emphasizing his regional *patois* and the simplicity and directness, if not outright coarseness, of his manner.

With Manet, the situation becomes far more complicated. For the first time, we are confronted with an oeuvre which, like the dandy himself (who was originally postulated as the human equivalent of a work of art), lives completely autonomously, as gratuitous and noncommunicative as Baudelaire's frigid incarnation of Beauty. How can one possibly take Manet at his word—and does he, in fact, wish us to?—when, in the catalogue statement for his private exhibition of 1867, he assures us that it is merely the "sincerity" of his works that gives them their "character of protest," or when he pretends to be shocked at the hostility with which the public has greeted them. "Manet has never wished to protest. It is rather against him who did not expect it that people have protested. . . ." These words ring hollow in the face of such outright affronts to public sensibility as *Déjeuner sur l'herbe* [4] or *Olympia*. What has never been sufficiently taken into account by "serious" criticism is the character of these works as monumental and ironic put-ons, *blagues,* a favorite form of destructive wit of the period, inflated to gigantic dimensions—pictorial versions of those endemic pranks which threatened to destroy all serious values, to profane and vulgarize the most sacred verities of the times. Significantly enough Manet, greatly at ease with "popular" turns of phrase, employs the term *blague* at least six times in the course of his (rather brief) recorded pronouncements.[16] The Goncourt brothers devote a rich and rhetorical paragraph in *Manette Salomon* to a discussion of the *blague:*

> The farcical *Credo* of scepticism, the Parisian revolt of disillusionment, the light and boyish formula of blasphemy, the great modern form, impious and

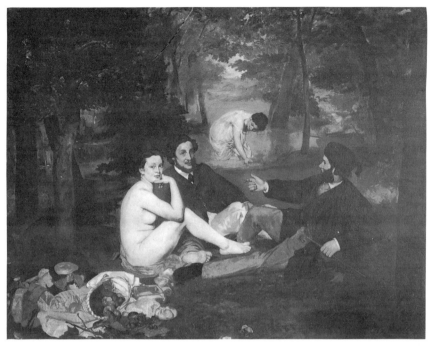

4. Edouard Manet, *Déjeuner sur l'herbe*, 1863, Paris, Musée d'Orsay

charivaresque, of universal doubt and national pyrrhonism; the *blague* of the
nineteenth century, that great destroyer, that great revolutionary, that poi-
soner of faith, killer of respect . . .[17]

No wonder, then, that an outraged critic, no worse than most, exclaimed
before *Le Bain*, as the *Déjeuner* was known in 1863: "This is a young man's
practical joke." And indeed, the *Déjeuner sur l'herbe*, with Manet's brother,
brother-in-law-to-be, and favorite model, Victorine, staring blandly out of
the decor of Giorgione's venerated pastoral idyll, their elegant contempo-
rary costume—or lack of it—making a mockery of the "timeless" Rapha-
elesque composition, must have seemed as full of protest and constituted
as destructive and vicious a gesture as that of Marcel Duchamp when he
painted a mustache on the Mona Lisa.

For Manet and for the avant-garde, as opposed to the men of 1848, the
relation of the artist to society was a phenomenological rather than a social
fact. He was involved in both the society and the political events of his
time—his project for the mural decoration of the new Hôtel de Ville in
Paris, with its series of compositions representing "Le Ventre de Paris"

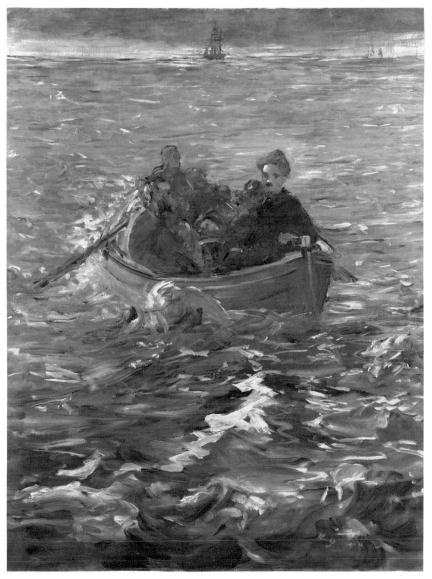

5. Edouard Manet, *The Escape of Rochefort*, 1881, Zurich, Kunsthaus

of 1879, his paintings *The Execution of Maximilian* and *The Escape of Rochefort*[5], as well as his activities during the siege of Paris and the Commune, bear witness both to his involvement and to his desire for accuracy of reportage. But Manet's works can hardly be considered direct

statements of a specific viewpoint or position. Quite often they seem more like embodiments of his own essential feeling of alienation from the society of his times, a dandyish coolness toward immediate experience, mitigated either by art or by irony, or his own inimitable combination of both. The most authentic statement of Manet's sense of his situation as a man and as an artist may well be his two versions, painted in 1881, of *The Escape of Rochefort,* in my opinion unconscious or disguised self-images, where the equivocal radical leader, hardly an outright hero by any standards, is represented in complete isolation from nature and his fellow men: he is, in fact, not even recognizably present in one of the paintings of his escape from New Caledonia. It is no longer a question of the Romantic hero in the storm-tossed boat; there is no ideological or physical contrast between controlled serenity and natural passion in Manet's paintings, as there is in their prototype, Delacroix's *Christ on the Sea of Galilee.* And even here, it must be noted, the faintest ghost of *blague* enters into the tone of the painting, with its open, ultra-Impressionist brushwork and vague, Chaplinesque figure at the rudder. The isolation here is built into the imagery,

6. Edouard Manet, *A Bar at the Folies-Bergère,* 1881–82, London, Courtauld Institute Galleries

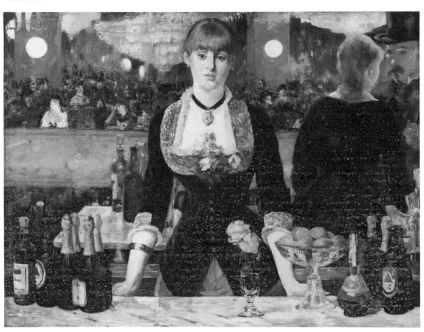

as it is in Manet's whimsical single stalk of asparagus, his lone rose, his centralized pickle jar: it is not the result of the observation of a specific social situation, it is an artful and pathetic statement of how it is to be an artist, how it is simply to be in the world at all.

This vision of isolation receives its apotheosis in *A Bar at the Folies-Bergère*[6], perhaps the most poignant image of alienation ever painted, a deadly serious spoof of Watteau's *Gilles* in completely modern "naturalist" terms, the anonymous yet concrete figure trapped between the world of tangible things and that of impalpable reflections, existing only as a way station between life and art. It is upon just such bad faith and alienation and the marvelously inventive, destructive, and self-destructive ways of making art about them that the modern avant-garde has built ever since. This is far indeed from Courbet's unified and unselfconscious vision of art and society—and his own direct and unambiguous relation to both—in the 1855 *The Painter's Studio: A Real Allegory of Seven Years of My Life as an Artist.*

Notes

1. Henri de Saint-Simon, *Opinions littéraires, philosophiques et industrielles* (Paris, 1825), cited in Donald D. Egbert, "The Idea of 'Avant-garde' in Art and Politics," *The American Historical Review* 73, no. 2 (December 1967): 343.

2. Cited by Renato Poggioli, *The Theory of the Avant-garde,* trans. Gerald Fitzgerald (Cambridge, Mass., 1968), p. 9.

3. Cited by Peter Collins, *Changing Ideals in Modern Architecture: 1750–1950* (London, 1965), pp. 261–62.

4. "Pierre Dupont," originally published 1851, Baudelaire, *Oeuvres complètes,* ed. Y.-G. Le Dantec and C. Pichois (Paris, 1961), pp. 605, 612, 614.

5. Poggioli, op. cit., p. 10.

6. See, for example, his deliberately provocative behavior toward the Comte de Nieuwerkerke, Director-General of the Imperial Museums, and his activities related to the Vendôme column incident during the Commune.

7. *Collected Works,* ed. E. T. Cook and A. Wedderburn (London, 1902–12), XIV, p. 60. The painting is now in the Tate Gallery.

8. See Pierre Gaudibert's extremely interesting analysis of Delacroix's essential conservatism, "Eugène Delacroix et le romantisme révolutionnaire: A Propos de *La Liberté sur les barricades,*" *Europe* 41 (April 1963): 4–21. For Guérin's influence on the *Liberty,* see Sixten Ringbom, "Guérin, Delacroix and 'The Liberty,'" *Burlington Magazine* 110 (1968): 270–74.

9. For the best source of information about these socially conscious painters prior to 1848, see Léon Rosenthal, *Du Romantisme au réalisme*, (Paris, 1914), pp. 345–98. Also, Joseph C. Sloane, *French Painting Between the Past and the Present* (Princeton, N.J., 1951), passim.

10. For a complete account of this fascinating failure, see Joseph C. Sloane, *Paul Marc Joseph Chenavard* (Chapel Hill, N.C., 1962).

11. "Salon of 1846," *Art in Paris: 1845–1862*, ed. and trans. J. Mayne (London, 1965), p. 101.

12. *L'Artiste*, June 2, 1844, p. 80.

13. For information on Brûyas and Sabatier see Montpellier, Musée Fabre, *Dessins de la collection Alfred Bruyas* (1962), introd. Jean Claparède (Inventaire des Collections Publiques Françaises, 6), n.p.

14. "Biographie de Courbet par lui-même," in *Courbet raconté par lui-même et par ses amis*, ed. P. Courthion (Geneva, 1950), II, p. 27.

15. Meyer Schapiro was the first to make this connection between Courbet's little boy and Töpffer's ideas about the art of children, in "Courbet and Popular Imagery," *Warburg Journal* 4 (1941): 178 and n. 4.

16. *Manet raconté par lui-même et par ses amis*, ed. P. Courthion (Geneva, 1945), pp. 27, 28, 30, 162, and passim.

17. Edmond and Jules de Goncourt, *Manette Salomon*, preface by Hubert Juin (Paris: Editions 10/18, 1979), pp. 42–43.

2

Courbet, Oller, and a Sense of Place: The Regional, the Provincial, and the Picturesque in 19th-Century Art

The slogan "Il faut être de son temps" has often been cited as central to the conception of nineteenth-century Realism. "One must be of one's times" was the battle cry of Courbet and his followers: the admonition to reject the atemporal generalization of classical art or the anachronistic historicism of the Romantics and turn instead to the contemporary world in all its detailed concreteness for inspiration. Yet no less crucial to the Realist project, it would seem to me, was another admonition, sometimes related to, sometimes in contradiction with, the concern to be of one's times: "One must be of one's place"—that is to say, the injunction to deal with one's native country, region, or even, at its most extreme, one's own property (for this, essentially, is what John Constable did, spending his life painting his father's mill and the river Stour within a two-mile radius of the family lands) in order to grasp the singularity, the concrete veracity of reality, as well as one's deepest and most authentic relation to it.

This injunction to be of one's place, in the case of both Gustave Courbet, the Frenchman from Ornans, and the Puerto Rican painter Francisco Oller (1833–1917), is even more central than the admonition to be of one's times. "Il faut être de son temps" seems somehow more germane to the up-to-date modernity of a basically urban vision like Manet's. To be of one's place implies an attachment to more lasting values, to a certain type of natural scene associated with rural life and folk customs. Indeed, one might say of Courbet that for no other painter outside

of Constable did the well-loved and well-known physiognomy of his native countryside play such a seminal role in the creation of the work. A vivid sense of place is central to Courbet's achievement.

The American writer and critic Eudora Welty has claimed that creating a sense of place is one of the most effective ways that the writer has to maintain the ties of his work to reality. Place, says Welty, is where the writer has his roots: "Place is where he stands; in his experience out of which he writes it provides the base of reference, in his work the point of view. . . . Location pertains to feeling, feeling profoundly pertains to place. . . ."[1] Although she was writing about *Wuthering Heights* and *The Sound and the Fury* and thinking about the deep South from which she came, her words apply with equal appositeness to Courbet's *Oak of Flagey* and to his Franche-Comté landscapes generally. They apply to a painter like Oller as well, as we shall see.

"Place" of course, referred in the nineteenth century, as today, to what was by definition the regional, the marginal, the peripheral. It was so defined by a dominant code in which the classical in the form of an imaginary Greco-Roman or biblical generalization functioned as the transgeographic—the *atopical*, so to speak. Or occasionally, provincial life might be presented in a suitably sweetened, idealized form as the "picturesque." But in general, one might say that a sense of place, in the form of provincialism or regionalism, was something the ambitious artist wished to discard rather than encourage in the mid-nineteenth century. Then, as now, power accrued from immersion in the so-called mainstream, in acquiescence to an imaginary ideal of the placeless.

How might a sense of place be constructed in the middle of the nineteenth century? The problem must be contextualized historically as well as geographically. A sense of place is obviously going to be construed differently in France in the nineteenth century in the context of Realism versus Academic-Classical and Romantic art than in Puerto Rico in the 1880s or 1890s—or today.

Courbet, in his monumental and ambitious *Burial at Ornans*[1], has insisted upon the ungeneralized, unidealized configuration of his own gnarled, unclassical, rocky countryside, the Franche-Comté, as a basic ingredient in his construction of a sense of place—harsh, unmodulated, insistently horizontal—and in the same way, insisted on a direct, unprettified representation of his fellow citizens of Ornans, which was interpreted

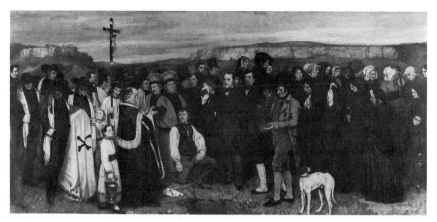

1. Gustave Courbet, *Burial at Ornans*, 1849–50, Paris, Musée d'Orsay

as caricature or, in some cases, like that of the red noses of the beadles, as sacrilege by many viewers and most critics at the Salon of 1850–51.

But in addition, Courbet felt the need of a new kind of contentious visual language with which to state his opposition to the dominant code of representation of his time; he found it in popular imagery, the crude, simplified woodcuts of the so-called *imagerie d'Epinal*. Popular imagery offered two different but related variables to Courbet's construction of a sense of place: first, a mode of composition which, in its simplicity, direct-ness, reduction, and naïveté, could signify "Le Peuple" and the cultural values associated with the 1848 Revolution, which had stressed both the popular and, to some degree, the regional and the folkloric. Secondly, in the context of 1848, an art related to popular imagery, in its apparently willful stiffness and gracelessness, on the enormous and "arrogant" scale of the *Burial,* could be read as provocative, oppositional, and even revolu-tionary. The sense of place conveyed by Courbet's painting understood in these terms was decidedly subversive of the dominant culture.

It is interesting to look at Francisco Oller's work from the vantage point of a sense of place and its pictorial construction. It is clear that, like Courbet in the *Burial* or his *Funeral Preparations* (a work, now over-painted, which underlies his much altered painting *The Bridal Prepara-tions,* now in the collection of Smith College), Oller too wished, in his major work, *El velorio* (The Wake)[2] of 1893, to convey a sense of *both* his native region and, perhaps less consciously and with more difficulty,

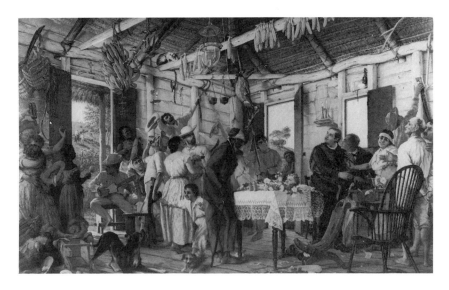

2. Francisco Oller, *El velorio* (The Wake), 1893, Río Piedras, Puerto Rico, Collection Museum of Anthropology, History and Art, University of Puerto Rico

a sense of *himself as a Puerto Rican artist*—not just someone who comes to Puerto Rico to paint local color. In the same way, Courbet had insisted on conveying a sense of being an Ornanais, not just a tourist visiting Ornans.

In contrast to the Scottish painter John—known as "Spanish"—Phillip's treatment of a similar theme from Spanish popular culture, *La gloria*, of 1864, where figures are idealized and smoothed out, the bereft mother assimilated to sentimental English notions of maternal grief; and where the colorful crowd is united in a smooth, theatrical dance—that is to say, where composition is unified and harmonized by conventional, sentimental narrative strategies and an idealized figure style—Oller, insisting on an insider's critical discourse rather than a tourist's patronizing and glamorizing one, creates a strikingly different image. Indeed, Oller, in *El velorio*, while intending to body forth an "orgy of brutish appetites under the guise of gross superstition" (his own statement), succeeds in creating an image which is much more interesting than a mere condemnation would be.[2] "Location pertains to feeling, feeling profoundly pertains to place," said Eudora Welty. It is precisely amid these "brutish appetites," these "gross superstitions" that Oller the Puerto Rican has his roots. Yet at the same time, as a member of the cultivated Puerto Rican middle class, the

tree itself (to continue the analogy) had grown and flourished far away, in France, in Spain, and within cosmopolitan vanguard and academic circles in both countries. *The Wake,* it seems to me, represents an attempt to reconcile tree and roots, as it were, under the guise of social or, more precisely, moral criticism.

It is clear that Oller has a profound attachment to the folkloric details, the accurate descriptive configuration of Puerto Rican popular and rural customs of the times. And of course, he relished the still-life aspects of the scene: the plantains; the baskets hanging from the rafters, the structure of the house itself; the lace of the table cover: all have been depicted with loving, one might almost say with a deliberately obsessive specificity. Indeed, there is a certain sense of willed naïveté, of deliberate exaggeration of awkward gestures, a separation of individual elements into independent statements which may, on the one hand, harken back to the broad comedic mode established by Courbet in *The Return from the Meeting* of 1863, a painting also highly critical of the clergy, a work Oller may in fact have seen in France at a time when he was probably in contact with Courbet and his circle. But on the other hand, although this is mere speculation on my part, it would seem to me that Oller may have turned to some form of local popular art for inspiration. Crude broadsides? Cheap, mass-produced lithographs? Journalistic caricature? I don't know which or what, but still the impact of popular art, probably some form of Hispanic popular art, makes itself felt in the anti-academic, generally anti–high art, anti-mainstream characteristics of *El velorio.*

In addition, Oller's major work establishes its oppositional character by refusing to be a "pretty" picture or an ingratiating or a unified one. Or rather, it relegates loveliness, along with a more sophisticated Impressionist style, to the place it belongs: out the door, in the form of two deliberately contrasting landscape vignettes. The very ease and tranquillity of these vignettes offer a striking contrast to the crowding, awkwardness, and popular energy, even grotesquery, of the main interior space. It is not merely the rich mixture of physiognomic and racial types, or the recording of folk customs and rituals, which of course had had a vigorous tradition in Spanish even more than in French nineteenth-century painting, or even the incorporation of authentic Puerto Rican objects and elements, not to speak of the localism of the theme of the *baquiné* which establishes *The Wake* as an expression of national identity. Rather, it is its conscious and unconscious refusal to conform to contemporary standards

of either the academic *or* the vanguard center—i.e., Paris or Spain of the 1890s—which makes it a difficult painting and at the same time, because of its very combination of awkwardness and ambition, confers upon it a genuine sense of place mediated through its author's conflicted but authentic sense of his Puerto Rican identity.

A sense of place can be closely allied to a sense of class, and therefore suggested by means of the human figures rather than literally described in a landscape or interior. Neither Oller nor Courbet relied simply on local color to communicate a sense of local experience in this case, which can be represented by Oller's drawing *Laundress* or Courbet's painting *Women Sifting Grain*. Rather, a certain kind of forceful drawing style, a marked deviation from conventions of benign, idealized generalization, a striking departure from the reigning notion of the charming or the acquiescent female worker separates both Courbet's and Oller's versions of the theme from the more regularized and prettified and universalized versions of a Breton or a Bastien-Lepage. Interestingly enough, it is a nearly contemporary drawing by the Dutchman van Gogh, *Peasant Woman Putting Corn in Sheaves* of 1884, that comes nearest to Oller's *Laundress* in some ways. Like Oller, van Gogh communicates a genuine sense of a specific type of peasant and of the backbreaking difficulty of routine manual labor through the deliberate anti-classicism of the pose and a boldly emphatic exaggeration of the awkwardness, crudeness, even, of the contour.

When we turn to Oller's portraits, such as *Colonel Contreras* (1880) or the poet *José Gautier Benítez* (1885)[3], we confront a different problem and a different solution. Here, after all, we have the artist confronting men of his own class, his own type: outstanding figures, not typical ones; heroes and cultural leaders, not peasants. How can one reconcile the demands of a sense of place, conceived of as a sort of aesthetic-egalitarian imperative, with those of the signification of heroism, by definition an elitist notion? Oller chooses to emphasize the idea of the specificity of the heroic in *Colonel Contreras* by placing this figure in a landscape, which is clearly meant to serve as a background for the military prowess of the hero, who maintains a comfortable if dominating position within his native habitat, rather like Courbet in his rocky setting in the *Self-Portrait with a Black Dog.*

In the case of the quite beautiful and moving representation of the poet José Gautier Benítez, the situation is more complicated. Despite the fact that Benítez was a strong nationalist as well as a Romantic poet and

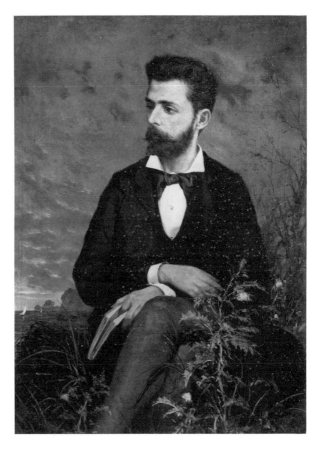

3. Francisco Oller, *José Gautier Benítez*, c. 1885–86, San Juan, Puerto Rico, Ateneo Puertorriqueño

converted "the geography and physical beauty of Puerto Rico into symbols of the growing national consciousness of the creole population," a poet who "became one of the island's most popular writers" for singing "the praises of the beauty of the countryside,"[3] it is the romantic rather than the national aspect of Benítez's achievement that Oller has chosen to stress in this painting, which was done as a memorial after the poet's death, in 1880, as Courbet had painted his friend the philosopher P.-J. Proudhon after the latter's death in 1865. But whereas Courbet had chosen to emphasize the everydayness of Proudhon's setting, placing the anarchist in his backyard with his children, having him wear a workman's *blouse* and

posing him looking up from scattered books, as though interrupted in the middle of work, Oller chooses not to dwell on the details of the authentic Puerto Rican landscape, but rather on the more cosmopolitan, romantic notion of the pathetic fallacy: nature transformed into an analogue of human emotions. The prominent gray clouds in the sky convey a sense of melancholy, in conjunction with the low horizon and the thistle with its yellow flowers; and the leafless branches of the bushes behind the poet undoubtedly symbolize "the grief of Nature at the loss of her bard."[4]

In this poignant painting, then, we are confronted by a genuine dilemma faced, now as then, by the provincial or so-called provincial artist vis-à-vis a sense of place: that is, the need to adhere to the codes of the mainstream versus the desire to create a sense of national and personal identity through the language of art. This was, and still is, a source of conflict. After all, what other ways are there of communicating with a large, confirmatory audience and feeling that one has succeeded in terms of high quality, of genuine excellence in a craft one has struggled to perfect over many years, except in terms of the standards of the main-stream? The alternative to so-called universality (i.e., adherence to the criteria established by the centers of power) then as now was marginality or lack of "quality." Then as now, universality was understood to be identical with high quality, and both were felt to be identified with the center, the art world. In Oller's terms, the appropriate setting for a hero of Puerto Rican culture, suitable for asserting his genius, was one that played down the sense of specific place in favor of the aura of universal meaning.

For nineteenth-century artists like Courbet and Oller, who were painting during what might be called, to borrow a phrase from John Berger, "the moment of landscape," this genre was most important of all in establishing a sense of place. For Courbet, for example, *The Great Oak of Flagey,* which he subtitled "Chêne de Vercingétorix, Camp de César près d'Alésia" when he showed it at his private exhibition in 1867, was an image rich in implications: personal, in that the oak could be read as a kind of self-image of the artist, rooted in his native soil of Flagey, near Ornans; political, in the association of the tree with Vercingetorix, the Gallic chieftain who had died for the cause of his people's national struggle against Julius Caesar at the Battle of Alesia, and whom Courbet could identify with the French left's struggle against the modern Caesar, Napoleon III; historical, in that the oak had been associated both with the Tree

of Liberty of the French Revolution and with popular notions of national self-determination (i.e., the Great Oak of Guernica). In short, without being directly symbolic, the painting of the oak—like landscape in general—could convey a range of implications, rooted in local meanings and concretized in the historic oak of Flagey.

Like Courbet's oak, one might imagine that Oller's *Palms* conveyed a range of implications, personal and political, as well as national. (This was, of course, before the adaptation of the palm as the logo of the statehood party in the twentieth century.) It is hard to believe, certainly, that the *Landscape with Royal Palms*[4] could be "just another motif" for

4. Francisco Oller, *Landscape with Royal Palms*, c. 1897, San Juan, Puerto Rico, Ateneo Puertorriqueño

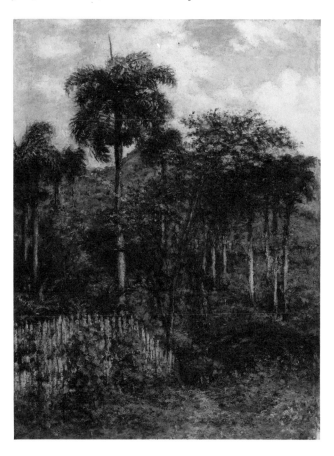

Oller on his return to Puerto Rico from France in about 1897. The domi-
nating uprightness of the central palm, isolated from its smaller, more
wavering neighbors; the overgrown pathway; and the crumbling fence
give the image overtones that go beyond the picturesque or the aestheti-
cally satisfying. Indeed, one might well be tempted to subtitle it, following
Courbet's lead, "The Great Palm of Borínquen: Tree of Puerto Rican
National Identity." For, like the oak for Courbet, the palm must have had
for Oller an emblematic as well as a merely pictorial significance.

But the styles of these paintings, the means used to convey the sense
of place, are very different. In Oller's *Palms,* the open brushwork, the
high-keyed color, the attempt to embed light and atmosphere in the very
fabric of the image point to his recent trip to France and his contact with
Pissarro. His style is a signifier not of Puerto Rican identity but of what,
for Oller, was the latest stylistic fashion in France. For some observers of
the time, the specifically Puerto Rican implications of the work—its very
sense of place, in fact—might have been felt to be attenuated, even contra-
dicted, by the aesthetic vanguardism of its style. This can only be viewed
as ironic, for Pissarro and Guillemet thirty years earlier had overtly as-
sociated their Impressionist style with the politics of revolutionary anar-
chism, as letters from these artists to Oller reveal.[5] But in the context of
Puerto Rican art at the end of the nineteenth century, such a stylistic
language seems more to proclaim the artist's affiliation with international
Modernism than with the concrete, national character of the motif it is
employed to depict.

Oller himself may have been aware of such contradictions in his work
of the 1890s. Whatever the reasons, he reverts to a more sober, less con-
spicuously "aesthetic" style in the landscapes of the turn of the century,
those specifically dedicated to capturing a vanishing Puerto Rican past,
representations of the obsolete sugar factories, a motif both objectively
historical, personally nostalgic, and of course, profoundly national at the
same time—a time, it must be said, of great national turbulence during
which the comforting emblems of a simpler, vanished way of life and the
apparently unchanging verities of nature might seem particularly appeal-
ing.

Ultimately, however, Oller most successfully, if paradoxically, estab-
lishes a sense of place mediated by an original visual language in the form
of still life. I say "paradoxically" because still life is often considered to
be the most neutral, inherently "pure" genre of all, a kind of abstraction

before the fact, in which the artist is concerned only with formal relation-
ships and nothing more. We, from Europe and North America, tend to
think of apples and oranges as "neutral," "natural" still-life components,
as though they were universals, and as though still lifes composed with
them had no particular national identity. Oller, to a degree, shared this
view. In *Guavas,* a still life heavily based on both Fantin-Latour and
Cézanne, he simply substituted a tropical fruit, the guava, for a northern
one and let this substitution stand for geographical difference. The same
might be said of his *Mangóes* of 1901–3[5], which is even more strongly, I
believe, based on a specific prototype, Cézanne's *Apples and Basket* (in the
Bartlett Collection, Art Institute of Chicago), and which, despite the
tropical subject, looks distinctively mainstream French, its Puerto Rican
products deliberately and coolly neutralized, an effect that is even more
apparent if one compares this painting with the deliberately exoticized,
primitivized still lifes of Gauguin. It is Gauguin the Frenchman, not Oller
the Puerto Rican, who emphasizes the primitiveness of his still lifes by the
way each object is clearly and "crudely" distinguished from the next, or
set off by deliberate, angular outline, or presented on an up-tilted table to
imply a mysterious, irrational primitive ritual or offering.

5. Francisco Oller, *Mangóes,* 1901–03, San Juan, Puerto Rico, Collection Eddie and
Gladys Irizarry

Obviously, then, it is not the subject matter per se, apples or guavas, that establishes a sense of place in still life. Indeed, Courbet, painting in prison after the fall of the Commune, in his still lifes with apples reminds us that there is nothing necessarily abstract or universal about apples. These dimpled, bumpy, juicy objects are not mere counters in a game of formal relationships but emblems of deep, personal yearning, of the lost pleasures of home and freedom. They can be experienced as concrete, sensuously differentiated tokens of place—at once desired and absent.

There is a group of Oller's still lifes that evokes a quality of profound rootedness in Puerto Rican reality. Certainly the subjects are the fruits of his native country and recognizably distinctive as "exotic"; certainly the impact of contemporary French still-life painting by Cézanne and Fantin-Latour is discernible. But equally present, as an important variable in a Latin American sense of place, is the impact of the Spanish Bodegón tradition, stretching back to the seventeenth century, with its moral seriousness and austerity offering a counter to French formalism and neutrality of the object. And this sense of moral weightiness, a solidity and heaviness at once material and spiritual, achieved through pictorial concentration and the willed divestment of all extraneous distraction, marks Oller's still-life masterpieces of 1892–93, the *Ripe Plantains* [6]. Here the artist has managed to "monumentalize this simple fruit of the earth, which was the main staple of the Carribbean diet . . ."[6] so that this Puerto Rican version of our daily bread assumes an unpretentious but almost sacramental solemnity. Here indeed, with minimal means and no apparent conflict, Oller has managed to project a sense of place, and of his own identity as an artist at the same time.

This discussion of Courbet, Oller, and a sense of place in nineteenth-century art has, I hope, raised more questions than it has answered: questions that are still central to the so-called provincial or marginal artist today. First of all, what do we mean by provincial and who decides who *is* provincial? Why was Cézanne's painting at Aix or Monet's at Etretat "mainstream," or central, whereas Oller's painting in Puerto Rico was not? Or, to put it another way, why was Cézanne's painting the Montagne Sainte-Victoire in Aix-en-Provence not considered regionalist? Or what if Pissarro had gone back to Saint Thomas to become the "national" painter of this Caribbean island, as Oller did for Puerto Rico? Clearly, the variables are not merely aesthetic ones, but relate to far broader issues of power and domination.

6. Francisco Oller, *Ripe Plantains,* 1892–93. San Juan, Puerto Rico, Collection Hanny Stubbe de López

And what is the difference between what is thought of, generally in belittling terms, as provincialism, and what has come to be known as "regionalism," a positive expression of local difference? And further, what is the function of the picturesque in the nineteenth century? Does it function as a way in which the dominant culture may confirm its judgments of outsiders? Can one's equals ever be viewed as "picturesque"? Above all, one must confront the ongoing conflict for the so-called provin-

cial, often third-world, artist among the demands of the local culture, the expression of national identity, and the frequently internalized demands for high quality, in which quality is inevitably equated with the standards of the world center.

Yet at the same time, one must not underestimate the importance, expecially in the nineteenth and earlier twentieth century, but today as well, of modernity and modernization as liberating, expansionist concepts, which opened doors, knocked down walls, expanded the cramped, often conventional roles inflicted on people by traditional village culture. Both nineteenth- and twentieth-century fiction offers us many visions of the talented or the unusual individual oppressed by or languishing in restrictive, stultifying provincial settings, from *Madame Bovary* to the *Three Sisters*. The center, then—Paris above all for the nineteenth-century artist—should be thought of not just in terms of oppression or domination, but as the source of liberation and stimulation as well. In this conflict, so central to the meaning and direction of art, and indeed, of all cultural creation today, Francisco Oller stands as an exemplary figure, one whose importance extends far beyond the island which nourished him with that all-important sense of place.

Notes

1. Eudora Welty, *Place in Fiction* (a condensation of lectures prepared for the Conference on American Studies, Cambridge, England, 1954) (New York: House of Books, 1957), n.p.

2. Francisco Oller, cited in the exhibition catalogue *Francisco Oller: Un Realisto del Impresionismo* (Francisco Oller: A Realist Impressionist) (Museum of Art, Ponce, Puerto Rico, June–December, 1983), cat. no. 43, p. 193.

3. *Francisco Oller*, cat. no. 23, p. 175.

4. Ibid.

5. Ibid., pp. 224–27.

6. *Francisco Oller*, cat. no. 35, p. 185.

3

The Imaginary Orient

What is more European, after all, than to be corrupted by the Orient?

—RICHARD HOWARD

What is the rationale behind the recent spate of revisionist or expansionist exhibitions of nineteenth-century art—*The Age of Revolution, The Second Empire, The Realist Tradition, Northern Light, Women Artists,* various shows of academic art, etc.? Is it simply to rediscover overlooked or forgotten works of art? Is it to reevaluate the material, to create a new and less value-laden canon? These are the kinds of questions that were raised— more or less unintentionally, one suspects—by the 1982 exhibition and catalogue *Orientalism: The Near East in French Painting, 1800–1880.* [1]

Above all, the Orientalist exhibition makes us wonder whether there are other questions besides the "normal" art-historical ones that ought to be asked of this material. The organizer of the show, Donald Rosenthal, suggests that there are indeed important issues at stake here, but he deliberately stops short of confronting them. "The unifying characteristic of nineteenth-century Orientalism was its attempt at documentary realism," he declares in the introduction to the catalogue, and then goes on to maintain, quite correctly, that "the flowering of Orientalist painting . . . was closely associated with the apogee of European colonialist expan-

sion in the nineteenth century." Yet, having referred to Edward Said's critical definition of Orientalism in Western literature "as a mode for defining the presumed cultural inferiority of the Islamic Orient . . . part of the vast control mechanism of colonialism, designed to justify and perpetuate European dominance," Rosenthal immediately rejects this analysis in his own study. "French Orientalist painting will be discussed in terms of its aesthetic quality and historical interest, and *no attempt will be made at a re-evaluation of its political uses.*"[2]

In other words, art-historical business as usual. Having raised the two crucial issues of political domination and ideology, Rosenthal drops them like hot potatoes. Yet surely most of the pictures in the exhibition—indeed the key notion of Orientalism itself—cannot be confronted without a critical analysis of the particular power structure in which these works came into being. For instance, the degree of realism (or lack of it) in individual Orientalist images can hardly be discussed without some attempt to clarify *whose* reality we are talking about.

What are we to make, for example, of Jean-Léon Gérôme's *Snake Charmer*[1], painted in the late 1860s (now in the Clark Art Institute,

1. Jean-Léon Gérôme, *Snake Charmer,* late 1860s, Williamstown, Massachusetts, Sterling and Francine Clark Art Institute

Williamstown, Mass.)? Surely it may most profitably be considered as a
visual document of nineteenth-century colonialist ideology, an iconic
distillation of the Westerner's notion of the Oriental couched in the
language of a would-be transparent naturalism. (No wonder Said used it
as the dust jacket for his critical study of the phenomenon of Oriental-
ism!)[3] The title, however, doesn't really tell the complete story; the paint-
ing should really be called *The Snake Charmer and His Audience,* for we
are clearly meant to look at both performer and audience as parts of the
same spectacle. We are not, as we so often are in Impressionist works of
this period—works like Manet's or Degas's *Café Concerts,* for example,
which are set in Paris—invited to identify with the audience. The watch-
ers huddled against the ferociously detailed tiled wall in the background
of Gérôme's painting are as resolutely alienated from us as is the act they
watch with such childish, trancelike concentration. Our gaze is meant to
include both the spectacle and its spectators as objects of picturesque
delectation.

Clearly, these black and brown folk are mystified—but then again, so
are we. Indeed, the defining mood of the painting is mystery, and it is
created by a specific pictorial device. We are permitted only a beguiling
rear view of the boy holding the snake. A full frontal view, which would
reveal unambiguously both his sex and the fullness of his dangerous per-
formance, is denied us. And the insistent, sexually charged mystery at the
center of this painting signifies a more general one: the mystery of the East
itself, a standard topos of Orientalist ideology.

Despite, or perhaps because of, the insistent richness of the visual diet
Gérôme offers—the manifest attractions of the young protagonist's rosy
buttocks and muscular thighs; the wrinkles of the venerable snake charmer
to his right; the varied delights offered by the picturesque crowd and the
alluringly elaborate surfaces of the authentic Turkish tiles, carpet, and
basket which serve as décor—we are haunted by certain *absences* in the
painting. These absences are so conspicuous that, once we become aware
of them, they begin to function as presences, in fact, as signs of a certain
kind of conceptual deprivation.

One absence is the absence of history. Time stands still in Gérôme's
painting, as it does in all imagery qualified as "picturesque," including
nineteenth-century representations of peasants in France itself. Gérôme
suggests that this Oriental world is a world without change, a world of

timeless, atemporal customs and rituals, untouched by the historical pro-
cesses that were "afflicting" or "improving" but, at any rate, drastically
altering Western societies at the time. Yet these were in fact years of
violent and conspicuous change in the Near East as well, changes affected
primarily by Western power—technological, military, economic, cul-
tural—and specifically by the very French presence Gérôme so scrupu-
lously avoids.

In the very time when and place where Gérôme's picture was painted,
the late 1860s in Constantinople, the government of Napoleon III was
taking an active interest (as were the governments of Russia, Austria, and
Great Britain) in the efforts of the Ottoman government to reform and
modernize itself. "It was necessary to change Muslim habits, to destroy
the age-old fanaticism which was an obstacle to the fusion of races and to
create a modern secular state," declared French historian Edouard Driault
in *La Question d'Orient* (1898). "It was necessary to transform . . . the
education of both conquerors and subjects, and inculcate in both the
unknown spirit of tolerance—a noble task, worthy of the great renown
of France," he continued.

In 1863 the Ottoman Bank was founded, with the controlling interest
in French hands. In 1867 the French government invited the sultan to visit
Paris and recommended to him a system of secular public education and
the undertaking of great public works and communication systems. In
1868 under the joint direction of the Turkish Ministry of Foreign Affairs
and the French Ambassador, the Lycée of Galata-Serai was opened, a
great secondary school open to Ottoman subjects of every race and creed,
where Europeans taught more than six hundred boys the French lan-
guage—"a symbol," Driault maintained, "of the action of France, exerting
herself to instruct the peoples of the Orient in her own language the
elements of Western civilization." In the same year, a company consisting
mainly of French capitalists received a concession for railways to connect
present-day Istanbul and Salonica with the existing railways on the Mid-
dle Danube.[4]

The absence of a sense of history, of temporal change, in Gérôme's
painting is intimately related to another striking absence in the work: that
of the telltale presence of Westerners. There are never any Europeans in
"picturesque" views of the Orient like these. Indeed, it might be said that
one of the defining features of Orientalist painting is its dependence for

its very existence on a presence that is always an absence: the Western colonial or touristic presence.

The white man, the Westerner, is of course always implicitly present in Orientalist paintings like *Snake Charmer;* his is necessarily the controlling gaze, the gaze which brings the Oriental world into being, the gaze for which it is ultimately intended. And this leads us to still another absence. Part of the strategy of an Orientalist painter like Gérôme is to make his viewers forget that there was any "bringing into being" at all, to convince them that works like these were simply "reflections," scientific in their exactitude, of a preexisting Oriental reality.

In his own time Gérôme was held to be dauntingly objective and scientific and was compared in this respect with Realist novelists. As an American critic declared in 1873:

> Gérôme has the reputation of being one of the most studious and conscientiously accurate painters of our time. In a certain sense he may even be called "learned." He believes as firmly as Charles Reade does in the obligation on the part of the artist to be true even in minute matters to the period and locality of a work pretending to historical character. Balzac is said to have made a journey of several hundreds of miles in order to verify certain apparently insignificant facts concerning a locality described in one of his novels. Of Gérôme, it is alleged that he never paints a picture without the most patient and exhaustive preliminary studies of every matter connected with his subject. In the accessories of costume, furniture, etc. it is invariably his aim to attain the utmost possible exactness. It is this trait in which some declare an excess, that has caused him to be spoken of as a "scientific picture maker."[5]

The strategies of "realist" (or perhaps "pseudo-realist," "authenticist," or "naturalist" would be better terms) mystification go hand in hand with those of Orientalist mystification. Hence, another absence which constitutes a significant presence in the painting: the absence—that is to say, the *apparent* absence—of art. As Leo Bersani has pointed out in his article on realism and the fear of desire, "The 'seriousness' of realist art is based on the absence of any reminder of the fact that it is really a question of art."[6] No other artist has so inexorably eradicated all traces of the picture plane as Gérôme, denying us any clue to the art work as a literal flat surface.

If we compare a painting like Gérôme's *Street in Algiers* with its prototype, Delacroix's *Street in Meknes,* we immediately see that Gérôme,

in the interest of "artlessness," of innocent, Orientalist transparency, goes much farther than Delacroix in supplying picturesque data to the Western observer, and in veiling the fact that the image consists of paint on canvas. A "naturalist" or "authenticist" artist like Gérôme tries to make us forget that his art is really art, both by concealing the evidence of his touch, and, at the same time, by insisting on a plethora of authenticating details, especially on what might be called unnecessary ones. These include not merely the "carefully executed Turkish tile patterns" that Richard Etting-hausen pointed out in his 1972 Gérôme catalogue; not merely the artist's renditions of Arabic inscriptions which, Ettinghausen maintains, "can be easily read";[7] but even the "later repair" on the tile work, which, function-ing at first sight rather like the barometer on the piano in Flaubert's description of Madame Aubain's drawing room in "Un coeur simple," creates what Roland Barthes has called "the reality effect" *(l'effet de réel).* [8]

Such details, supposedly there to denote the real directly, are actually there simply to signify its presence in the work as a whole. As Barthes points out, the major function of gratuitous, accurate details like these is to announce "we are the real." They are signifiers of the category of the real, there to give credibility to the "realness" of the work as a whole, to authenticate the total visual field as a simple, artless reflection—in this case, of a supposed Oriental reality.

Yet if we look again, we can see that the objectively described repairs in the tiles have still another function: a moralizing one which assumes meaning only within the apparently objectivized context of the scene as a whole. Neglected, ill-repaired architecture functions, in nineteenth-century Orientalist art, as a standard topos for commenting on the corrup-tion of contemporary Islamic society. Kenneth Bendiner has collected striking examples of this device, in both the paintings and the writings of nineteenth-century artists. For instance, the British painter David Rob-erts, documenting his *Holy Land* and *Egypt and Nubia,* wrote from Cairo in 1838 about "splendid cities, once teeming with a busy population and embellished with . . . edifices, the wonder of the world, now deserted and lonely, or reduced by mismanagement and the barbarism of the Moslem creed, to a state as savage as the wild animals by which they are sur-rounded." At another time, explaining the existence of certain ruins in its environs, he declared that Cairo "contains, I think, more idle people than any town its size in the world."[9]

The vice of idleness was frequently commented upon by Western

travelers to Islamic countries in the nineteenth century, and in relation to
it, we can observe still another striking absence in the annals of Orientalist
art: the absence of scenes of work and industry, despite the fact that some
Western observers commented on the Egyptian fellahin's long hours of
back-breaking labor, and on the ceaseless work of Egyptian women en-
gaged in the fields and in domestic labor.[10]

When Gérôme's painting is seen within this context of supposed Near
Eastern idleness and neglect, what might at first appear to be objectively
described architectural fact turns out to be *architecture moralisée*. The lesson
is subtle, perhaps, but still eminently available, given a context of similar
topoi: these people—lazy, slothful, and childlike, if colorful—have let their
own cultural treasures sink into decay. There is a clear allusion here,
clothed in the language of objective reportage, not merely to the mystery of
the East, but to the barbaric insouciance of Moslem peoples, who quite
literally charm snakes while Constantinople falls into ruins.

What I am trying to get at, of course, is the obvious truth that in this
painting Gérôme is not reflecting a ready-made reality but, like all artists,
is producing meanings. If I seem to dwell on the issue of authenticating
details, it is because not only Gérôme's contemporaries, but some present-
day revisionist revivers of Gérôme, and of Orientalist painting in general,
insist so strongly on the objectivity and credibility of Gérôme's view of
the Near East, using this sort of detail as evidence for their claims.

The fact that Gérôme and other Orientalist "realists" used photo-
graphic documentation is often brought in to support claims to the objec-
tivity of the works in question. Indeed, Gérôme seems to have relied on
photographs for some of his architectural detail, and critics in both his
own time and in ours compare his work to photography. But of course,
there is photography and photography. Photography itself is hardly im-
mune to the blandishments of Orientalism, and even a presumably inno-
cent or neutral view of architecture can be ideologized.

A commercially produced tourist version of the Bab Mansour at Mek-
nes[2] "orientalizes" the subject, producing the image the tourist would
like to remember—picturesque, relatively timeless, the gate itself photo-
graphed at a dramatic angle, reemphasized by dramatic contrasts of light
and shadow, and rendered more picturesque by the floating cloud which
silhouettes it to the left. Plastic variation, architectural values, and colorful
surface are all played up in the professional shot; at the same time, all
evidence of contemporaneity and contradiction—that Meknes is a modern

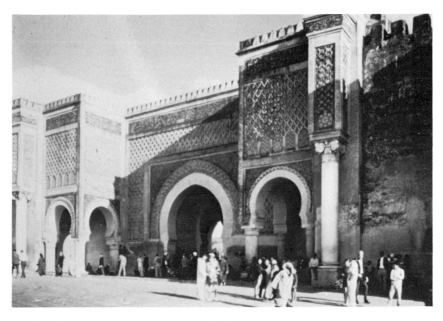

2. "Official" tourist photograph of the Bab Mansour

3. The Bab Mansour at Meknes, photo by Linda Nochlin

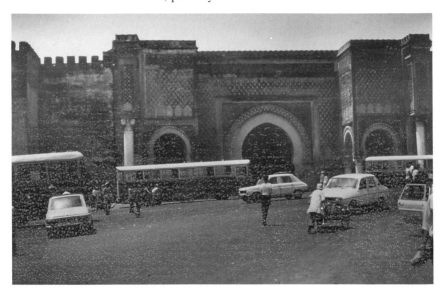

as well as a traditional city, filled with tourists and business people from East and West; that cars and buses are used as well as donkeys and horses—is suppressed by the "official" photograph. A photo by an amateur[3], however, foregrounding cars and buses and the swell of empty macadam, subordinates the picturesque and renders the gate itself flat and incoherent. In this snapshot, Orientalism is reduced to the presence of a few weary crenellations to the right. But this image is simply the bad example in the "how-to-take-good-photographs-on-your-trip" book which teaches the novice how to approximate her experience to the official version of visual reality.

But of course, there is Orientalism and Orientalism. If for painters like Gérôme the Near East existed as an actual place to be mystified with effects of realness, for other artists it existed as a project of the imagination, a fantasy space or screen onto which strong desires—erotic, sadistic, or both—could be projected with impunity. The Near Eastern setting of Delacroix's *Death of Sardanapalus*[4] (created, it is important to emphasize,

4. Eugène Delacroix, *Death of Sardanapalus*, 1827–8, Paris, Louvre

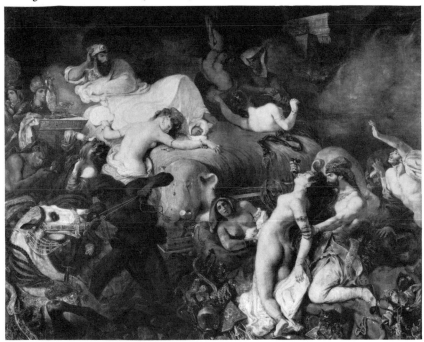

before the artist's own trip to North Africa in 1832) does not function as a field of ethnographic exploration. It is, rather, a stage for the playing out, from a suitable distance, of forbidden passions—the artist's own fantasies (need it be said?) as well as those of the doomed Near Eastern monarch.

Delacroix evidently did his Orientalist homework for the painting, probably reading descriptions in Herodotus and Diodorus Sicilis of ancient Oriental debauchery, and dipping into passages in Quintus Curtius on Babylonian orgies, examining an Etruscan fresco or two, perhaps even looking at some Indian miniatures.[11] But it is obvious that a thirst for accuracy was hardly a major impulse behind the creation of this work. Nor, in this version of Orientalism—Romantic, if you will, and created forty years before Gérôme's—is it Western man's power over the Near East that is at issue, but rather, I believe, contemporary Frenchmen's power over women, a power controlled and mediated by the ideology of the erotic in Delacroix's time.

"In dreams begin responsibilities," a poet once said. Perhaps. Certainly, we are on surer footing asserting that in power begin dreams—dreams of still greater power (in this case, fantasies of men's limitless power to enjoy the bodies of women by destroying them). It would be absurd to reduce Delacroix's complex painting to a mere pictorial projection of the artist's sadistic fantasies under the guise of Orientalism. Yet it is not totally irrelevant to keep in mind that the vivid turbulence of Delacroix's narrative—the story of the ancient Assyrian ruler Sardanapalus, who, upon hearing of his incipient defeat, had all his precious possessions, including his women, destroyed, and then went up in flames with them—is subtended by the more mundane assumption, shared by men of Delacroix's class and time, that they were naturally "entitled" to the bodies of certain women. If the men were artists like Delacroix, it was assumed that they had more or less unlimited access to the bodies of the women who worked for them as models. In other words, Delacroix's private fantasy did not exist in a vacuum, but in a particular social context which granted permission for as well as established the boundaries of certain kinds of behavior.

Within this context, the Orientalizing setting of Delacroix's painting both signifies an extreme state of psychic intensity and formalizes that state through various conventions of representation. But it allows only so much and no more. It is difficult, for example, to imagine a *Death of*

Cleopatra, with voluptuous nude male slaves being put to death by women servants, painted by a woman artist of this period.[12]

At the same time he emphasized the sexually provocative aspects of his theme, Delacroix attempted to defuse his overt pictorial expression of men's total domination of women in a variety of ways. He distanced his fears and desires by letting them explode in an Orientalized setting and by filtering them through a Byronic prototype. But at the same time, the motif of a group of naked, beautiful women put to the sword is not taken from ancient versions of the Sardanapalus story, although the lasciviousness of Oriental potentates was a staple of many such accounts.[13] Nor was it Byron's invention but, significantly, Delacroix's own.[14]

The artist participates in the carnage by placing at the blood-red heart of the picture a surrogate self—the recumbent Sardanapalus on his bed. But Sardanapalus holds himself aloof, in the pose of the philosopher, from the sensual tumult which surrounds him; he is an artist-destroyer who is ultimately to be consumed in the flames of his own creation-destruction. His dandyish coolness in the face of sensual provocation of the highest order—what might be called his "Orientalized" remoteness and conventionalized pose—may indeed have helped Delacroix justify to himself his own erotic extremism, the fulfillment of sadistic impulse in the painting. It did not satisfy the contemporary public. Despite the brilliant feat of artistic semisublimation pulled off here, both public and critics were for the most part appalled by the work when it first appeared in the Salon of 1828.[15]

The aloofness of the hero of the piece, its Orientalizing strategies of distancing, its references to the *outré* mores of long-dead Near Eastern oligarchs fooled no one, really. Although criticism was generally directed more against the painting's supposed formal failings, it is obvious that by depicting this type of subject with such obvious sensual relish, such erotic panache and openness, Delacroix had come too close to an overt statement of the most explosive, hence the most carefully repressed, corollary of the ideology of male domination: the connection between sexual possession and murder as an assertion of absolute enjoyment.

The fantasy of absolute possession of women's naked bodies—a fantasy which for men of Delacroix's time was partly based on specific practice in the institution of prostitution or, more specifically, in the case

of artists, on the availability of studio models for sexual as well as professional services—also lies at the heart of such typical subjects of Orientalist imagery as Gérôme's various *Slave Markets*. These are ostensibly realistic representations of the authentic customs of picturesque Near Easterners. Indeed, Maxime Du Camp, a fellow traveler in the picturesque byways of the Middle East, remarked of Gérôme's painting (or of one like it): "Gerome's *Slave Market* is a fact literally reproduced. . . . People go [to the slave market] to purchase a slave as they do here to the market . . . to buy a turbot."[16]

Obviously, the motivations behind the creation of such Orientalist erotica, and the appetite for it, had little to do with pure ethnography. Artists like Gérôme could dish up the same theme—the display of naked, powerless women to clothed, powerful men—in a variety of guises: that of the antique slave market, for instance, or in the subject of Phryne before the Tribunal. What lies behind the production of such popular stimuli to simultaneous lip-licking and tongue-clicking is, of course, the satisfaction that the delicious humiliation of lovely slave girls gives to the moralistic voyeur. They are depicted as innocents, trapped against their will in some far-off place, their nakedness more to be pitied than censured; they also display an ingratiating tendency to cover their eyes rather than their seductive bodies.

Why was it that Gérôme's Orientalist assertions of masculine power over feminine nakedness were popular, and appeared frequently in the Salons of the mid-nineteenth century, whereas earlier Delacroix's *Sardanapalus* had been greeted with outrage? Some of the answers have to do with the different historical contexts in which these works originated, but some have to do with the character of the paintings themselves. Gérôme's fantasia on the theme of sexual politics (the Clark collection *Slave Market*, for example) has been more successfully ideologized than Delacroix's, and this ideologizing is achieved precisely through the work's formal structure. Gérôme's version was more acceptable because he substituted a chilly and remote pseudoscientific naturalism—small, self-effacing brushstrokes, and "rational" and convincing spatial effects—in other words, an apparently dispassionate empiricism—for Delacroix's tempestuous self-involvement, his impassioned brushwork, subjectively outpouring perspective, and inventive, sensually self-revelatory dancelike poses. Gérôme's style justified his subject—perhaps not to us, who are

cannier readers—but certainly to most of the spectators of his time, by guaranteeing through sober "objectivity" the unassailable Otherness of the characters in his narrative. He is saying in effect: "Don't think that I or any other right-thinking Frenchman would ever be involved in this sort of thing. I am merely taking careful note of the fact that less enlightened races indulge in the trade in naked women—but isn't it arousing!"

Like many other art works of his time, Gérôme's Orientalist painting managed to body forth two ideological assumptions about power: one about men's power over women; the other about white men's superiority to, hence justifiable control over, inferior, darker races, precisely those who indulge in this sort of regrettably lascivious commerce. Or we might say that something even more complex is involved in Gérôme's strategies vis-à-vis the *homme moyen sensuel:* the (male) viewer was invited sexually to identify with, yet morally to distance himself from, his Oriental counterparts depicted within the objectively inviting yet racially distancing space of the painting.

Manet's *Masked Ball at the Opera* [see Figure 1, Chapter 5] of 1873–74 may, for the purposes of our analysis, be read as a combative response to and subversion of the ideological assumptions controlling Gérôme's *Slave Market* [5]. Like Gérôme's painting, Manet's work (to borrow a phrase from the German critic Meier-Graefe, who greatly admired it) represents a *Fleischbörse*—a flesh market. Unlike Gérôme, however, Manet represented the marketing of attractive women not in a suitably distanced Near Eastern locale, but behind the galleries of the opera house on the rue Le Peletier. The buyers of female flesh are not Oriental louts but civilized and recognizable Parisians, debonair men about town, Manet's friends, and, in some cases, fellow artists, whom he had asked to pose for him. And the flesh in question is not represented *au naturel,* but sauced up in the most charming and provocative fancy-dress costumes. Unlike Gérôme's painting, which had been accepted for the Salon of 1867, Manet's was rejected for that of 1874.

I should like to suggest that the reason for Manet's rejection was not merely the daring close-to-homeness of his representation of the availability of feminine sexuality and male consumption of it. Nor was it, as his friend and defender at the time Stéphane Mallarmé suggested, its formal daring—its immediacy, its dash, its deliberate yet casual-looking cut-off view of the spectacle. It was rather the way these two kinds of subversive

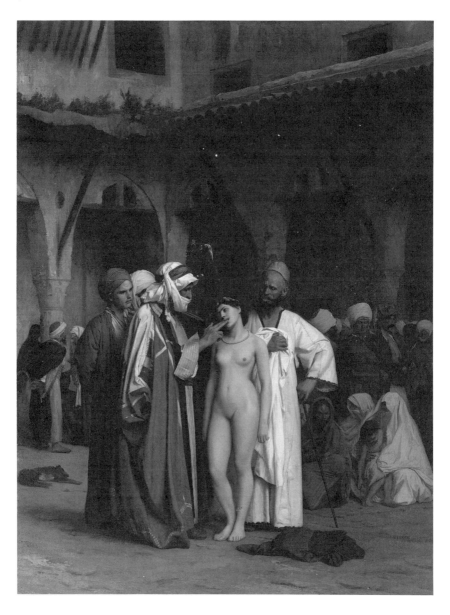

5. Jean-Léon Gérôme, *The Slave Market,* early 1860s, Williamstown, Massachusetts,
Sterling and Francine Clark Art Institute

impulse are made to intersect. Manet's rejection of the myth of stylistic transparency in a painting depicting erotic commercial transactions is precisely what calls into question the underlying assumptions governing Gérôme's Orientalist version of the same theme.

By interrupting the unimpeded flow of the story line with the margins of his image, Manet frankly reveals the assumptions on which such narratives are premised. The cut-off legs and torso on the balcony are a witty, ironic reference to the actual motivations controlling such gatherings of upper-middle-class men and charming women of the theater: pleasure for the former; profit for the latter. The little legs and torso constitute a witty synecdoche, a substitution of part for whole, a trope par excellence of critical realism—a trope indicating the sexual availability of delectable female bodies for willing buyers.

By means of a similar synecdoche—the half-Polichinelle to the left, cut off by the left-hand margin of the canvas—Manet suggests the presence of the artist-entrepreneur half inside, half outside the world of the painting; at the same time, he further asserts the status of the image as a work of art. By means of a brilliant, deconstructive-realist strategy, Manet has at once made us aware of the artifice of art, as opposed to Gérôme's solemn, pseudoscientific denial of it with his illusionistic naturalism. At the same time, through the apparently accidentally amputated female legs and torso, Manet foregrounds the nature of the actual transaction taking place in the worldly scene he has chosen to represent.[17]

Despite his insistence on accuracy as the guarantee of veracity, Gérôme himself was not beyond the blandishments of the artful. In his bath scenes like the *Moorish Bath* [6], the presence of a Cairene sunken fountain with two-color marble inlay in the foreground and a beautiful silver-inlaid brass basin with its Mamluk coat-of-arms held by a Sudanese servant girl (as well as the inevitable Turkish tiles) indicate a will to ethnographic exactitude. Still, Gérôme makes sure we see his nude subject as art as well as mere reportage. This he does by means of tactful reference to what might be called the "original Oriental backview"— Ingres's *Valpinçon Bather*. The abstract linearism of Ingres is qualified and softened in Gérôme's painting, but is clearly meant to signify the presence of tradition: Gérôme has decked out the products of his flesh market with the signs of the artistic. His later work often reveals a kind

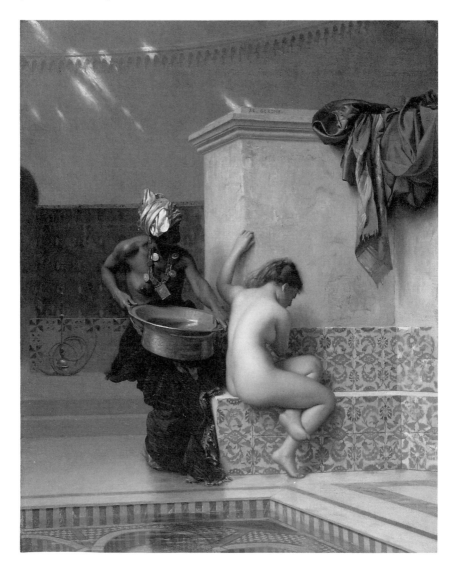

6. Jean-Léon Gérôme, *Moorish Bath,* 1880s. Boston, Museum of Fine Arts, Gift of Robert Jordan from the Collection of Eben D. Jordan

of anxiety or a division—what might be called the Kitsch dilemma—between efforts to maintain the fiction of pure transparency—a so-called photographic realism—and the need to prove that he is more than a mere transcriber, that his work is artistic.

This anxiety is heightened when the subject in question is a female nude—that is to say, when an object of desire is concerned. Gérôme's anxiety about proving his "artistic-ness" at the same time that he panders to the taste for naturalistic bodies and banal fantasy is revealed most obviously in his various paintings of artists and models, whether the artist in question is Pygmalion or simply Gérôme himself in his studio. In the latter case, he depicts himself surrounded by testimonials to his professional achievement and his responsiveness to the classical tradition. For Gérôme, the classical would seem to be a product that he confects matter-of-factly in his studio. The sign of the artistic—sometimes absorbed into, sometimes in obvious conflict with the fabric of the painting as a whole—is a hallmark of *quality* in the work of art, increasing its value as a product on the art market.

Like the artistic back, the presence of the black servant in Gérôme's Orientalist bath scenes serves what might be called connotative as well as strictly ethnographic purposes. We are of course familiar with the notion that the black servant somehow enhances the pearly beauty of her white mistress—a strategy employed from the time of Ingres, in an Orientalist mood, to that of Manet's *Olympia,* in which the black figure of the maid seems to be an indicator of sexual naughtiness. But in the purest distillations of the Orientalist bath scene—like Gérôme's, or Debat-Ponsan's *The Massage* of 1883—the very passivity of the lovely white figure as opposed to the vigorous activity of the worn, unfeminine ugly black one, suggests that the passive nude beauty is explicitly being prepared for service in the sultan's bed. This sense of erotic availability is spiced with still more forbidden overtones, for the conjunction of black and white, or dark and light female bodies, whether naked or in the guise of mistress and maidservant, has traditionally signified lesbianism.[18]

Like other artists of his time, Gérôme sought out instances of the picturesque in the religious practices of the natives of the Middle East. This sort of religious ethnographic imagery attempted to create a sleek, harmonious vision of the Islamic world as traditional, pious, and unthreatening, in direct contradiction to the grim realities of history. On the one hand, the cultural and political violence visited on the Islamic peoples of France's own colony, Algeria, by specific laws enacted by the French legislature in the sixties had divided up the communally held lands of the native tribes. On the other hand, violence was visited against native reli-

gious practices by the French Society of Missionaries in Algeria, when, profiting from widespread famine at the end of 1867, they offered the unfortunate orphans who fell under their power food at the price of conversion. Finally, Algerian tribes reacted with religion-inspired violence to French oppression and colonization; in the Holy War of 1871, 100,000 tribesmen under Bachaga Mohammed Mokrani revolted under the banner of Islamic idealism.[19]

It is probably no coincidence that Gérôme avoided French North Africa as the setting for his mosque paintings, choosing Cairo instead for these religious *tableaux vivants,* in which the worshipers seem as rigid, as rooted in the intricate grounding of tradition and as immobilized as the scrupulously recorded architecture which surrounds them and echoes their forms. Indeed, taxidermy rather than ethnography seems to be the informing discipline here: these images have something of the sense of specimens stuffed and mounted within settings of irreproachable accuracy and displayed in airless cases. And like the exhibits displayed behind glass in the natural-history museum, these paintings include everything within their boundaries—everything, that is, except a sense of life, the vivifying breath of shared human experience.

What are the functions of the picturesque, of which this sort of religious ethnography is one manifestation? Obviously, in Orientalist imagery of subject peoples' religious practices one of its functions is to mask conflict with the appearance of tranquillity. The picturesque is pursued throughout the nineteenth century like a form of peculiarly elusive wildlife, requiring increasingly skillful tracking as the delicate prey—an endangered species—disappears farther and farther into the hinterlands, in France as in the Near East. The same society that was engaged in wiping out local customs and traditional practices was also avid to preserve them in the form of records—verbal, in the way of travel accounts or archival materials; musical, in the recording of folk songs; linguistic, in the study of dialects or folk tales; or visual, as here.

Yet surely, the very notion of the picturesque in its nineteenth-century manifestations is premised on the fact of destruction. Only on the brink of destruction, in the course of incipient modification and cultural dilution, are customs, costumes, and religious rituals of the dominated finally *seen* as picturesque. Reinterpreted as the precious remnants of disappearing ways of life, worth hunting down and preserving, they are finally transformed into subjects of aesthetic delectation in an imagery in

which exotic human beings are integrated with a presumably defining and overtly limiting decor. Another important function, then, of the picturesque—Orientalizing in this case—is to certify that the people encapsulated by it, defined by its presence, are irredeemably different from, more backward than, and culturally inferior to those who construct and consume the picturesque product. They are irrevocably "Other."

Orientalism, then, can be viewed under the aegis of the more general category of the picturesque, a category that can encompass a wide variety of visual objects and ideological strategies, extending from regional genre painting down to the photographs of smiling or dancing natives in the *National Geographic.* It is no accident that Gérôme's North African Islamic procession and Jules Breton's or Dagnon-Bouveret's depictions of Breton Catholic ceremonies have a family resemblance. Both represent backward, oppressed peoples sticking to traditional practices. These works are united also by shared stylistic strategies: the "reality effect" and the strict avoidance of any hint of conceptual identification or shared viewpoint with their subjects, which could, for example, have been suggested by alternative conventions of representation.

How does a work avoid the picturesque? There are, after all, alternatives. Neither Courbet's *Burial at Ornans* nor Gauguin's *Day of the God* falls within the category of the picturesque. Courbet, for whom the "natives" included his own friends and family, borrowed some of the conventions of popular imagery—conventions signifying the artist's solidarity, indeed identity, with the country people represented. At the same time he enlarged the format and insisted upon the—decidedly non-picturesque—insertion of contemporary costume. Gauguin, for his part, denied the picturesque by rejecting what he conceived of as the lies of illusionism and the ideology of progress—in resorting to flatness, decorative simplification, and references to "primitive" art—that is to say, by rejecting the signifiers of Western rationalism, progress, and objectivity *in toto.*

Delacroix's relation to the picturesque is central to an understanding of the nature and the limits of nineteenth-century Orientalism. He admired Morocco when he saw it on his trip accompanying the Comte de Mornay's diplomatic mission in 1832, comparing Moroccans to classical senators and feverishly recording every aspect of Moroccan life in his notebooks. Nevertheless, he knew where to draw the line between Them and Us. For him, Morocco was inevitably picturesque. He clearly distinguished between its visual beauty—including the dignified, unselfcon-

scious deportment of the natives—which he treasured, and its moral quality, which he deplored. "This is a place," he wrote to his old friend Villot from Tangiers, "completely for painters. Economists and Saint-Simonians would have a lot to criticize here with respect to the rights of man before the law, but the beautiful abounds here."[20] And he distinguished with equal clarity between the picturesqueness of North African people and settings in general, and the weaknesses of the Orientals' own vision of themselves in their art. Speaking of some Persian portraits and drawings, he remarks in the pages of his *Journal* that the sight of them "made me repeat what Voltaire said somewhere—that there are vast countries where taste has never penetrated. . . . There are in these drawings neither perspective nor any feeling for what is truly painting . . . the figures are immobile, the poses stiff, etc."[21]

The violence visited upon North African people by the West was rarely depicted by Orientalist painting; it was, in fact, denied in the painting of religious ethnography. But the violence of Orientals to each other was a favored theme. Strange and exotic punishments, hideous tortures, whether actual or potential, the marvelously scary aftermath of barbaric executions—these are a stock-in-trade of Orientalist art. Even a relatively benign subject like that represented in Léon Bonnat's *Black Barber of Suez* can suggest potential threat through the exaggerated contrast between muscularity and languor, the subtle overtones of Samson and Delilah.

In Henri Regnault's *Execution Without Judgment Under the Caliphs of Granada* of 1870, we are expected to experience a *frisson* by identifying with the victim, or rather, with his detached head, which (when the painting is correctly hung) comes right above the spectator's eye level. We are meant to look up at the gigantic, colorful, and dispassionate executioner as—shudder!—the victim must have only moments earlier. It is hard to imagine anyone painting an *Execution by Guillotine Under Napoleon III* for the same Salon. Although guillotining was still a public spectacle under the Second Empire and through the beginning of the Third Republic, it would not have been considered an appropriate artistic subject. For guillotining was considered rational punishment, not irrational spectacle—part of the domain of law and reason of the progressive West. One function of Orientalist paintings like these is, of course, to suggest that *their* law is irrational violence; *our* violence, by contrast, is law.

Yet it was precisely the imposition of "rational" Western law by Napoleon III's government on the customary practices of North Africa that tribesmen experienced most deeply as fatal violence. Nor was this violence unintended. The important laws pertaining to landed property in Algeria, imposed on the native population by the French from the 1850s through the mid-1870s—the Cantonment of 1856, the Senatus Consulte of 1863 and the Warnier Law of ten years later—were conceived as measures which would lead to the destruction of the fundamental structures of the economy and of the traditional society—measures of legally approved violence, in other words. And they were experienced as such by Algerian natives, who felt their speedy, devastating effects as a savage lopping off of the head of traditional tribal existence, an execution without judgment.

A French army officer, Captain Vaissière, in his study of the Ouled Rechaïch, published in Algiers in 1863, relates that when this group found out that the law of the Senatus Consulte was going to be applied to their tribe, they were thrown into consternation, so clearly were they aware of the destructive power contained in this measure. "The French defeated us in the plain of Sbikha," declared one old man. "They killed our young men; they forced us to make a war contribution when they occupied our territories. All that was nothing; wounds eventually heal. But the setting up of private property and the authorization given each individual to sell his share of the land [which was what Senatus Consulte provided for], this means the death sentence for the tribe, and twenty years after these measures have been carried out, the Ouled Rechaïch will have ceased to exist."[22]

It is not completely accurate to state that the violence inflicted by the West—specifically, by the French in North Africa—was never depicted by the artists of the period—although, strictly speaking, such representations fall under the rubric of "battle painting" rather than Orientalist genre. "At the origin of the picturesque is war," declared Sartre at the beginning of his analysis of French colonial violence in *Situations V* in 1954. A painting like Horace Vernet's *Capture of the Smala of Abd-el-Kader at Taguin, May 16, 1843,* a vast panorama exhibited along with six pages of catalogue description in the Salon of 1845, seems a literal illustration of Sartre's contention.[23] This minutely detailed pictorial commemoration of the victory of the Due d'Aumale's French troops over thirty thousand noncombatants—old men, women, children, as well as the treasure and flocks of the native chief, who was leading the rebellion against French

military domination at the time—seems fairly clear in its political implications, its motivations fairly transparent.

What is less clear today is the relation of two other works, also in the Salon of 1845, to the politics of violence in North Africa at the time. The Salon of 1845 was the Salon immediately following the crucial Battle of Isly—the climax of French action against the Algerian rebel forces led by Abd-el-Kader and his ally, Sultan Abd-el-Rahman of Morocco. After the destruction of his *smala,* or encampment, at Taguin—the very incident depicted by Horace Vernet—Abd-el-Kader was chased from his country and took refuge in Morocco. There he gained the support of Sultan Abd-el-Rahman—the very sultan that Delacroix had sketched and whose reception he had so minutely described when he had visited Meknes with the Comte de Mornay on a friendly diplomatic mission more than ten years earlier.

Delacroix had originally planned to commemorate the principal event of Mornay's mission by including, in a prominent position, members of the French delegation at the sultan's reception. Although it exists as a sketch, this version of the painting was never brought to completion, for the event it was supposed to commemorate—Mornay's carefully worked out treaty with the sultan—failed to lead to the desired détente with Morocco. Delacroix's projected painting would no longer have been appropriate or politically tactful. When the defeated Abd-el-Kader sought refuge with the sultan of Morocco after the defeat at Isly, Moroccan affairs abruptly took a turn for the worse. The French fleet, with English, Spanish, and American assistance, bombarded Tangiers and Mogador, and Abd-el-Rahman was forced to eject the Algerian leader from his country. The defeated sultan of Morocco was then forced to negotiate a new treaty, which was far more advantageous to the French. Moroccan affairs having become current events, the journal *L'Illustration* asked Delacroix to contribute some North African drawings for its account of the new peace treaty and its background, and he complied.

It is clear, then, why Delacroix took up the subject again for his monumental painting in 1845, but in a new form with different implications, based on a new political reality. In the final version (now in the Musée des Augustins, Toulouse), it is a vanquished opponent who is represented. He is dignified, surrounded by his entourage, but an entourage that includes the defeated leaders of the fight against the French and as such constitutes a reminder of French prowess. In Delacroix's *Moulay-*

Abd-el-Rahman, Sultan of Morocco, Leaving His Palace at Meknes, Surrounded by His Guard and His Principal Officers[7], as it was called in the Salon catalogue of 1845, there is no longer any question of mingling the French presence with the Moroccan one.[24]

In the same Salon appeared a painting which is always compared to Delacroix's *Sultan of Morocco:* Théodore Chassériau's equestrian *Portrait of Kalif Ali-Ben Hamet (or Ahmed) Followed by His Escort.* Indeed, in the

7. Eugène Delacroix, *Moulay-Abd-el-Rahman, Sultan of Morocco,* Toulouse, Musée des Augustins

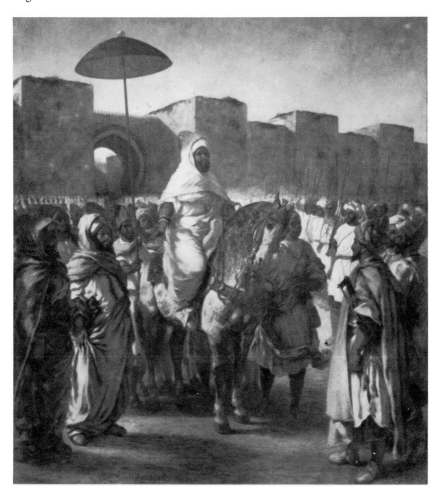

Rochester Orientalism catalogue, Chassériau's painting is described as "inevitably recalling Delacroix's portrait," although more "detailed and portrait-like."[25] But Chassériau's is actually a very different image, serving a radically different purpose. It is actually a commissioned portrait of an Algerian chieftain friendly to the French, who, with his entourage, was being wined and dined by the French authorities in Paris at the time.[26]

Ali-Ben Ahmed, in short, unlike the uncooperative and defeated Abd-el-Rahman, was a leader who triumphed as a cat's-paw of the French. The relationship between the two works, then, is much more concrete than some vague bond created by their compositional similarity—they are actually quite different in their structure—or the obfuscating umbrella category of Orientalism. For it is a concrete relationship of opposition or antagonism, political and ideological, that is at issue here. Indeed, if we consider all the other representations of North African subjects in the Salon of 1845—and there were quite a few—merely as examples of Orientalism, we inevitably miss their significance as political documents at a time of particularly active military intervention in North Africa. In other words, in the case of imagery directly related to political, diplomatic, and military affairs in the inspirational territory of Orientalism, the very notion of "Orientalism" itself in the visual arts is simply a category of obfuscation, masking important distinctions under the rubric of the picturesque, supported by the illusion of the real.

How then should we deal with this art? Art historians are, for the most part, reluctant to proceed in anything but the celebratory mode. If Gérôme ostensibly vulgarizes and "naturalizes" a motif by Delacroix, he must be justified in terms of his divergent stylistic motives, his greater sense of accuracy, or his affinities with the "tonal control and sense of values of a Terborch or a Pieter de Hooch."[27] In other words, he must be assimilated to the canon. Art historians who, on the other hand, wish to maintain the canon as it is—that is, who assert that the discipline of art history should concern itself only with major masterpieces created by great artists—simply say that Orientalists like Gérôme—that is to say, the vast majority of those producing Orientalist work in the nineteenth century (or who even appeared in the Salons at all)—are simply not worth studying. In the view of such art historians, artists who cannot be included in the category of great art should be ignored as though they had never existed.

Yet it seems to me that both positions—on the one hand, that which sees the exclusion of nineteenth-century academic art from the sacred precincts as the result of some art dealers' machinations or an avant-garde cabal; and on the other, that which sees the wish to include them as a revisionist plot to weaken the quality of high art as a category—are wrong. Both are based on the notion of art history as a positive rather than a critical discipline. Works like Gérôme's, and that of other Orientalists of his ilk, are valuable and well worth investigating not because they share the aesthetic values of great art on a slightly lower level, but because as visual imagery they anticipate and predict the qualities of incipient mass culture. As such, their strategies of concealment lend themselves admirably to the critical methodologies, the deconstructive techniques now employed by the best film historians, or by sociologists of advertising imagery, or by analysts of visual propaganda, rather than those of mainstream art history. As a fresh visual territory to be investigated by scholars armed with historical and political awareness and analytic sophistication, Orientalism—or rather its deconstruction—offers a challenge to art historians, as do many other similarly obfuscated areas of our discipline.

Notes

1. Organized by Donald A. Rosenthal, the exhibition appeared at the Memorial Art Gallery, University of Rochester (Aug. 27–Oct. 17, 1982) and at the Neuberger Museum. State University of New York, Purchase (Nov. 14–Dec. 23, 1982). It was accompanied by a catalogue-book prepared by Rosenthal. This article is based on a lecture presented in Purchase when the show was on view there.

2. Donald A. Rosenthal, *Orientalism: The Near East in French Painting 1800–1880* (Rochester, 1982), pp. 8–9, italics added.

3. The insights offered by Said's *Orientalism* (New York, 1978) are central to the arguments developed in this study. However, Said's book does not deal with the visual arts at all.

4. Driault, pp. 187 ff., cited in George E. Kirk, *A Short History of the Middle East* (New York, 1964), pp. 85–86.

5. J. F. B., "Gérôme, the Painter," *The California Art Gallery* 1–4 (1873): 51–52. I am grateful to William Gerdts for bringing this material to my attention.

6. Leo Bersani. "Le Réalisme et la peur du désir," in *Littérature et réalité*, ed. G. Genette and T. Todorov (Paris, 1982), p. 59.

7. Richard Ettinghausen in *Jean-Léon Gérôme (1824–1904)*, exhibition catalogue, Dayton Art Institute, 1972, p. 18. Edward Said has pointed out to me in conversation that

most of the so-called writing on the back wall of the *Snake Charmer* is in fact unreadable.

8. Roland Barthes. "L'Effet de réel," in *Littérature et réalité.* pp. 81–90.

9. Cited by Kenneth Bendiner, "The Portrayal of the Middle East in British Painting 1835–1860," Ph.D. Dissertation. Columbia University, 1979, pp. 110–11. Bendiner cites many other instances and has assembled visual representations of the theme as well.

10. See, for example, Bayle St. John's *Village Life in Egypt,* originally published in 1852, reprinted 1973, I, pp. 13, 36, and passim.

11. The best general discussion of Delacroix's *Death of Sardanapalus* is Jack Spector's *Delacroix: The Death of Sardanapalus,* Art in Context Series (New York, 1974). This study deals with the relationship of the work to Delacroix's psychosexuality, as well as embedding the painting in the context of its literary and visual sources. The footnotes contain references to additional literature on the painting. For other discoveries about Delacroix's use of Oriental sources, see D. Rosenthal. "A Mughal Portrait Copied by Delacroix," *Burlington Magazine* CXIX (1977): 505–6, and Lee Johnson, "Towards Delacroix's Oriental Sources," *Burlington Magazine* CXX (1978): 144–51.

12. Cabanel's *Cleopatra Testing Poisons on Her Servants* (1887) has been suggested to me by several (male) art historians as coming close to fitting the bill. But of course the scenario is entirely different in Cabanel's painting. First of all, the male victims are not the sex objects in the painting: it is their female destroyer who is. And secondly, the painting is, like Delacroix's, by a man, not a woman: again, it is a product of male fantasy, and its sexual *frisson* depends on the male gaze directed upon a female object, just as it does in Delacroix's painting.

13. For a rich and suggestive analysis of this myth in the seventeenth and eighteenth centuries, see Alain Grosrichard, *Structure du Sérail: La Fiction du despotisme asiatique dans l'occident classique* (Paris, 1979).

14. This is pointed out by Spector throughout his study, but see especially p. 69.

15. For public reaction to the picture, see Spector, pp. 75–85.

16. Cited in Fanny F. Hering, *Gérôme, His Life and Work* (New York, 1892), p. 117.

17. These issues are addressed in greater detail in "Manet's *Masked Ball at the Opera*"; see Chapter 5.

18. For a discussion of lesbian imagery in Orientalist painting, see Rosenthal, *Orientalism,* p. 98.

19. Claude Martin. *Histoire de l'Algérie française, 1830–1962* (Paris, 1963), p. 201.

20. Letter of February 29, 1832, *Correspondance générale de Eugène Delacroix,* A. Joubin, ed. (Paris, 1936), I, pp. 316–17.

21. Entry of March 11, 1850, *Journal de Eugène Delacroix,* ed. A. Joubin (Paris, 1950), I, p. 348.

22. Cited in Pierre Bourdieu. *The Algerians,* trans. A. C. M. Ross (Boston, 1962), pp. 120–21.

23. For an illustration of this work, now in the Musée de Versailles, and an analysis of it from a different viewpoint, see Albert Boime. "New Light on Manet's *Execution of Maximilian,*" *Art Quarterly* XXXVI (Autumn 1973), fig. 1 and p. 177 and note 9, p. 177.

24. For an extremely thorough account of the genesis of this painting, the various versions of the subject and the political circumstances in which it came into being, see Elie Lambert, *Histoire d'un tableau: "L'Abd el Rahman. Sultan de Maroc" de Delacroix*, Institut des Hautes Etudes Marocaines, no. 14 (Paris, 1953), pp. 249–58. Lee Johnson, in "Delacroix's Road to the Sultan of Morocco," *Apollo* CXV (March 1982): 186–89, demonstrates convincingly that the gate from which the sultan emerges in the 1845 painting is not, as is usually thought, the Bab Mansour, the principal gate to Meknes, but more likely is a free variation on the Bab Berdaine, which did not figure in the ceremonial occasion.

25. Rosenthal, *Orientalism*, pp. 57–58.

26. For information about Chassériau's portrait and its subject, see Léonce Bénédite. *Théodore Chassériau, sa vie et son oeuvre* (Paris, 1932) I, pp. 234 ff., and Marc Sandoz. *Théodore Chassériau, 1819–1856* (Paris, 1974), p. 101.

27. Gerald Ackerman, cited in Rosenthal, *Orientalism*, p. 80. Also see Ackerman, *The Life and Work of Jean-Léon Gérôme* (London and New York: Sotheby's, 1986), pp. 52–53.

4

Camille Pissarro:
The Unassuming Eye

"The gift of seeing is rarer than the gift of creating," Zola once remarked. Certainly, it is this rare gift, more than any other, which marks the work of Camille Pissarro (1830–1903). His long career encompasses the whole range of nineteenth-century French visual discovery, from Corot through Neo-Impressionism, and ends on the very brink of the Cubist rejection of perception as the foundation of art. Reversing the usual direction of the voyage of self-discovery, Pissarro fled his exotic but stultifying birthplace, Saint Thomas in the West Indies, for the stimulation of mid-century Paris and its infinitely civilized countryside, just in time to participate in the major artistic revolution of his epoch.

The present-day penchant for ferocity, single-mindedness, and ambiguity may stand in the way of a full response to an art at once so open and so limited as Pissarro's, unredeemed by either emotional undertow or technical bravura. The finished work reveals that Pissarro's self-effacement before the motif was at times truly remarkable. In the late 1860s and early 1870s, with a modesty matched only by that of his first master, Corot, he produced a series of landscapes so disarming in their unassailable visual rectitude, so unforced in execution and composition, that Cézanne said of them in later years: "If he had continued to paint as he did in 1870, he would have been the strongest of us all."[1] Cézanne's remark reminds us that Pissarro was endowed not only with the gift of seeing but with the even rarer ability to make other artists see for themselves: Cézanne,

Gauguin, and van Gogh bear witness to the effectiveness of Pissarro as a teacher, or rather, one whose very presence in the vicinity of the chosen motif might serve as a catalyst, a liberating agent for the act of visual response, freed both from traditional *poncif* and subjective distortion. Nor was his role forgotten: Gauguin hotly defended his former master's "intuitive, purebred" art against charges of derivativeness as late as 1902, and the old, already venerated Cézanne, in an exhibition at Aix in 1906, the year of his death, had himself listed in the catalogue as "Paul Cézanne, pupil of Pissarro." More than any other Impressionist, Pissarro remained faithful to the basic tenets of the group as they were formulated during the high point of the 1870s—he was the only one to participate in all eight Impressionist exhibitions—and to the end, he maintained his faith in natural vision as the guiding principle of art.

But this is far too simple and unproblematic a formulation of both the revolutionary nature of the Impressionist enterprise and Pissarro's specific contribution to it. Seeing, for a painter, must always involve a simultaneous act of creation if there is to be a work of art at all, and in any case, "la petite sensation," the whole notion that it is possible to divorce seeing from its cognitive, emotional, and social context is as idealistic, in its way, as any classical norm. The idea that there can be such a thing as a neutral eye, a passive recorder of the discrete color sensations conveyed by brilliant outdoor light is simply an element of Impressionist ideology, like their choice of "ordinary" subjects and "casual" views, not an explanation of the style itself. After all, the difference between what Vermeer "saw" when he looked out of his window in Delft in the seventeenth century and what Pissarro "saw" when he looked out of his in Rouen in the nineteenth can hardly be laid to mere physical differences like optic nerves and climate on the one hand, nor to willful distortion of the visual facts on the other. Yet the same light that crystalized and clarified forms on a surface of impeccable, mirrorlike smoothness in the *View of Delft* seems to have blurred and softened them on Pissarro's crusty, pigment-streaked canvas. What an artist sees, as revealed by the evidence of the painted image, would seem to depend to an extraordinary degree on *when* he is looking and *what* he has chosen to look at.

For Pissarro, a convinced and professing anarchist, Impressionism was the natural concomitant of social progress, political radicalism, belief in science rather than superstition, individualism, and rugged straightforwardness in personal behavior. His lifelong insistence on art as truth to

immediate perception, his faith in "les effets si fugitifs et si admirables de la nature"[2] were intimately related to his commitment to the progressive nineteenth-century belief in human and physical nature as basically good, corrupted only by a repressive and deceiving social order, by prejudice and obscurantism. Impressionism sought to restore the artist to a state of pristine visual innocence, to a prelapsarian sense-perception free of the a priori rules of the academy or the a posteriori idealization of the studio. Courbet professing ignorance of the subject recorded by his brush, Monet wishing that he had been born blind, Pissarro advising his artist son, Lucien, not to overdevelop his critical sense but to trust his sensations blindly—all testify to the same belief that natural vision is a primary value in art, and can only be attained through a process of ruthless *divestment* rather than one of solid accumulation, a rejection of past traditions rather than a building upon them.

Pissarro, in the course of one of the heated discussions of the young rebels at the Café Guérbois, once declared that they ought to "burn down the Louvre,"[3] surely the most extreme statement of its kind until the Futurist manifestos of the twentieth century. "L'Impressioniste," wrote the poet Jules Laforgue in a remarkable article of 1883, "est un peintre moderniste qui . . . oubliant les tableaux amassés par les siècles dans les musées, oubliant l'éducation optique de l'école (dessin et perspective, coloris), à force de vivre et de voir franchement et primitivement dans les spectacles lumineux en plein-air . . . est parvenu à se refaire un oeil naturel, à voir naturellement et à peindre naïvement comme il voit."[4] Painting becomes a continual search and learning to paint the often agonizing process of a lifetime, not a set of rules to be mastered in a series of graduated stages within an academy. The rejection of "values" as the basis of painting in the progressive art after Corot can thus be interpreted both in the pictorial sense of an abandonment of under-painting—a fixed, hierarchical scheme of abstract light-and-shade predetermining the final "meaning" of the work—and at the same time, as the rejection of the social, moral, and epistemological structures which such a pictorial scheme presupposes. As such, it has constituted a permanent rejection on the part of avant-garde art right down to the present day.

Like the other Impressionists, and more strongly than some of them, Pissarro was convinced that what the purified eye must confront was contemporary appearance. "[Nous devons chercher] des éléments dans ce qui nous entoure, avec nos propres sens," he wrote to Lucien in 1898. "Et

l'on ne travaille dans ce sens qu'en observant la nature avec notre propre tempérament moderne. . . . C'est une erreur grave de croire que tous les arts ne se tiennent pas étroitement liés à une époque."[5] This sensitivity to the quality of his own time is evident in Pissarro's work as early as 1866, when a critic remarked on his landscape in the Salon of that year, *Bords de la Marne en hiver* (Banks of the Marne, Winter)[1] that "M. Pissarro n'est pas banal par impuissance d'être pittoresque" and has used his robust and exuberant talent specifically "à faire ressortir les vulgarités du monde contemporain." Zola commented on the harsh veracity of the same work, and of a similar view in the Salon of 1868, exclaimed: "C'est là la campagne moderne." One is often aware of the more or less discreet encroachments of industrialization in Pissarro's landscapes: a smokestack appears as early as 1868 and there is a fine group of paintings of factories in 1873. Pissarro sees them neither as dark, satanic mills nor as harbingers of technological progress, but simply as elements, neither denied nor unduly emphasized, within an admirable, contemporary pictorial motif.

When he sought refuge in London from the rigors of the Franco-Prussian War, he chose to paint, forthrightly, with a sprightly, unromantic verve, that emblematic structure of modernity, the Crystal Palace, not

1. Camille Pissarro, *Bords de la Marne en hiver* (Banks of the Marne, Winter), 1866, Chicago, Art Institute of Chicago, Mr. and Mrs. Lewis Larned Coburn Memorial Fund

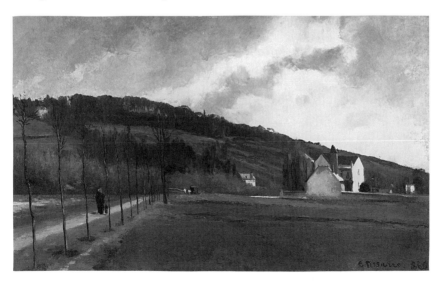

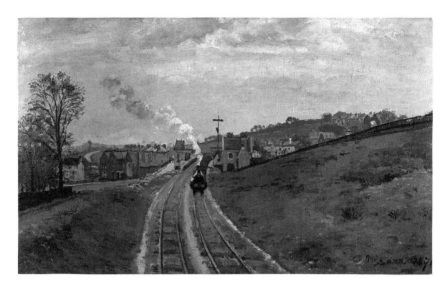

2. Camille Pissarro, *Lordship Lane Station, Upper Norwood, London*, 1871, London, Courtauld Institute Galleries

just once but twelve times over. His vision of the railroad there is not visionary and excited like Turner's *Rain, Steam and Speed: The Great Western Railway*, but direct, vivid, matter of fact[2]. Yes, the tracks cut a path through the bosom, as it were, of nature. No, this is not horrific or menacing, but part of the modern given, how things are in the industrial world.

Yet, while he never said it in so many words, and generally insisted on equating Impressionist vision with scientific progress, human value and left-wing politics, Pissarro could not have failed to have been aware of the basically subjective, almost solipsistic bias with which Impressionism might be afflicted. The "petite sensation," the basis of Pissarro's art, while it made for the richness and range of individual styles within the Impressionist gamut, could also lead to fantasy and exaggeration—in short, to precisely that self-indulgent mysticism which Pissarro found so abhorrent and reactionary. What one might be painting might not be nature, not wholesome, everyday reality, but a shifting, floating, evanescent, even deceptive, veil of maya. Laforgue found this *symboliste* aspect of Impressionism much to his taste: the impossibility of attaining a stable, unequivocal reality, the inevitable exaltation of the individual sensibility

at a unique moment in time. "Même en ne restant que quinze minutes devant un paysage, l'oeuvre ne sera jamais l'équivalent de la réalité fugitive, . . ." Laforgue wrote. "L'objet et le sujet sont donc irrémédiablement mouvants, insaisissables et insaisissants."[6] Pissarro, one imagines, did not feel easy with this aspect of the movement.

It was perhaps for this reason, among others, in the middle 1880s, when the Impressionist impulse was at a low ebb and the group itself disintegrating as a coherent entity, that Pissarro took temporary refuge in the solid theoretical basis and apparently universal objectivity of Neo-Impressionism, adopting the "scientific" color-division and painstaking, dotted brushwork of the young Seurat when he himself was fifty-five years old. The Neo-Impressionist affinity for the systematized and the socially progressive might also have been tempting at this time, as a comparison of the 1889 painting *Les Glaneuses* with some of Pissarro's earlier, less consciously monumental representations of peasants in landscapes would reveal. At this moment, he refers to the orthodox Impressionists as "romantic" (to differentiate them from his new, "scientific" colleagues), and criticizes Monet's work of 1887 as suffering from a "désordre qui ressort de cette fantaisie romanesque qui . . . n'est pas en accord avec notre époque."[7]

Pissarro's whole series of paintings of peasant women in the decade of the 1880s raises certain interesting social and stylistic issues. Certainly, as Richard Brettell has pointed out, it is Degas who stands behind Pissarro in his renewed concentration on the expressive potential of the human figure in these paintings (as opposed to earlier ones, where they are just staffage) and doubtless, as Brettell says, it was Degas's images of the working women of Paris that provided a new repertory of poses, gestures, and viewpoints;[8] I think Degas's ballet dancers also figured in this process.

A few years before he painted *Les Glaneuses,* in the early to mid-1880s, Pissarro's resolute modernity, his intention not to sentimentalize but to be of his times, is evident in his choice of the theme of the peasant woman in the marketplace rather than the more traditional topos of the peasant woman working in fields or nourishing her young[3]. These more traditional peasant themes evoke the connection of the peasant woman with the unchanging natural order. Pissarro's market woman, on the contrary, clearly demonstrates that the peasant woman like the rest of humanity and, perhaps in a heartfelt way, like the artist in particular has to hustle her wares for a living. The country woman is envisioned by Pissarro as an active and

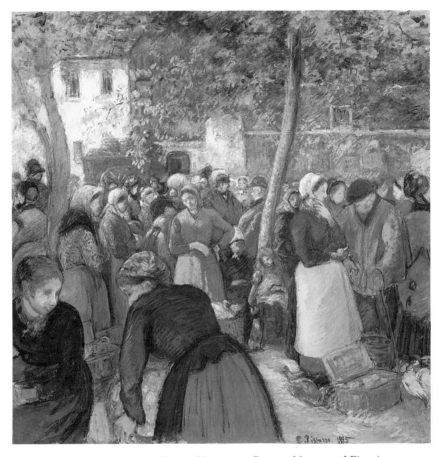

3. Camille Pissarro, *Poultry Market at Gisors,* 1885, Boston, Museum of Fine Arts, Bequest of John T. Spaulding

individuated force in contemporary economic life rather than as a generalized icon of timeless submission to nature. At the same time, town and country are seen to interact in the modest arena of commerce—briskly, not darkly—rather than being idealized as opposing essences.

One can see differences in a comparison of Pissarro's and Millet's *Les Glaneuses.* Pissarro has, in a sense, responded to the challenge of Millet by demystifying Millet's image, making it more irregular and variegated; by having one woman stand up in an assertive and dominating pose and talk to another, he refuses the identification of woman and nature suggested

by Millet's composition. In the same way, Pissarro's *Paysans dans les champs, Eragny-sur-Epte* of 1890 seems to be a contemporary, up-to-date reinterpretation of the generalized pieties of Millet's *L'Angélus*. There are ways in which Pissarro's *Les Glaneuses* reminds one of the self-conscious multiplicity of poses and variations of Jules Breton's *Le Rappel des gla- neuses* of 1859, although he has staunchly refused both Breton's glamoriza- tion of his subject and the slick, fussy detail of his style.

Still, one does not feel that either the ambitious monumentality or the systematic paint application of Neo-Impressionism have been satisfac- torily assimilated by Pissarro. The ghostly example of *La Grande Jatte* [see Figure 1, Chapter 9] lies in the background of works like the 1889 *Les Glaneuses* and accounts for its inner contradictions. The Seurat-inspired self-consciousness of the composition—rationalized brushwork, clarifying light, and measured space—clashes with the spontaneous irregularity of Pissarro's figure style. Missing is that harmonious regularity of contour and volume with which Seurat had united his figures with their setting. The demands of systematization and the delights of informality; the coun- tering signs of the colloquial and the monumental are left unresolved in Pissarro's paintings.

The same contradictions, redeemed by a more interesting decorative effect, mark another major Neo-Impressionist work, *La Cueillette des pommes, Eragny-sur-Epte* (Apple-Picking)[4] of 1888. It is hard to escape certain allegorical significations of the theme itself in this painting, for the tree is deliberately, and apparently meaningfully, centralized and the composition regularized as though to insist upon its metaphorical status. The motif of fruit-picking with symbolic overtones becomes a kind of fin-de-siècle leitmotif. It is picked up in Mary Cassatt's 1893 mural for the Chicago World's Fair, *Allegory of Modern Woman*, a work which is more overtly utopian in its resonance than Pissarro's *La Cueillette des pommes:* the women are represented plucking the fruits of knowledge. And certainly "utopian" is the word to describe Signac's social allegory, featuring a worker plucking fruit from a tree, *Au Temps d'Harmonie*, painted for the town hall of Montreuil in 1895. [See Figure 4, Chapter 9.] And, in a very different mood, fruit-picking figures as the central motif of Gauguin's dark allegory of human existence, *D'Où venons-nous? Que sommes-nous? Où allons-nous?* of 1897.

Yet Pissarro's work, neither before nor after what Rewald has termed

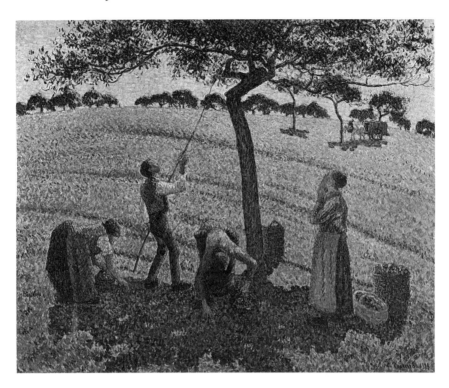

4. Camille Pissarro, *Apple Picking, Eragny-sur-Epte*, 1888, Dallas, Museum of Art,
Munger Fund

his "divisionist deviation," was never really threatened by the dissolution
of objects into webs of broken color. In his *Boulevard Montmartre, mardi-
gras* [5], for example, one of a series of city vistas of 1897, there is a sense
of lively, all-over surface activation, merging people, buildings, and bud-
ding trees in a carnival atmosphere of colored movement, somewhat remi-
niscent of Monet's dazzling *La rue Montorgueil fête du 30 juin* of 1878, and
illustrating his own advice to a young artist of the very year it was painted:
"Ne pas faire morceau par morceau; faire tout ensemble, en posant des
tons partout. . . . L'oeil ne doit pas se concentrer sur un point particulier,
mais tout voir. . . ."[9] But at the same time, Pissarro's brush scrupulously
maintains the individual rights of separate forms, substances, and textures
within this context of unifying atmosphere, differentiating with staccato
touches the crowd at the right from the longer, more continuous strokes
of the procession in the background, and distinguishing by feathery,
diaphanous swirls the tops of the trees from the solid rectangular patches

of the kiosks beneath them, marking off the latter in turn from the more fluid, less substantial rectangles of chimneys and attics.

It was perhaps his feeling for things, his commitment to nature and human value, rather than theory or an innate sense of form which protected him, or limited his power of invention, according to how one chooses to look at it. Pissarro was never, as was Monet (or as the Monet mythology would have it) in his later years, forced into near-abstraction by the urgency of an obsessive chase after the wild goose of the *instantané*; for Pissarro, the vision of nature always implied a point of view, a certain distance, a beginning, a middle, and an end within a given canvas. One might even say (as one never could of the tormented old Monet, hovering feverishly over his ninety canvases in the Savoy Hotel in London, searching for exactly the right patch in exactly the right canvas for this particular instant of light), that Pissarro accepted nature's calm quiddity as simply

5. Camille Pissarro, *Boulevard Montmartre, mardi-gras*, 1897, Los Angeles, The Armand Hammer Collection

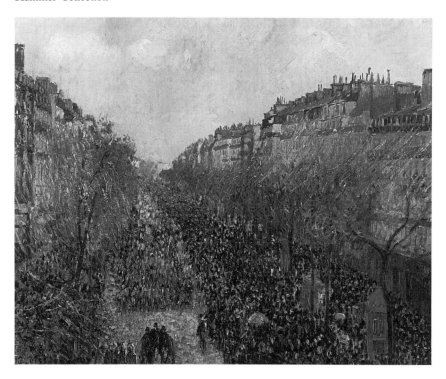

more *possible* for the painter than the perpetual flow of her random splendor, more appropriate to his temperament and the nature of his task than a dizzying descent into the heart of process at the bottom of a lily pond. If one compares Pissarro's view of Rouen Cathedral[6] with one of Monet's famous Rouen *Façades* of the previous years, one immediately sees that while Monet completely identifies pictorial motif and painted object, dissolving the architectonic façade of the actual building in light, and then petrifying his sunset sensations into a corrugated, eroded pigment-facade, Pissarro has effected no such alchemical metamorphosis. Thoroughly familiar with Monet's series, which he had admired at Durand-Ruel's, he deliberately chose a more panoramic, less destructive view. "Tu te rappelles," he wrote to Lucien, "que les *Cathédrales* de Monet étaient toutes faites avec un effet très voilé qui donnait, du reste, un certain charme mystérieux au monument. Mon vieux Rouen avec sa Cathédrale

6. Camille Pissarro, *The Roofs of Old Rouen, Gray Weather (The Cathedral)*, 1896, Toledo, Ohio, The Toledo Museum of Art, Gift of Edward Drummond Libbey

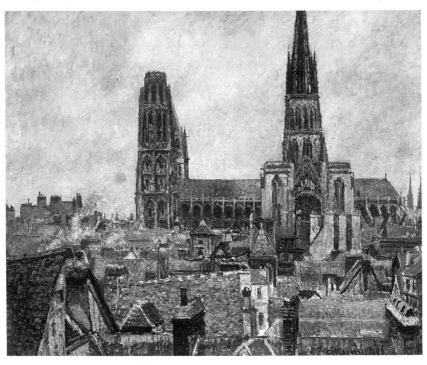

au fond est fait par temps gris et assez ferme sur le ciel. J'en étais assez satisfait; cela me plaisait de la voir se profiler grise et ferme sur un ciel uniforme de temps humide."[10] In Pissarro's painting, Rouen Cathedral remains Rouen Cathedral, paint remains paint, and both depend on the eye and hand of the painter, situated at a certain determinable point of distance from his motif.

The ultimately liberating implications of Impressionism, its freeing of the artist to establish a system of independent relationships of form and color on the canvas were obviously foreign to Pissarro's conception of it. Like others of his time, he saw Gauguin's synthetist symbolism and the decorative abstraction of the Nabis as rejections of Impressionism, rather than extensions of its inherent possibilities. Gauguin, with his turning away from natural perception in favor of "mysterious centers of thought" and his quasi-religious predilections, he considered an apostate if not an outright charlatan. "Je ne reproche pas à Gauguin d'avoir fait un fond vermillon . . . ," he wrote in 1891, "je lui reproche de ne pas appliquer sa synthèse à notre philosophie moderne qui est absolument sociale, anti-autoritaire et anti-mystique. . . . Gauguin n'est pas un voyant, c'est un malin qui a senti un retour de la bourgeoisie en arrière. . . ."[11]

In the last years of his life, a bent but indefatigable old man with a prophet's beard and ailing eyes, he returns to the deep perspectives and apparently spontaneous perceptions characteristic of the Pontoise land-scapes of the 1870s, but this time, chooses to immerse himself in the variegated motifs offered by the boulevards and avenues of Paris[7]. How little sense there is of the grimness of urban reality in these panoramas, viewed, generally rather distantly, from the height of a hotel window! It is not that the painter has avoided the issue, it is just that what he sees before him is anything but grim. "Ce n'est peut-être très esthétique," he writes to Lucien near the turn of the century, "mais je suis enchanté de pouvoir essayer de faire ces rues de Paris que l'on a l'habitude de dire laides, mais qui sont si argentées, si lumineuses et si vivantes. . . . C'est moderne en plein!"[12] *Allées* of trees are now replaced by vistas of stone façades, peasants by pedestrians, hedgerows by carriages, cabbage fields by cobblestones, or, at times, nature is permitted to intrude, mingle with, enrich the cityscape. Although these late Parisian street scenes are uneven in quality, in the best of them there is an invigorating achievement of freshness, consummate control and freedom. In the *Pont Royal et Pavillon de Flore*, painted during the last year of the artist's life, a sense of vernal

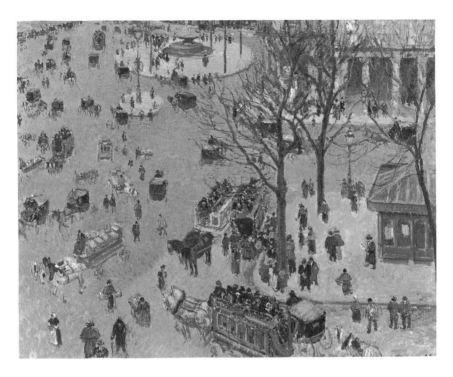

7. Camille Pissarro, *Place du Théâtre français,* 1898, Los Angeles, Los Angeles County
Museum of Art

lightness arises from the delicate balance established between the demands
of the motif—sprightly, wavering openness of the central tree, calm hori-
zontal curve of the bridge, diagonal of facades on the opposite bank—and
those of pictorial unity, the latter created by an all-over high-keyed pastel
palette and the granular consistency of the surface texture.

Looking at this group of late cityscapes as a whole, no matter how we
evaluate them—and certainly, they are not masterpieces in the usual sense
of the term—we nevertheless tend to accept them as authentic records of
how things looked, how things *were* in Paris at the turn of the century.
Perhaps this is because they coincide so neatly with our own view of how
Paris was—or even, if we are unabashedly romantic and Francophile, of
how Paris is. Pissarro has created an imagery of liveliness rather than
urban hysteria; of spontaneity rather than confusion; of pleasurable ran-

domness within a setting of spacious order rather than alienation in an oppressively crowded chaos.

Yet Pissarro's vision of a motif like the Pont Neuf is as determining and chosen as any other: it is no more "real" Paris than, say, the photographer Hippolyte Jouvin's cooler and more utilitarian stereoscopic photograph of the same motif—the Pont Neuf of 1860–5. It involves a certain notion of the nature of the modern city itself and the artist's relation to it.

Nor is Pissarro's vision of urban reality any more privileged than Gustave Doré's melodramatic, exaggerated perspective of workday London in 1872, which emphasized the feverish pressure of a crowd in a blocked, funnellike space rather than easy recession. By "vision" I of course mean the social and psychological assumptions controlling vision at any moment in history as well as aesthetic decisions about vantage point, distance, or placing of the image within the frame. It is precisely the difference in these assumptions which, of course, makes Caillebotte's urban imagery in his *Boulevard vu d'en haut* of 1880 so different from Pissarro's boulevard paintings: so much more distanced, arbitrary-seeming, and aestheticized. And it is obvious that Pissarro was incapable of experiencing or setting forth the city as a projection of menacing alienation, as had Munch in 1889.

Pissarro's particular unstrained and accepting modality of urban vision had to do with a kind of freedom which he thought of as freedom of perception. We are, perhaps, more cynical about the possibilities of individual freedom, or, alternatively, conceive of freedom—artistic freedom at any rate—in more grandiose terms. But confronting some of these later urban vistas of Pissarro one feels ready to revise, no matter how little, one's twentieth-century prejudices about the nature of freedom in art, prejudices about the necessarily *extreme* character of all choice. Perhaps one can be relatively free without self-conscious rebellion or dramatic gestures, free like Pissarro to trust one's own unassuming but unacerbated intuitions of truth and reality. For the old anarchist, freedom in this unspectacular sense seems to have been the essential condition of painting, of seeing; perhaps of living. "Il faut de la persistence, de la volonté et des sensations *libres,* " he wrote, well on in years and neither very rich nor very famous, "dégagées de toute autre chose que sa propre sensation."[13]

Notes

This is an expanded and revised version of an article that was originally published with the same title in *ARTnews* LXIV (April 1965), pp. 24–27 and 59–62. Thanks are due to the editor of *ARTnews* for permission to reprint the article in this way.

1. Letter from Cézanne to the painter Louis LeBail; cited by John Rewald, *The History of Impressionism*, rev. ed. (New York: The Museum of Modern Art, 1962), p. 536.

2. Pissarro to H. van de Velde, March 27, 1896 as quoted in J. Rewald, *L'Histoire de l'impressionnisme* (Paris, 1955), pp. 329–30.

3. Pissarro as cited in J. Rewald, *Camille Pissarro* (New York, 1963), p. 18.

4. *Oeuvres complètes de Jules Laforgue, Mélanges posthumes*, 3rd ed. (Paris, 1903), p. 133.

5. Camille Pissarro, *Lettres à son fils Lucien*, ed. J. Rewald (Paris, 1950), pp. 451 and 459 (March 7, 1898, and August 19, 1898).

6. Laforgue, op. cit., pp. 140 and 141.

7. *Lettres à son fils Lucien*, pp. 111 and 124 (November 1886 and January 9, 1887).

8. *Camille Pissarro 1830–1903*, London (Hayward Gallery), Paris (Grand Palais), Boston (Museum of Fine Arts), 1980–81, p. 29.

9. From the unpublished private notes of the painter Louis LeBail, who received Pissarro's advice during the years 1896–97, as quoted in Rewald, op. cit. (1955), pp. 279–80.

10. *Lettres à son fils Lucien*, p. 403 (March 24, 1896).

11. Ibid., pp. 234–35 (April 20, 1891).

12. Ibid., p. 442 (December 15, 1891).

13. Ibid., p. 291 (September 9, 1892).

5

Manet's
Masked Ball at the Opera

On April 12, 1874, the Salon jury rejected Manet's *Masked Ball at the Opera*[1]. It is not difficult to see why. Even today, this painting attracts and disturbs almost equally. More disconcertingly, what attracts us in the *Ball* is exactly what disturbs us about it: its mixture of brutality and sensuality; the way it manages to suggest coarseness with infinite refinement; the way the nostalgic frivolity of the Rococo masked ball is recast in the up-to-date, down-to-earth language of the bourse, the boulevardier, and the cocotte. Only one year earlier, Manet had used a similar compositional structure—a back-view figure with raised arms confronting a random group facing out of the picture space—in his lithograph *The Barricade,* a pictorial record of the execution of a Communard. Although the Salon jury probably only sensed this coincidence, there is a confrontational energy to the painting that at this particular moment in history could easily have been interpreted as a subliminal threat.

Ball at the Opera refused—and still refuses—to comply with the conventional view of its subject, with notions like "merrymaking," "gay abandon," or "lighthearted revelry." Such notions account for only part of its impact. The avidity of its gestures, the close-up concentration of its format, the all-embracing darkness of its color scheme—all this seems to point to a more complex range of experience and sensibility. One contemporary chronicler wrote of the moist lips and sensual eyes of the men, "alight with truffles and Corton"—men who, in the words of the same

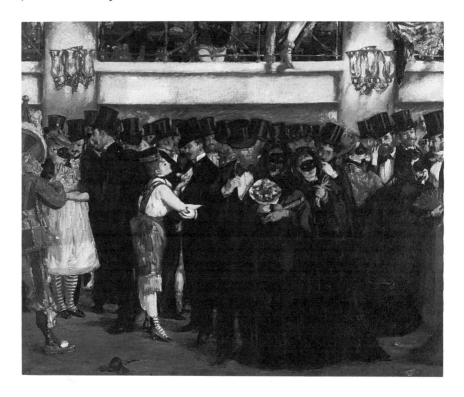

1. Edouard Manet, *Masked Ball at the Opera*, 1873, Washington, D.C., National Gallery of Art, Gift of Mrs. Horace Havemeyer in memory of her mother-in-law, Louisine W. Havemeyer

writer, "are rich . . . with pockets full of *louis d'or.* "[1] The twentieth-century German critic Julius Meier-Graefe, who loved the painting but never minced words, called it a *Fleischbörse*—a flesh market.[2] It was no doubt these connotations, as well as the apparent recognizability of several of the men-of-the-world who had posed for the painting, that made the jury of 1874, which had accepted Manet's *Railroad* and his watercolor *Polichinelle*, balk at *Ball at the Opera*. Neither moralizing nor trivializing his subject, Manet reveals sexual commerce all too openly, constructing the inextricable mingling of business and pleasure in a variety of literal and figurative disguises—all this in a painting that itself plays seriously with strategies of disguise and recognition.

As in so many of Manet's most important paintings, women—

marginal, equivocal, unclassifiable, or all-too-classifiable—lie at the heart of the critical Realism of *Ball at the Opera* and its modern, urban, explicitly Parisian imagery. In a way, *Ball at the Opera* stands to the folklore of the city as Courbet's *Burial at Ornans* stands to the folklore of the country. Both works use the very currency of social clichés—in the Manet, about the relation of the sexes; in the Courbet, about the relation of classes—against themselves, in order to deconstruct them, undermine their authority.

Although it is a relatively small painting (59 × 72.5 cm), the *Ball at the Opera* merits serious investigation. Manet's friend and admirer the poet Stéphane Mallarmé, protesting the painting's exclusion from the Salon in an indignant letter to the press, declared that it was "of capital importance in the painter's work and a culminating point within it, summing up many previous efforts."[3] Manet's friend and biographer Théodore Duret emphasized the amount of time the artist spent on the painting.[4] The work was begun after March 1873, when Manet probably attended the *bal des artistes* which followed the annual masked ball at the Opera House on the rue Le Peletier; it was still unfinished on November 18, when the singer Faure bought it; it must have been completed in time to be refused by the jury of the Salon in April of the following year. Manet's preparatory studies for the work include two oil sketches of the subject, several related watercolors, and possibly three or four drawings as well.[5]

Although the painting is usually referred to as *Masked Ball at the Opera*, only the women are actually masked and wearing fancy dress; the men wear ordinary evening clothes. The only exception is the partially visible figure of Polichinelle, cut off by the frame at the left, who seems more like an observer than a participant. The cast of characters includes about five or six women, all masked or shrouded in black dominoes except for the trousered figure left of center, and about two dozen top-hatted *hommes du monde*. At far left, a group of men surrounds a young woman dressed as Columbine; left of center, a girl *en débardeuse*—the longshoreman's costume popularized by Gavarni in his print series earlier in the century—talks intently to a man who holds her by the elbow. Behind this couple, a single, provocative white-stockinged leg announces the presence of another *débardeuse*, hidden by the encircling darkness of masculine evening dress.

At center, almost disappearing into the general blackness of the men's

clothes, two women in masks and black dominoes stand together, facing out. One holds a big bouquet, an orange, and a fan; both seem to be flirting with the men to their right and left. Next to this group and slightly behind it, a masked, costumed woman places her hand on the shoulder of a top-hatted man. At far right, almost invisible but arresting in its intimacy and *désinvolture* once you notice the group, there is a masked, dominoed woman leaning over, her chin in her hand; her elbow rests on the knee of a man seated on what may be a bar, while he gazes down with playful absorption at her upturned face.

Around the room, on the floor, is the detritus of frenetic merrymaking: a mask, some flower petals, and, in the right foreground, a little dance program with Manet's signature. On the balcony above, cut off by the painting's top margin, is the torso of one scantily clad woman; the leg of another, along with her red sash; and the shawl of a third.

Finished in the year of the first Impressionist show (1874), the *Ball* seems in some ways related to the sensibility of Impressionism, even though Manet chose never to exhibit with the group. Radically modern and provocatively Realist in both structure and subject, *Ball at the Opera*, like so many of Manet's most interesting pictures, hints at older art, but more in terms of what it rejects—its refusal of tradition—than what it accepts from it. The same might be said of its attitude toward the subject of the masked ball itself, which has a long career in the history of art, continuing into the nineteenth century primarily in the works of caricaturists like Gavarni, Doré[2], and Alfred Grévin.[6] But Manet recasts this subject in terms of a particular kind of astringent sensuality to produce a poignant yet witty—and thoroughly modern—vision of the subject, one that is rooted in a particular time and place.

The artist's vision oscillates between that of a participant in the scene and that of an observer of it. Manet's self-conscious awareness and deliberate articulation of both his own Parisian modernity and a contemporary problematic of eroticism is manifested in the picture's construction. The cut-off view of the scene substitutes part for whole, implying instantaneity and arbitrariness; but the provocatively fragmented figures at the edges of the work do not merely suggest a continuing reality beyond the frame; they also allude to the nature of the transactions going on within it.

For Manet, synecdoche, or the substitution of part for whole—which, according to the linguist Roman Jakobson, was central to the literary

2. Gustave Doré, *Loups,* 1860, Paris, Bibliothèque Nationale

imagery of nineteenth-century Realism[7]—constituted an important strategy of pictorial invention as well, a way of avoiding the closure imposed by traditional narrative compositional devices. This fragmentary aspect of the work of Manet and of the Impressionists in general disturbed many members of the contemporary public, who associated these artists' substitution of part for whole with an inability to compose properly, to "finish" their pictures. At the same time, it was paradoxically associated with willfulness and deliberate provocation.

The theme of the *Ball at the Opera* can be related to a variety of Manet's preferred subjects, especially to his many representations of women of the theater and the demimonde, the courtesan, or the prostitute, sometimes with a male admirer present or suggested, as in *Olympia* or, later, *Nana.* It can also be related to his contemporary Parisian scenes of recreation and enjoyment, like *Music in the Tuileries*[3], and to his various paintings of bars and cafés, culminating in *Bar at the Folies-Bergère.* Disguise, whether fancy dress, travesty, or outright theatrical costume, is an ambiguous constant in his work, in both the costume portraits of Léon Koëlla dressed up in seventeenth-century costume in the *Boy with a Sword*

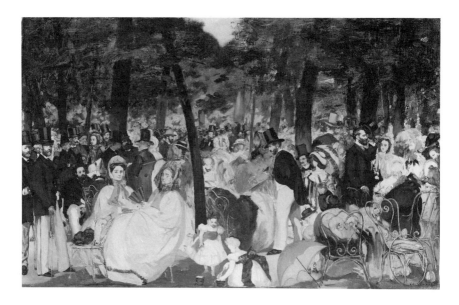

3. Edouard Manet, *Music in the Tuileries,* 1862, London, The National Gallery

and of Victorine Meurent *en travesti* as an espada, and the more straight-forwardly costumed theatrical portraits, like those of Philibert Rouvière or Faure as Hamlet, or Emilie Ambre in the role of Carmen.

The particular dress-up situation associated with the commedia dell'arte, and with the figure of Polichinelle in particular, was manifested in Manet's work as early as 1862, in a frontispiece etching in which Poli-chinelle may well stand in for the artist.[8] It attracted him again in 1873, the same year that he worked on *Ball at the Opera,* in which Polichinelle plays a role. That year, Manet created several independent versions, in a variety of mediums, of this commedia figure: two variations in oil, a watercolor, and a seven-color lithograph.[9] Obviously, though, it was not Manet's choice of theme but the inventive structure of *Ball at the Opera* that called forth Mallarmé's defense of the work as the culminating point in his friend's career. In the boldness of its cuts, above and to the left, the *Ball* seems the most vivid example yet of Manet's "slice of life" vision, his conception of this particular group of foyer strollers and their companions signifying a larger and more extensive world beyond the painting's boundaries. To borrow the words of Mallarmé, who perfectly grasped the unusual coincidence of the casual and the deliberate in Manet's pictorial

vision, the artist discovered a new "manner of cutting down pictures" so that the frame has "all the charm of a merely fanciful boundary, such as that which is embraced by one glance at a scene framed by one's hands."[10]

The cut-off view was certainly not Manet's invention, nor was it his exclusive property. Daumier had cut off the heads of his classical hero and heroine in *The Orchestra During a Performance of a Tragedy* (1852) in order to create an ironic antithesis between the high-flown, "timeless" world of classical drama and the workaday boredom of the members of the orchestra in the foreground pit. The cut-off view became a standard feature of Impressionist composition in the 1870s and was frequently related to the Impressionists' innovative, spontaneous vision of modern life, as well as to such novel sources of inspiration as photography and the Japanese print.[11] Cut-off compositions appear in Manet's work throughout his career. Quite early, in 1862, in *Music in the Tuileries*—a work which seems related to *Ball at the Opera* in a variety of ways—he slices off half of his own figure at left. In *Old Musician* of the same year, he cuts off half of the figure of the old Jew with the righthand margin.

A more elusive—and provocative—kind of cut-off occurs in Manet's 1868 *Portrait of Emile Zola* [4], in which a reproduction of his own work, *Olympia*, appears in altered form. Not only do the eyes of the reproduced *Olympia* swerve toward the sitter, as though in gratitude for his defense of her reputation,[12] but the margin of the photograph within the painting has itself been cropped on the right immediately against the body of the black cat, which almost disappears into the background rather than standing out with memorable perversity, as in the original. The cut-off is a way of making the *Olympia* in the Zola portrait more modest, less sexually charged in the presence of her knight-at-arms. The rather prim Zola had stoutly denied that *Olympia* was in any way obscene or sexually provocative. It is certainly possible that Manet, an inveterate *blagueur*, substituted a chastened as well as a grateful Olympia for the original—a private visual joke between himself and his friend.

More overt examples of partial figures with sexually suggestive overtones occur later in Manet's career. In *Nana* [5], for example, from 1877, half a top-hatted man observes a seductively half-dressed young woman at her toilette. In the *Woman Serving Beer* of 1879, a working-class man in a blouse gazes toward a tantalizingly fragmentary view of a female performer.

4. Edouard Manet, *Portrait of Emile Zola,* 1868, Paris,
Musée d'Orsay

However, the cut-offs in the *Ball at the Opera* assume their particular
significance only within the context of the work itself. That context is
deliberately contemporary and concrete—but more concrete in some as-
pects than in others. The setting, for example, is highly specific: the scene
takes place not in the *salle,* or auditorium, but rather in the promenade,
or gangway, behind the boxes of the Opera on the rue Le Peletier—which,
in fact, burned down the very year Manet painted the picture.

Manet also carried veracity to an extreme in his depiction of the male
figures. Duret, who served as a model himself, assures us in his biography
of the painter that the models were all "men of the world," Manet's friends
and acquaintances, and that the artist insisted that they keep their habitual

5. Edouard Manet, *Nana*, 1877, Hamburg, Kunsthalle

postures and expressions. "The men," Duret writes, "have their hats placed on their heads in the most varied ways possible. This was not the result of an imaginative arrangement but actually of the way all these men really wore their hats. Manet asked them, 'How do you put on your hat when you're not thinking about it? All right—when you pose, put it on that way, without premeditation.'" So anxious was Manet to capture real life, Duret continues, that he used a different model for each of the supernumeraries in the back row, even though only a part of a head or a shoulder might be visible.[13]

Although specific individuals have been cited as models for the men in the painting, Manet's male figures stubbornly "resist identification," to borrow Françoise Cachin's apt phrase. Matching names with faces has proved, as so often in the artist's work, to be a slippery business. The bearded man at the far left is usually identified as the composer Emmanuel Chabrier, on the basis of one of two portraits Manet did of him in 1880, as well as a little head of the composer in a Degas painting. Cachin, however, has recently disputed this identification; she sees Chabrier in the dark, bearded man to the right under the chandelier.[14] The fact is, in evening dress one bearded man tends to look rather like another.

The crowd also includes an old school friend, Paul Roudier, and Albert Hecht, one of the first *amateurs* to have bought Manet's paintings. (Hecht also bought one of the sketches for *Ball at the Opera* after Manet's death.) The first man at left in profile may be Duret, who was known to be tall; Duret, however, claims to have served as a model for "part of a hat, an ear, and a bearded cheek," which hardly makes for a strong identification. Also included are two young painters, Guillaudin, to the left of the woman with the bouquet at center, and Edmond André, a painter of genre and military subjects who died in 1877 and is said to have served as the model for both the half-figure of Polichinelle in *Ball at the Opera* and for Manet's various single-figure versions of this character from the same period.

Manet may have included a self-portrait in the blond-bearded figure, second from the right, immediately above the little dance card bearing his signature.[15] But this image can hardly be counted as a striking likeness: Manet had broader cheekbones and a distinctively aquiline nose. However, it is entirely in character for Manet to tuck himself modestly into the margin of the scene, as he had in *Music in the Tuileries* more than a decade

earlier, so that he could be both a participant in and the observer-constructor of the painting.

It seems to me no accident that it is difficult, if not impossible, to attach the specific names cited by Duret to specific figures in *Ball at the Opera*. If the male figures "resist identification," I believe that it is because Manet wished them to. He was not painting a group portrait of his friends and companions, but rather using them as models to give authenticity to the representation of a certain class or group. It was not an accurate likeness, but rather a genuine ear, an eye, a gesture, the tilt of a hat, the bulge of a shirt front that Manet was after. Duret, Chabrier, Guillaudin, and the rest are there not as portrait subjects—identifiable individuals—but merely to provide the genuine raw material for a worldly, masculine typology, an intermittent, provocative, but never verifiable shock of recognition.

How and why did the half-figure of Polichinelle get into *Ball at the Opera?* He certainly doesn't appear in the preparatory oil sketches for the work, and while there is no reason for him *not* to be part of the crowd at a masked ball, it is nevertheless significant that his brilliantly colored half-figure backed up to the left side of the frame, visible hand raised in a gesture of surprise or dismay—or mock-command—should be the only costumed male figure in the picture. I think that Manet is up to something with his half-a-Polichinelle, and that this something is a half-joking reference outside the picture. This reference is probably political—although, as we will see, it may be other things as well.

Theodore Reff has recently made a convincing case that Manet's color lithograph of Polichinelle of June 1874 is a disguised caricature of Marshal MacMahon, who in early 1871 had led the French army to its stunning defeat by the Prussians at Sédan, and then compounded this offense by directing the bloody suppression of the Commune the following May. In May 1873 MacMahon was elected president of the Republic.[16] According to Reff, the printer's assistant later recalled that some 1,500 examples of the lithograph, part of a larger edition to be distributed to subscribers of the staunchly Republican *Le Temps,* were destroyed by the police because of the resemblance between the insolent old Punchinello with his baton and the newly elected president, whose cabinet had embarked on a campaign to restrain the press in order to silence the government's leftist opponents.[17]

A radical Republican, Manet had strong political opinions in the years immediately following the defeat of France in the Franco-Prussian war and of the Commune.[18] He went to the Assembly to sketch Gambetta and tried to persuade him to sit for a portrait when he was temporarily allied with the far left after the by-elections of July 1871.[19] At the end of 1873 Manet, with Duret and other friends, attended the treason trial of Marshal Bazaine, where he made several reportorial sketches of Bazaine confronting the *conseil de guerre*—sketches which are hardly flattering to this military leader of the Second Empire.[20]

For a politically concerned left Republican like Manet, MacMahon's election to the presidency constituted a threatening defeat. Following the so-called parliamentary coup d'état of May 24, 1873, MacMahon inaugurated the reign of "Moral Order" and the right's biggest effort to effect a monarchical restoration.[21] What better way of making a covert dig at the Marshal and his government of Moral Order than to include him in *Ball at the Opera*, his back turned safely to the audience, half in, half out of the picture, and have him confront with apparent alarm the world of Manet, his friends, and their women companions—a world obviously neither moral nor orderly?

If the men in the painting "resist" identification," not a single one of the women is identifiable.[22] This is not because of factual uncertainty—the loss of once-known identities over the course of history—but because of the way in which Manet conceived the picture. The women are anonymous, their identities disguised and deleted, their faces concealed by masks, their bodies swathed in dominoes. In an even more radical strategy of anonymity, some of them exist only piecemeal, as fragments—a trunk here, a leg there. Still, the women, in their provocative anonymity, are the point of the picture—or rather, the point is in some sense the nascent act of physical intimacy growing up everywhere among the hidden but patently attractive women and the (theoretically) identifiable men of the world who surround them.

The densely packed mass of figures is constantly punctuated by interesting nuances of touch, physical pressure, leanings against, intimate glances; all these subtle and not-so-subtle moves mark the various stages of making out. This is not so much a scene of merrymaking as one of erotic commerce, in which women are the product—enticingly, seductively, and mysteriously packaged—and the men, the buyers. The female trunk and leg at the top border of the painting function like traditional

shop signs—a leg at the stocking seller, a watch at the clockmaker—advertising the available merchandise.

This is not to say that Manet is overtly critical of what is going on—far from it. These are his friends, this is their—and his—natural habitat, and their transactions are meant to be seen as pleasurable for both buyer and seller. There is nothing moralistic about Manet's depiction of the situation; however, an interesting tension is created by the doubling of viewpoints, the shift from the notion of the scene as a transparent slice of life to that of the image as an arbitrary creation with an implication of distancing or even of ironic commentary.

Where did Manet get the idea for this rigorously horizontal two-story composition? Edmond de Goncourt thought that it was inspired by the mise-en-scène of the Goncourt brothers' play *Henriette Maréchal* (1865); writing in his journal on Thursday, November 20, 1873, he notes, "Today, I was in Manet's studio, looking at his painting of the *Ball at the Opera*, which is, so to speak, the set for the first act of *Henriette Maréchal*."[23] This opinion was seconded by Ernest Chesneau in 1874 and recently reiterated by a contemporary critic.[24] But R. Ricatte, the modern editor of the Goncourts' *Journals*, correctly points out that there is a considerable difference between the "colorful verve" of the Goncourts' description of the opera ball and "the rigor of Manet's file of black-clad figures . . . under the implacable balcony which extends across the painting's entire width."[25]

Recently, Alain de Leiris has suggested a compositional analogy between *Ball at the Opera* and the line of black-clad figures, their white linen setting off the portrait heads, in El Greco's *Burial of Count Orgaz.*[26] Obviously, there are many possible formal precedents for Manet's painting, including an almost inexhaustible supply of illustrations in the popular press. However, I know of only one work which both represents a ball at the opera and shares the rigorously horizontal structure of Manet's painting, including the balcony which divides the scene across its entire width. I am thinking of a print by the minor French artist Jean-Francois Bosio, *The Ball at the Opera*, one of five large, brilliantly colored *compositions des moeurs* designed in 1804 for the *Journal des dames.*[27] We don't, of course, know that Manet actually knew Bosio's print; even if he did, when we place the two works side by side, their differences turn out to be more interesting than their schematic similarity.

Even if Bosio's composition did enter into the story, it has been all but eradicated in Manet's work; the print remains a minor prototype that provided only the scaffolding and the faintest reverberation of the past against which the spirit of the present could ring out all the more vividly. Manet substituted observed gestures for conventional poses, the poses of his friends and contemporaries for Bosio's vapid types. Above all, whereas Bosio presented a finished, carefully detailed composition—a pictorial totality, fixed and premeditated despite its would-be sprightliness—Manet deliberately emphasized the fleeting, tangential, variable aspect of his subject through the cut-off view and a partial representation. In Manet's *Ball at the Opera* everything has been done to convey a sense of the fragmentary rather than the whole, of suggestion rather than overstatement, of momentary incident instead of unfolding plot, of mood rather than narrative, of contemporaneity rather than mere modishness.

Manet's conception of pictorial structure is analogous to the aesthetic of the fragmentary, the "slice of life" theory articulated by the French literary Naturalists later in the century. Doing away with conventional plot and characterization, these writers sought to create an authentic equivalent of experienced reality. Guy de Maupassant, for example, in his theoretical discussion of literary art, *Le Roman* (1888), insisted that the writer must strive for an illusion of truth rather than tell a good story: "Instead of contriving a surprising event and then having it unfold in a way that keeps the plot interesting right up to the denouement," he wrote, "the novelist should simply take up his characters at a certain point in their lives and let them proceed by natural transitions to the next."[28] Presumably like life itself, the Naturalist novel or story offered no convenient solutions; protagonists were frequently left in midstream, as it were, to continue their struggles outside the boundaries of the work itself.[29]

In visual art, the aesthetic of the fragment was articulated most forcefully by critic and novelist Edmond Duranty;[30] in his most sustained discussion of the innovative painting of his time, *La Nouvelle Peinture*, published in 1876, after the second Impressionist show, Duranty seems almost to be describing Manet's compositional practice in *Ball at the Opera*. In reality, Duranty maintained, there are thousands of unpredictable views of both people and things, and the artist can create an authentic equivalent of experience by deploying his figures asymmetrically, never placing them in the center of the canvas. In the new painting, Duranty

continues, the figure is not always represented as a totality: "Sometimes it may appear cut off at mid-leg, half-length or longitudinally."[31]

Manet's use of the fragment does not, however, merely create a naturalistic illusion. The remarkable synecdoche at the top of *Ball at the Opera* suggests a continuing, even inexhaustible supply of women's bodies beyond the boundaries of the image. But it also functions as a signifier of artifice which points to the painter's deliberate and willful choice. Mallarmé's claim that there is "nothing disorderly or scandalous about the painting which seems to want to step out of its frame"[32] suggests that there were in fact people who found it scandalous or disturbing.

The image of the cut-off leg functions in art as an easily understood, nontransferable synecdoche for sexual attractiveness and female availability, right down to the present. When the leg is feminine, as it is in Alfred Stieglitz's photograph of Dorothy True (1919) or in André Kertész's *American Ballet* (1939), it refers to the model's passivity—the very source of her sexiness for the male spectator. Similarly fragmented masculine legs never have the same implication. From the time of the medieval manuscript to that of the modern comic strip, male legs have functioned as potent emblems of energy—either upwardly mobile, as in the case of the Ascending Christ, or a destructive, downward force, as in Jerry Siegel and Bernard Baily's *The Spectre*, in which a foot crushes a car with stunning force.[33]

In Manet's work, cut-off female legs—suggesting the world beyond the picture frame and signifying complex meanings within—will turn up again in *Bar at the Folies-Bergère*[6], exhibited in the Salon of 1882. In both theme and formal structure, this work recalls *Ball at the Opera*. The little green shoes of the trapezist at upper left echo the brilliant green of the crème-de-menthe bottle in the lower right foreground. The barmaid—herself both seller and sold, immobile yet alive and vulnerable—is positioned between these two reference points. She functions as a kind of way station between the world of inert, densely painted objects in the foreground and that of the evanescent, openly brushed pleasure seekers reflected in the mirror behind her—a world into which the green-shod feet of the trapezist swing for an incandescent moment, seeming to distill the transitoriness of pleasure itself. Those feet sum up, in a way, the whole point of the bar, the ball, and the *café concert*—that is, of Manet's subjects, and a significant part of his life as well.[34]

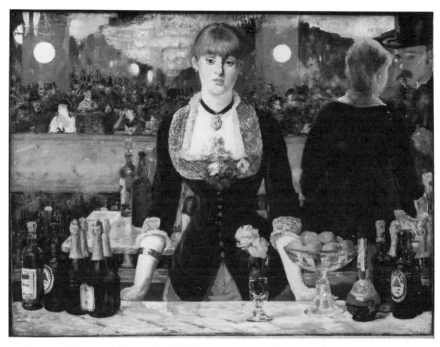

6. Edouard Manet, *A Bar at the Folies-Bergère*, 1881–82, London, Courtauld Institute Galleries

Although Manet himself is not recognizable in the crowd reflected in the mirror, he might just as well be there, alongside his demimondaine friends Méry Laurent and Jeanne Demarsy. Once more, Manet can be thought of as both an inhabitant of the world of the painting and an ironically detached observer of it, remarking on its venality as well as its pleasurableness. Manet was aware of the peculiar vulnerability of the demimondaine, of the marginal or working-class women who frequented these places of pleasure. Yet he saw these women's defining and perpetual availability as an acceptable part of their attraction, their simply being there for him and for men like him.[35]

There is certainly a sense in which *Ball at the Opera* is a subversive painting, daring in its open representation of feminine sexual availability and the recognizability of the male consumers of it—especially at a time when Moral Order was the order of the day. The painting is also daring in its formal strategies—its immediacy, its brio, its deliberate yet casual-

looking cut-off view of the spectacle. It was no doubt the intersection of these two impulses that made the Salon jury reject the painting in 1874, and Mallarmé admire it. Today, Manet's antinarrative strategies seem to call into question the ideology of his time. By rejecting traditional modes of pictorial storytelling, by interrupting the flow of the story line, Manet seems to be making a witty and ironic reference to the underlying assumptions controlling such gatherings of upper-middle-class men and charming women of the theater—pleasure for the former, profit for the latter. The cut-off legs and torso at the top are a brilliant Realist device, a substitution of part for whole, through which Manet makes us aware of the artifice of his art and, at the same time, of the nature of the actual power structure underlying the worldly goings-on here.

There is some truth in this vision of Manet and his work; but things are even more complicated than this. Money—buying and selling—lay at the heart of pleasure in Manet's Paris. As a man of his time, his city, his class—a man of the world, in short—Manet knew and accepted this, even if he was sometimes able to stand back from his world in order to set it forth, to paint the flesh market in its various disguises. If we tend to accept his version of nineteenth-century reality so readily, perhaps this is because it coincides so easily and so unconsciously with our own reality—depending, of course, on who we mean by "we." For in *Ball at the Opera* Manet sets forth erotic pleasure as mutually engaging for prosperous men and marginal or anonymous women, no matter what its ultimate price, literal and figurative—which can hardly be the same for both.

When all is said and done, Polichinelle may assume still another meaning. We know that in the past Manet had identified himself with his commedia figure.[36] Michael Fried relates Manet's work to the marionette theater of the 1860s, suggesting that Punch, like the artist, was both producer of and participant in his own creations.[37] If Polichinelle in some way stands for Manet in *Ball at the Opera*, drawing back momentarily to criticize the scene, he is nevertheless an alter ego whose very disguise and half-bodied presence mocks his own condemnatory gesture.

Notes

1. The chronicler in question was Fervacques, quoted in Moreau-Nelaton, *Manet raconté par lui-même* (Paris, 1926), II, pp. 9–10, and in turn cited by Françoise Cachin

in her catalogue entry on *Masked Ball at the Opera* in *Manet 1832–1883* (New York, 1983), no. 138, pp. 349–52. This catalogue entry is a rich source of information and documentation about the painting, as are Theodore Reff, *Manet and Modern Paris* (Washington, D.C., 1982), no. 39, p. 122, and Denis Rouart and Daniel Wildenstein, *Edouard Manet: Catalogue raisonné* (Lausanne, 1975), I, no. 216. For another interpretation of the work see Alain de Leiris, "Manet and El Greco: The 'Opera Ball,' " *Arts*, September 1980, pp. 95–99. For studies of Manet's *Masked Ball* published after the completion of this article, see Melissa Hall, "Manet's *Ball at the Opera:* A Matter of Response," *Rutgers Art Review*, Spring, 1984, and John Hutton, "The Clown at the Ball: Manet's Masked Ball at the Opera," *The Oxford Art Journal* 10:2 (1987):76–94. For the theme of the masked ball from the viewpoint of cultural history, see Ann Ilan-Alter, "Je te connais, beau masque . . ." (Women, Sex and Class at the Bal de L'Opéra, 1830–1873). Paper presented at the American Historical Association, December 1985.

2. Julius Meier-Graefe, *Edouard Manet* (Munich, 1912), p. 216. Meier-Graefe also maintained that the painting was "ein Stück, das ein Ganzes ergibt." His analysis of the work (pp. 215–18), though brief, is brilliant.

3. Stéphane Mallarmé, "Le Jury de peinture pour 1874 et M. Manet," *Oeuvres complètes*, ed. H. Mondor and G. Jean-Aubry (Paris, 1945), p. 695. The letter originally appeared in *La Renaissance artistique et littéraire* in 1874.

4. Théodore Duret, *Histoire d'Edouard Manet et son oeuvre*, 2nd ed. (Paris, 1919), p. 109.

5. For related works see the oil sketches in Rouart-Wildenstein, I, nos. 214–15, and an ink-wash study, II, no. 503. There may be three or four related drawings as well. See de Leiris, *The Drawings of Edouard Manet* (Berkeley and Los Angeles, 1969), nos. 412–15.

6. Reff reproduces the relevant Grévin caricature in *Manet and Modern Paris*, fig. 62, p. 122.

7. Roman Jakobson, "The Metaphoric and Metonymic Poles," *Fundamentals of Language* (The Hague, 1956), pp. 76–82.

8. T. Reff, "The Symbolism of Manet's Frontispiece Etchings," *Burlington Magazine*, May 1962, pp. 182–87.

9. For the color lithograph, see Reff, *Manet and Modern Paris*, no. 40. For the watercolor study, see Rouart-Wildenstein II, no. 563; for the oil sketch, I, no. 212; and for the finished oil, I, no. 213.

10. Cited by Jean C. Harris, "A Little-Known Essay on Manet by Stéphane Mallarmé," *Art Bulletin*, Dec. 1964, p. 561. Mallarmé's essay had originally appeared in the English *Art Monthly Review* in 1876.

11. See, for example, the caricature of the work of the photographer Disderi by Cham, from *Le Charivari* of 1861, reproduced by Aaron Scharf, *Art and Photography* (London, 1968), fig. 144. p. 155, in which the legs of the passengers on an omnibus are amputated by the upper margin of the image.

12. T. Reff, "Manet's 'Portrait of Zola,' " *Burlington Magazine*, Jan. 1975, p. 41.

13. Duret, pp. 110–12.

14. Cachin, p. 350. For images of Chabrier, see R. DeCage, "Chabrier et ses amis impressionistes," *L'Oeil*, Dec. 1963, pp. 16–23f.

15. De Leiris, "Manet and El Greco," p. 98.

16. Reff, *Manet and Modern Paris*, p. 124.

17. J. P. T. Bury, *Gambetta and the Making of the Third Republic* (London, 1973), p. 155.

18. For a detailed examination of Manet's activities during the Franco-Prussian War and the Commune, see Marianne Ruggiero, "Manet and the Image of War and Revolution: 1851–1871," *Edouard Manet and the Execution of Maximilian* (Providence, R.I., 1981).

19. Bury, pp. 38–39.

20. Duret, pp. 173–74.

21. Bury, p. 152.

22. Cachin, p. 351.

23. Edouard and Jules de Goncourt, *Journal*, ed. R. Ricatte (Paris, 1956).

24. Eric Darragon, "Le Bal de L'Opéra, espace et réalité post-romanesque chez Manet en 1873," *L'Avant-Guerre sur l'art* 3 (1983).

25. Ricatte, Goncourt *Journal*, Thurs., Nov. 20, 1873.

26. De Leiris, "Manet and El Greco," pp. 95–96, 99.

27. Bosio's engraving, in the Cabinet des Estampes of the Bibliothèque Nationale, is brilliantly colored. For information about J.-F. Bosio, see Jean Adhémar, *Bibliothèque Nationale: Département des Estampes; Inventaire du Fonds francais après 1800* (Paris, 1942), III, 157–58.

28. Cited by A. Vial, *Guy de Maupassant et l'art du roman* (Paris, 1971), p. 77.

29. For an articulation of this view of the Naturalist novel, see Lillian Furst and Peter N. Skrine, *Naturalism* (London, 1971), p. 47.

30. Duranty, founder of the influential review *Réalisme* in 1856, had known Manet since 1863, if not earlier. Both figured in Fantin-Latour's *Hommage à Delacroix* at that time. In Duranty's novella *La Simple Vie du peintre Louis Martin*, published in 1872, there are reminiscences of Manet's work in the Salon des Réfusés of 1863. Their relation was generally a close one despite a duel they fought in 1870 over a not-too-complimentary article Duranty had written about the artist. See L. E. Tabary, *Duranty (1833–1880): Etude biographique et critique* (Paris, 1954), Etudes Francais, 46, passim.

31. Duranty, *La Nouvelle Peinture: à propos du groupe d'artistes qui expose dans les galeries Durand-Ruel* (1876), ed. M. Guérin (Paris, 1946), pp. 46–47. Although Duranty's remarks are generally associated with Degas's compositional innovations, they apply equally well to those of Manet. In *La Nouvelle Peinture* Duranty praises Manet as an unparalleled innovator, "the audacious head of the movement" (pp. 35–36).

32. Mallarmé continues: ". . . but on the contrary, the noble attempt to capture, through purely pictorial means, a total vision of contemporary life." Mallarmé, *Oeuvres complètes*, p. 689.

33. Meyer Schapiro, who devoted a major article to the motif of Christ's feet in Ascension imagery ("The Image of the Disappearing Christ: The Ascension in English Art Around the Year 1000," *Gazette des Beaux-Arts*, March 1943, pp. 135–152), noted the "remarkable and unexpected vivacity and realism of this motif . . . [which] with its emphasis on the viewpoint of an earthly observer is relatively unique in the medieval period." Schapiro goes on to connect this "daringly realistic" type of Ascension with the radical transformation of traditional conceptions in England in favor of

more concrete and active types. He sees "an intensified concreteness in rendering the transitive and dynamic aspects of the old religious scenes," an "emphasis on the act of seeing at an objective moment of the story," connecting these features with the "empiricism and pragmatic aspect of English philosophy in the Middle Ages"—in brief, with what might be termed a "realist-empirical outlook" analogous to, though of course very different from, that of Manet and his fellows in the nineteenth century.

34. In the days when women's legs were more provocative, Manet obviously relished the sight of dainty feet and ankles. See, for example, the neat, black-stockinged legs depicted in his 1880 note to Mme Guillemet (de Leiris, *Drawings,* no. 583; Rouart-Wildenstein II, no. 580). In a watercolor study of legs (Rouart-Wildenstein II, no. 518), dated about the same time, the angles and curves of legs and feet, in proximity with the skinny, inanimate curves of the legs of the café table next to them, suggest not merely a personality but a whole milieu.

35. The definitive study of French prostitution and attitudes toward it in the nineteenth and twentieth centuries is Alain Corbin, *Les Filles de noce* (Paris, 1978).

36. Reff, "Manet's Frontispiece Etchings," p. 184.

37. Michael Fried, "Manet's Sources: Aspects of his Art, 1859–1865," *Artforum,* March 1969, pp. 70–71.

6

Van Gogh, Renouard, and
the Weavers' Crisis in Lyons

Sometime during the winter of 1885, just about the time he began work on his monumental *Potato Eaters,* Vincent van Gogh wrote from Nuenen to his brother Theo: "You would greatly oblige me by trying to get for me: *Illustration* No. 2174, 24 October 1884. . . . There is a drawing by Paul Renouard in it, a strike of weavers at Lyon. . . ." Van Gogh goes on to discuss other drawings by Renouard, and concludes: " . . . I think the drawing of the weavers the most beautiful of all; there is so much life and depth in it that I think this drawing might hold its own beside Millet, Daumier, Lepage."[1] The drawing in question must have meant a great deal to van Gogh, for he mentions it again in a letter to his brother a little later in the year: "I am sorry you did not send *L'Illustration,* for I have followed Renouard's work pretty regularly, and for many years I have saved up what he did for *L'Illustration.* And this is one of the most splendid which I think would delight you too."[2] Still later, van Gogh's tone of urgency deepens, as does the specificity of his description of the work in question: "Many thanks for the *Illustrations* you sent, I am much obliged to you. I think all the various drawings by Renouard beautiful and I did not know one of them.

"However—this is not to give you extra trouble, but because I wrote things about it which perhaps cannot quite be applied to other drawings of his—the composition to which I referred is not among them. Perhaps that number of *Illustration* is sold out. The breadth of the figure in it was

superb; it represented an old man, several women and a child, I believe, sitting idle in a weaver's home in which the looms stood still."[3]

The drawing of the weavers in question recently came to light at a Paris art dealer's, and it is indeed a beautiful and moving image—beautiful, that is to say, in van Gogh's peculiarly transvaluated sense of the word; awkward and unsettling in more conventional terms. Of course, it is important to realize that van Gogh was actually talking not about the original pencil drawing, but about the masterly wood engraving after it by Albert Bellenger.[4] It had appeared in the October 25, 1884, *L'Illustration* with the caption *La Crise industrielle à Lyon: Sans Travail*[1] and the subheading "Dessin d'après nature de M. Renouard, envoyé spécial de *L'Illustration.*" *Sans Travail* was second in a series of three eyewitness reports by Renouard of the contemporary crisis in the weaving industry of Lyons: the first of the series, *Un Canut à son métier,* had appeared in the issue of October 18; and the third, *Une Réunion d'ouvriers aux Folies-Bergère,* did not appear until November 15.[5] Renouard's drawing is interesting for a variety of reasons, and on a number of levels: first of all, for the light it sheds on van Gogh and his predilections, formal and icono-

1. Paul Renouard, *La Crise industrielle à Lyon: Sans Travail,* wood engraving by Albert Bellenger, Paris, Bibliothèque Nationale

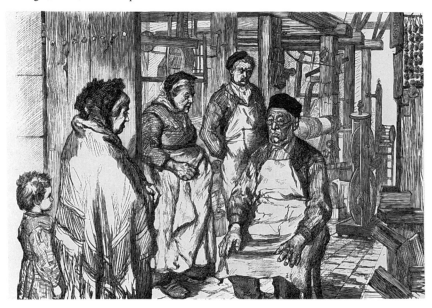

graphic, in the middle 1880s; secondly, as an art work in its own right, an outstanding example, rich in suggestive overtones and ambiguity, of the work of the once-illustrious draftsman Paul Renouard, and, in its reproduced form, of the mass medium of wood engraving by means of which his drawings were disseminated in the popular journals of the time; and finally, *Sans Travail* assumes significance as a document of the crisis in the weaving industry in Lyons in 1884, and, more generally, of the situation of manual workers in the nineteenth century, a situation in which the plight of the hand-loom weavers seems to have played an exemplary role, vividly commemorated in art and literature.

Charles-Paul Renouard (1845–1924) was one of that group of cosmopolitan reporter-draftsmen who made their living, and their substantial reputations, working for the illustrated journals of the day, a group which included the Englishmen Hubert Herkomer, Frank Holl, Luke Fildes, E. J. Gregory, and John Nash, and the Frenchmen Gustave Doré, Paul Gavarni, Félix and Guillaume Regamey, Auguste Lançon, and Jules Férat, as well as many others.[6] Their work appeared, skillfully reproduced by highly regarded wood engravers, in such journals as *The Graphic*, perhaps the most socially committed of these publications and the one most favored by van Gogh; *The Illustrated London News; L'Illustration*, the journal with which Renouard was most consistently connected; *Le Monde illustré;* and *Harper's Weekly.*[7]

Renouard's production during the course of his long career was enormous and wide ranging. He dealt with all kinds of subjects, traveled to many countries—one critic dubbed him "le Juif-Errant de l'illustration"— and was attracted to all kinds of physical types and a wide spectrum of social classes. His oeuvre included numerous sketches of the world of entertainment, most notably that of the Opéra, which he also commemorated in an album of etchings, *Le Nouvel Opéra* of 1881; various aspects of public life—the Bourse, the Courts, the Navy, the Chamber of Deputies, and the American Congress; eyewitness reports of famous trials of the time, especially the Dreyfus case; and all sorts of "miscellaneous" subjects—children playing, guests at a working-class wedding, fashionable ladies taking tea, Queen Victoria's funeral, an orchestra leader in action, animals in motion, public ceremonies, and private gestures. Yet perhaps the realm he preferred above all others, at least during the 1880s, the period that concerns us, was that of the poor and the oppressed, whether it be the working poor—miners, fishermen, artisans, and factory

workers; or the scrofulous inhabitants of the *bas-fonds*—ragpickers, drunkards, slum dwellers; or those existing on the margins of modern life, like the members of the Anarchist Club, or the down-and-out beggars of Ireland and England; or the lives of those too weak or twisted to make it on their own: the inmates of the Foundling Hospital, the prisons, the Home for the Blind, the old soldiers at the Invalides, or the mad people at La Salpêtrière. In addition, he illustrated Jules Vallès's novel of martyred childhood, *L'Enfant*, in 1881, and, in 1907, brought out his culminating masterpiece, *Eaux-Fortes, Mouvements, gestes, expressions,* a series of two hundred etchings covering his various areas of expertise, animal and human: plates of rabbits, chickens, pigs, beetles, tigers, and kangaroos doing their thing; human beings engaged in gymnastics, music-making, fishing, or bathing; children playing, jumping, giggling, dancing; fashionable ladies in incredible hats strolling or gossiping, heads of state behind the scenes, politicians of the time flamboyant in high rhetorical gesture— especially vivid in the case of Gambetta and Rochefort—lawyers and their clients in action in the courtroom, the Salvation Army, scenes of London life.[8]

Renouard was admired as much for his technical innovations and formal daring as for the range of his subjects: indeed, almost from the beginning, form and content were seen as inseparable features of his modernity, his inimitable grasp of the spirit and substance of his own time. Considered a master of the on-the-spot sketch and the synoptic drawing style it demanded, he was appointed "professeur de croquis" at the Ecole des Arts Décoratifs in 1903.[9] For one critic, writing, it is true, well into the twentieth century, Renouard was the very inventor of a modern drawing style, the style demanded by the dynamism of contemporary life itself: "Cette facture moderne, Renouard l'a trouvée!" exclaimed Clément-Janin in 1922, making out the rather conventional virtuosity of the artist to be a sort of Futurism before the fact. "Il a inventé une forme rapide et colorée, pour ainsi dire, à fleur d'écriture. . . . C'est un *instantané de dessin.*"[10] For still another early-twentieth-century admirer, perhaps more realistic in his assessment of Renouard's quite genuine, if less innovative, abilities, he was a " 'journalist' in the very highest sense of the word," possessed of a "living style which expresses everything in a few lines, which notes the fluctuations of ideas, the movements, the characteristics, the gestures of his subjects. . . ."[11] And for still another, Renouard's

drawings were characterized by "impeccable design and bold, firm impressionism."[12]

Vincent van Gogh was one of Renouard's earlier admirers, and a devoted one: he mentioned the artist more than twenty times in the course of his correspondence, first in the spring of 1882. By the autumn of that year, he wrote to his friend and fellow artist Rappard, he already had about forty large and small reproductions of Renouard's work, including his *Bourse,* his *Discours de M. Gambetta,* and also some of the *Enfants Assistés,* [13] which he characterized as "superb" in a letter to Theo of the same period.[14] By the end of November 1882, he complained to Rappard that he had been unable to get hold of Renouard's *Miners* despite all his efforts,[15] and more than a year later, in a letter to the same friend, he mentions that he is familiar with some sketches by Renouard of cats, pigs, and rabbits[16] although he does not own any of them; he does, however, have in his possession Renouard's *Mendiants le jour de l'an.* [17] In the winter of 1885, shortly before requesting the drawing of weavers from his brother, he wrote Theo that he had received from Rappard a series of drawings by Renouard, *Le Monde judiciaire,* types of lawyers, criminals, and so on. "I do not know if you have noticed them," he remarks; "I like them very much. And I think he is one of the genuine race of the Daumiers and the Gavarnis."[18] Although van Gogh doesn't mention Renouard in his letters after 1885, his *Passage at St. Paul's Hospital* [2], painted as late as 1889, would seem to be a kind of homage, unconscious perhaps, to Renouard's *Blind Men* from the latter's *Invalides* series of 1886 [3], with its stark frontality and hauntingly empty vista.

Still, it is worth pointing out that van Gogh was anxious to differentiate *Sans Travail* from Renouard's other drawings. He was right to do so, for, as he himself pointed out, it is true that the things he says about it "cannot quite be applied to other drawings" of the artist.[19] *Sans Travail* coincides to a remarkable degree, both in form and content, with van Gogh's preoccupations, those of 1885 and of before and after this date. It also stands apart in Renouard's oeuvre.

The drawing represents a scene of enforced idleness in one of the domestic workshops, those individual units which, taken together, constituted Lyons's weaving industry. It is executed in pencil heightened with touches of black ink wash and accents of black chalk or crayon. Fairly large in scale (32 × 48 cm), the drawing is rich in the kind of graphic detail that

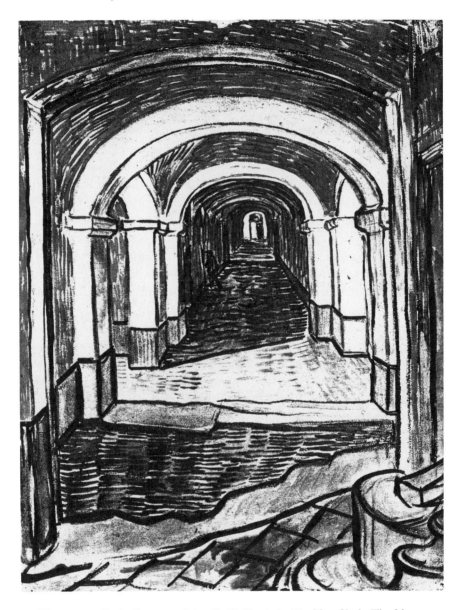

2. Vincent van Gogh, *Passage at Saint Paul's Hospital,* 1889, New York, The Museum of Modern Art, Abby Aldrich Rochefeller Bequest

3. Paul Renouard, *Les Invalides: Les aveugles,* wood engraving, Paris, Bibliothèque Nationale

seems to guarantee "documentary" authenticity, as well as lending itself admirably to translation into wood engraving. It is signed and dedicated in the lower right-hand corner: "à Monsieur Depaepe / souvenirs affectueux / P. Renouard," a dedication which has a certain significance in the interpretation of the work, as we shall see. The group represented would appear to consist of the "chef d'atelier" and his family, with one of the "compagnons," the hired laborers who assisted in the home workshops of the weavers, standing behind the seated old man. The written description accompanying the engraved version of the drawing in *L'Illustration* is fairly explicit about the critical situation depicted: "No work anywhere, and the scene, drawn from nature, which our engraving represents, is to be seen on almost every floor of the houses of the populous quarters of the city which is being so sorely tried: the Croix-Rousse, St.-Just, and the whole suburb of Lyons near La Guillotière. Our artist has taken us to the Croix-Rousse district, the staircase of the Carmélites. We are in a poor room where a whole family of old weavers lives: the father, the mother, and the widowed daughter with her child, a little girl. . . . No more resources; soon no more bread. Here and there some furniture and looms, abandoned and covered with paper to preserve the working parts from dust. And that is all. To think that the house in which this family lives has 370 windows, that each of these windows illuminates a room, and that in each room, or nearly each one, a scene like this is taking place!"[20]

The scene indeed seems to be drawn from nature, and derives its strength from this fact, but there is something more to it than the accuracy of a good piece of reporting. First of all, the weavers are lending themselves, if modestly, to the enterprise, sitting for their portraits as though to a sympathetic local photographer rather than being seized or violated in their privacy. Secondly, the drawing style is remarkably free of just that exaggerated virtuosity, that flamboyant gestural impressionism so well suited to an art of seizure and appropriation, which captivated Renouard's admirers at the beginning of the twentieth century. On the contrary, Renouard's *facture* here seems to root his subjects to the spot with a kind of painstaking immobility. Certainly, there is no sense here of "une forme rapide et colorée" or "un instantané de dessin."[21] The formal language, like the mood of the drawing, is hushed, tensely meditative, still. Indeed, *Sans Travail* is remarkable for its intensity and concentration of vision, for the way the lot of this working-class family is at once so starkly individuated and yet so resonant with implications beyond its unique

presence—*not*, it must be emphasized, diluted by the idealist generalization or the self-conscious quest for universality characteristic of more ambitious treatments of working-class subjects during the period. Indeed, the larger authenticity of the image is generated precisely by its concreteness and the modesty of its goals: the very sense that this much, this kind of detail is determined not by the author's will, or his aesthetic ambition, but by internal necessity. The result is a moving additiveness of effect, in which the very stiffness and angularity of the pencil strokes, the odd, off-beat near-symmetry of the composition, and the awkward, lumpy figure style are precisely what make the image so eloquent; virtuosity would have made it rhetorical; simplification, banal. Remarkable is the apparently deliberate *antigrazioso* of the traditionally glamorizing device of the *profil perdu* in the head of the left foreground woman,[22] and the way these working-class people, somewhat embarrassed, eyes cast down, not sure of what to do with their hands, are slant-rhymed against the minutely described, unpolished surfaces and staccato protuberances of the looms.

The potential emotional pull of deep space is at once suggested and deflected by the density of the foreground statement as opposed to the busy multiplicity of forms that fills the background. The seated old protagonist is defined and contained almost haphazardly by the wavery hatching of the timber beams to the left, behind, and to the right, an effect of surface tension perhaps more apparent in Bellenger's wood-engraved version of the image than in the original drawing. One wonders how much this awkward yet expressively effective spatial truncation owes to the exigencies of the situation itself: once more the sheer force of necessity seems to play a role in the effectiveness of the drawing. Interestingly enough, it was van Gogh who articulated the nature of the problem: in early January 1884, he had written to Theo about his own practical difficulties in dealing with weavers. Remarking on the rarity of drawings of hand-loom operators, he observes, as a photographer might: "Those people are very hard to draw because one cannot take enough distance in those small rooms to draw the loom. I think that is the reason why so many drawings turn out failures."[23]

Throughout Renouard's drawing, this difficult reality is recorded with a line as caringly unbeautiful, as unstylishly differentiated, as the people and things it records, variegated pencil strokes urgently marking out sags and wrinkles, droops and bristles, splintery and worn-out surfaces, often in short, broken hatches, sometimes in contrasting long, wav-

ering ones in an insistent graphic interplay especially evident in the engraved version. This brand of graphic integrity, united with an uncompromising confrontation of reality, must have struck a responsive chord in van Gogh. Indeed, his profound response to this drawing led him to a meditation on the necessary connection between confrontation of real life and the development of technical expertise or a "personal handwriting." In the same letter to his brother cited above, in which he first requested *Sans Travail*, van Gogh continues, after comparing Renouard's drawing with the work of Millet, Daumier, and Lepage:

> When I think how he rose to such a height by working from nature from the very beginning, without imitating others, and yet is in harmony with the very clever people, even in technique, though from the very first he had his own style, I find him proof again that by truly following nature the work improves every year.
>
> And every day I am more convinced that people who do not first wrestle with nature never succeed.
>
> I think that if one has tried to follow the great masters attentively, one finds them all back at certain moments, deep in reality. I mean one will see their so-called *creations* in reality if one has similar eyes, a similar sentiment, as they had. And I do believe that if the critics and connoisseurs were better acquainted with nature, their judgment would be more correct than it is now, when the routine is to live only among pictures, and to compare them mutually. Which of course, is one side of the question, is good in itself, but lacks a solid foundation if one begins to forget nature and looks only superficially. . . . The most touching things the great masters have painted still originate in life and reality itself.[24]

In Renouard's drawing, then, van Gogh found the text for a little sermon on the superiority of nature over art in the creation of art itself, and the opportunity of administering a gentle admonition to those whose contradictory judgment controlled the art world.

Yet there were still further reasons attaching van Gogh to *Sans Travail*. The drawing clearly synthesizes, in a single image, two realms of subject matter which deeply moved him: the old, working-class man, and the weavers. The image of the weaver obsessed him during his stay in Nuenen. Writing to Theo at the beginning of January 1884, he states his preference for unworldly people, like peasants and weavers, rather than more civilized folk, praises his friend Rappard's earlier study of weavers, and states, succinctly and accurately: ". . . Since I have been here . . . I have been absorbed in the weavers."[25] Indeed, during his stay in Nuenen, mostly in 1884, he did over thirty studies of weavers in oil, watercolor, and

drawing.[26] There is an ominous sense of projected anxiety—something distressing, claustrophobic—about almost all these representations of weavers, as well as those drawn in his letters at the same time: in most of them, the operative seems less in control of than entrapped by the complex mechanism of his loom, like a fly caught in the mechanical meshes of a giant, angular spider web. Van Gogh, in one way or another, seems to press his weavers, no matter how closely observed, into service as objective correlatives for his own overwhelming sense of isolation; it is not the weavers as a family group that occupy him so much as the solitary working weaver, more akin to the image presented by Renouard in *Un Canut à son métier.*[27]

The image of the old, worn-out, working-class man so convincingly depicted by Renouard in *Sans Travail* attracted van Gogh for a longer period and more diversely. As early as 1882, at The Hague, he had embarked on his series of studies of "orphan men," "poor old fellows from the workhouse,"[28] figures which themselves recall Herkomer's treatment of old men in *Sunday at Chelsea Hospital,*[29] a work van Gogh knew and admired, a series perhaps culminating in the lithograph *Worn Out* of November 1882,[30] an image later transposed into a more heavily expressionist oil painting subtitled *At Eternity's Gate* in 1890.[31] But Renouard's old weaver is more self-controlled, less overtly despairing than van Gogh's, in no sense an orphan but a family man, stoical and dignified in his bearing. A similar sense of long-suffering self-respect, a self-respect bordering on secular sanctity, dignifies the old men whom van Gogh portrayed later in his career, figures like *Père Tanguy* of 1887, *The Postman Joseph Roulin* of 1888, or *Patience Escalier, Shepherd of Provence* of the same year.[32] Indeed, there is a remarkable affinity between Renouard's old weaver in *Sans Travail* and van Gogh's old color merchant, Père Tanguy, although van Gogh has heightened the potential religious overtones by choosing absolute rather than near frontality; suggested Buddhistic affiliations in pose and setting; clasped the hands instead of resting them more matter-of-factly on the sitter's knees; and played up the halolike propensities of the hat and Mount Fuji. Still, it is *Sans Travail* which remains more naturally religious, as it were, an everyday icon of the modern man of sorrows, a man of sorrows distanced from his fellow sufferers by greater age and loss, seated in helpless, puffy dignity, twisted hands on wrinkled apron, respectfully regarded by his standing dependents, worshipers who in some way threaten their object of devotion,

isolating him with claims of unfulfillable responsibility, as much as they pay him homage.

The strength of Renouard's image, then, has to do with its secure and unlovely grasp, less sentimental than van Gogh's "orphan men" and more explicit than his later portraits, of what it meant to be old, out of work, and helpless to change the situation. As such, it is an image replete with painful contradictions: the family together but each member isolated, the space of work transformed into the arena of enforced idleness; the protective, paternal figure the most overtly helpless of all, as peripheral as the literally peripheral child and more hopelessly outmoded. The very details underscore in their way the larger contradictions: the useless apron—what is there to protect?; the useless glasses—what is there to see?; above all, the useless hands—what is there to weave?

Renouard's *Sans Travail* succeeds better as a document and as a work of art than other images of the 1884 weavers' crisis in Lyons, works like Férat's contemporary *La Crise lyonnaise: Intérieur d'un tisseur en sôie*, where the space is annoyingly dominated by the looms and the meager human interest thrust into a corner, rather than the two crucial elements being naturally united as they are in Renouard's version. In its effect of bitter constatation of the facts, of coming to grips with and uniting the actuality of the situation with its deeper and more unsettling implications without making a visible commentary on them, *Sans Travail* shares certain of the qualities of contemporary photographs of the lot of the down-and-out, like those of Jacob Riis[4], which themselves seem to echo the formal and iconographic patterns of top-quality Renouard productions of the period[5]—in this case, the same head-on confrontation of the architecture of oppression peopled by a collaborating, rather than caught, cast of characters. The effect of sheer, phenomenological accuracy perhaps reaches its climax in Renouard's unexpected garbage still life[6] from the same series of images of slum life, a striking metonymy of the social status of poverty itself.[33]

Sans Travail also stands out from the other two works in Renouard's own "Industrial Crisis in Lyons" series. If he meant the three works as a unified sequence—with *Un Canut* showing the weavers peacefully at work, *Sans Travail* representing them out of work as a result of the industrial crisis, and *Une Réunion d'ouvriers* as the workers taking action to remedy the situation—then he failed of his purpose, for the total effect lacks dramatic coherence, or indeed, any sense of internal order or climax;

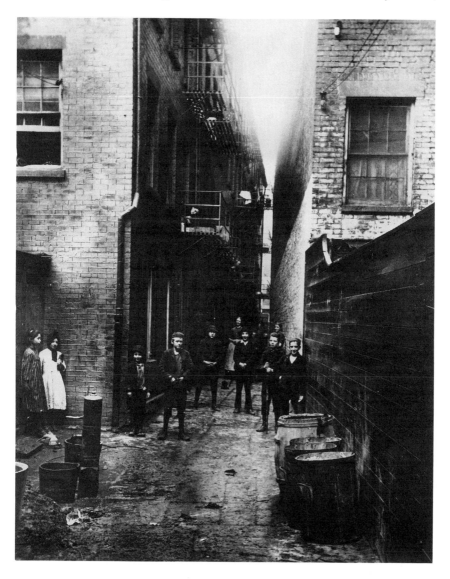

4. Jacob Riis, *Mullen's Alley, New York City,* photograph, New York, Museum of the City of New York

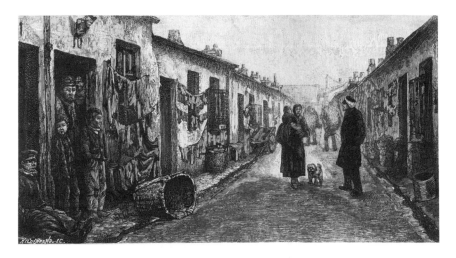

5. Paul Renouard, *Cité ouvrière*, wood engraving, Paris,
Bibliothèque Nationale

on the contrary, these seem like three stylistically disparate—and discon-
nected—images; in addition, the two other drawings are weaker and less
effective as individual works, and one is tempted to speculate on why this
should be so. His first image, *Un Canut à son métier*, is mere description
despite its fairly effective angle of vision, more interesting from the point
of view of affording information about the vanishing art of hand-weaving
than for any other reason. His third work from the series, *Une Réunion
d'ouvriers aux Folies-Bergère*, is overtly unconvincing, although it has some
nice touches, like the slouching back-view figure in the foreground and
the hat on the edge of the table; but it lacks not only the rhetoric of
political engagement but even the energy of human conviction. One
cannot help but compare the flabby gesture and downcast pose of the
worker on the left with the energetic brio of the sculptural groups in the
background: the irony is compounded by the fact that the group to the
right is that very embodiment of revolutionary élan, Rude's *Departure of
the Volunteers* on the Arc de Triomphe. The written account accompany-
ing the engraving after Renouard's eyewitness drawing in *L'Illustration*
suggests far greater drama than the lackadaisical unfocusedness of Reno-
uard's image: "La séance a été fort tumultueuse et certains orateurs très
violents dans leurs discours. . . . "[34] There is not a hint of either tumult

or violence in Renouard's drawing, nor even of energy, unless he meant us to read it out of the iconographically innocent sculptural groups in the background. The artist clearly shies away from the representation of conflict, from the dramatic gesture or expressive manipulation of shadow

6. Paul Renouard, *Garbage,* wood engraving, Paris, Bibliothèque Nationale

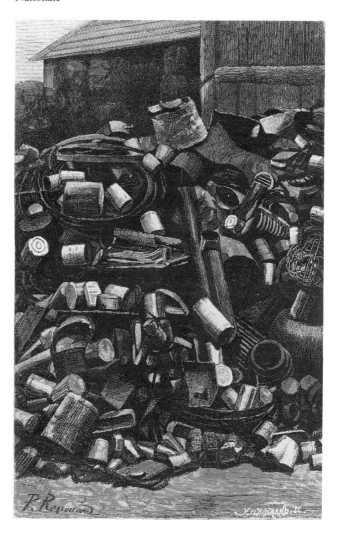

by means of which Käthe Kollwitz was to emphasize her commitment to working-class objectives in almost identical subject matter a little more than a decade later, in her print cycle *A Weavers' Revolt* of 1894–98.

Indeed one wonders, on the basis of the variation in quality in Renouard's series, and in comparison to Kollwitz's far more overtly class-conscious and activist weaver images, to what degree Renouard saw his weavers as representatives of a class at all, rather than merely as pathetic individuals. One might indeed surmise that it was the very innocuousness of the situation depicted in *Sans Travail*—workers not working but not doing anything about the situation in the form of threatening collective action—the unprovocative sense of individualism, singularity, and bearing with the situation inherent in the subject—that gave Renouard permission to conceive of it with such unhabitual depth of feeling: these people's very passivity permitted the artist an eloquent pictorial structure instead of a merely adequate one. For *Sans Travail* is ultimately a monument to the same kind of humanitarian, as opposed to political, attitude that characterized the work not merely of the popular illustrators of the time, but van Gogh's and Jacob Riis's contemporary responses toward the poor as well, a compassion that, in visual terms, postulates the workers and the poor as victims (a condition later softened by the euphemism "underprivileged")—staunch, enduring victims worthy of help and uplift, victims about whom something should be done, but victims nevertheless—rather than as class-unified activists fighting for their rights by means of revolutionary, collective political action, such as those depicted, however tragically, in Kollwitz's *A Weavers' Revolt*. Images like Renouard's, van Gogh's, or Riis's, if they are in some sense a call to action—and certainly Riis meant his to be—depend ultimately on an appeal to the *conscience* of the prosperous and powerful rather than to the *consciousness*—the class consciousness—of the workers themselves: they are clearly reformist in their thrust, backed by a judicious dosage of salutory empiricism, rather than revolutionary.

The ambiguity of Renouard's attitude toward the weavers he depicts in his "Industrial Crisis in Lyons" series is compounded by the dedication inscribed on the original drawing of *Sans Travail:* "à Monsieur Depaepe: souvenirs affectueux." The Monsieur Depaepe in question must have been César de Paepe, a Flemish printer and prominent socialist who founded the Belgian Labor Party in 1885. De Paepe had been an active participant in the congresses of the First International from 1867 to 1870, and a col-

laborator in Europe's first overtly socialist newspaper, *L'Egalité,* founded by Jules Guesde in 1877. In 1884, the year of Renouard's drawing and dedication, he had signed an important manifesto in praise of Belgian Republicanism.[35] One cannot help feeling that Renouard was working under the pressure of unusual commitment when he created *Sans Travail,* and one cannot help wondering whether some of this commitment was generated by his relationship to the political activist de Paepe at the time; or perhaps, on the contrary, he felt that *Sans Travail* was a sufficiently forceful statement of his response to a major labor crisis to serve as an homage to an important labor leader like de Paepe on the eve of the latter's founding of the Belgian Labor Party. If *Sans Travail* represents the limits of the humanitarian, as opposed to the overtly political, imagery of the oppression of the working class, still, this vision may well have been given added edge and tension by Renouard's involvement in contemporary labor history through de Paepe.[36]

Yet in considering the limits of Renouard's *engagement,* it must be stressed that the very nature of the 1884 crisis of the Lyons weavers was itself fraught with ambiguities and contradictions. On the one hand, the tocsin of ominous historical precedent sounded in the background. This was not the first time that a crisis had occurred in the Lyons weaving industry—far from it—and fifty years earlier the weavers had taken action. Still within living memory was the precedent of the revolutionary uprising of 1831, the so-called Révolte des Canuts, the only "Mouvement de révolte corporative" of the time,[37] when the silk workers, suffering from terrible working conditions combined with low wages and lay-offs, and perhaps stimulated by the ideals of the 1830 Revolution, after pressing their demands for a minimum wage, finally though briefly took over the city government. This insurrection was quickly put down by the army, and the hungry workers had to content themselves as best they could with the immortal words addressed to them by Casimir Perier, president of the council, after the restoration of order: "Il faut que les ouvriers sachent bien qu'il n'y a des remèdes pour eux que la patience et la résignation."[38] The city had been shaken by various economic crises and conflicts since that time, most notably in 1848 and 1871, and had experienced a particularly severe crisis in 1877. In 1884, the attitude of the government, now Republican, was far from being as overtly hard-hearted as it had been in the 1830s in its reaction to the plight of the Lyons weavers: the workers were now permitted to organize openly, and the Waldeck-Rousseau Law of March

21, 1884, constituted an attempt at reconciliation. It provided for the estab-
lishment of professional unions and for discussion of the interests of
workers and employers in a free forum. Nevertheless, the various workers'
syndicates quickly united to form a weapon of combat: their mission in
a sense remained that of the rebels of 1831, to obtain a minimum wage from
the manufacturers.[39] Even when the crisis deepened in the autumn of 1884,
the government remained conciliatory, perhaps because the press, and
presumably public opinion, was so sympathetic to the workers: in October
1884 it sent to Lyons a forty-four-man parliamentary commission to study
the situation of the unemployed weavers. The commission, however,
reported that the suffering of the Lyons workers had been much exag-
gerated by the sensational articles appearing in the press, and maintained
that the silk industry was merely experiencing one of those periodic crises
that had dogged the steps of its history, crises "inseparable from the life
of a great industry subject to the vagaries of an international market."[40]

But the situation of the Lyons weavers—part strike, part lay-off, not
quite either—depicted by Renouard was complicated by factors more
integral and concrete than the vagaries of the international market: these
weavers were, in fact, representatives of a dying system of manufacture
and an outmoded technology. They were hand-loom operators in a period
of increasing mechanization; and they worked in small, individual work-
shops rather than in more centralized and efficient factories. They were,
in short, home-based artisans of a dying trade. Indeed, the hand-loom
weaver had been represented as a prime example of "industries that are
disappearing" in a series of illustrations published by *L'Illustration* in 1881,
an engraving by Ryckebusch duly collected by van Gogh.[41] The *chefs
d'atelier* of these little workshops, like the old man represented by Reno-
uard, occupied an anomalous position somewhere between employer and
employee; dependent for their meager existence on the whims of the
market and the exigencies of the *fabricant* who farmed out the raw materi-
als and paid for the finished product, they were, at the same time indepen-
dent and proud of their skill. In the words of one spokesman of the period:
"Le tisseur lyonnais travaille sous le régime de la liberté absolue. Il n'est
pas un ouvrier d'usine, pour rien au monde il ne voudrait abdiquer sa
liberté; c'est une sorte d'artiste, il aime garder son indépendance, traiter
avec le fabricant de puissance à puissance, être maître de son modeste
atelier, plutôt que de goûter à la sécurité des travailleurs d'usines."[42]

The image of the long-suffering hand-loom weaver, oppressed yet

feisty—struggling for his right to a modest livelihood of independent craftsmanship against savage odds of local exploitation and increasing mechanization, threatened by international competition, brutal reprisals, and outright starvation—appears again and again in the work of socially conscious writers and artists in the nineteenth century. As early as 1831, Madame Desbordes-Valmore had penned a heartfelt tribute to the workers of Lyons, "Dans la Rue: Par Un Jour funèbre de Lyon";[43] and in 1877, on the occasion of another industrial crisis among the Lyons weavers, Victor Hugo, addressing a meeting at the Château-d'Eau held in their aid, declared that Lyons itself was the essentially French city, the Lyons worker the quintessentially French worker: "C'est la ville du métier," he maintained, "c'est la ville de l'art, c'est la ville où la machine obéit à l'âme, c'est la ville où dans l'ouvrier il y a un penseur, et où Jacquard se complète par Voltaire. . . . " "The worker of Lyon is suffering," Hugo asserted, "poverty creating riches."[44] In England, George Eliot had dealt with the plight of the hand-loom weaver in *Silas Marner,* published in 1861, and had touched on the subject briefly in the introduction to her "political" novel of 1866, *Felix Holt: The Radical,* in which she describes "the pale, eager faces of handloom-weavers, men and women, haggard from sitting up late at night to finish the week's work. . . ."[45]

It was in Germany, however, that the fate of the weavers received its most significant artistic formulation. One relatively minor incident, the uprising of the Silesian weavers of 1844, provided the major artistic expressions of sympathy and outrage. Poets like the socialist Ferdinand Freiligrath in his *Aus dem schlesischen Gebirge,* or, more unexpectedly, the conservative Emanuel Geibel in his *Mene Tekel,* commemorated the event, as did Carl Hübner, the Düsseldorf painter of socially conscious genre scenes in his ambitious *Silesian Weavers* of 1844. The most powerful of these earlier responses, which has been termed "Germany's greatest social lyric," is Heinrich Heine's *The Silesian Weavers* (inspired by the account of the uprising that the poet read in June 1844 in Karl Marx's *Vorwärts* in Paris), a bitter and relentless poem, with its stark refrain "Wir weben, wir weben!"[46] The most extensive imaginative response to the Silesian weavers' uprising, however, was Gerhard Hauptmann's moving drama *Die Weber,* published in 1892, a play which, although inspired by the 1844 uprising in Hauptmann's native province, was even more directly related to a trip its author made to the Silesian villages in the Eulenbirge in 1891 to refresh his boyhood memories and talk to eyewitnesses.[47] The circum-

stances of the weavers in the last decade of the century seemed as bad as they had been fifty years before, and many people who first read or saw the play, which was quickly forbidden on the stage by the government, believed the misery depicted in it was based on contemporary newspaper articles.[48] The contemporary, rather than the merely historical, significance of the weavers' tragedy represented in Hauptmann's drama no doubt inspired the imagery of the French anarchist artist Henri-Gabriel Ibels, in his poster for the French production of the play at the Théâtre Libre in 1892–93.[49] And no doubt it was the contemporary relevance of Hauptmann's play that inspired Käthe Kollwitz, when she saw its first performance in Germany by the Freie Bühne, to undertake her *A Weavers' Revolt* cycle, six plates, three lithographed and three etched, which brought the young artist her first great success when they were exhibited in Berlin in 1898. Kollwitz, following Hauptmann but also basing her imagery on her own research and her own interpretation of the meaning of the weavers' struggle, resorts neither to van Gogh's self-preoccupied individualism nor to Renouard's eyewitness objectivity in her version of the weavers' situation. Her cycle begins and ends with stark, unremitting tragedy, but the three central plates, *Deliberation, Weavers on the March,* and *Attack,*[50] show the weavers, downtrodden and starving though they may be, making decisions and taking collective action against their oppressors; even in *The End,* her print of the tragic aftermath showing the rebels' corpses brought home to their desolate cottage, the figure of the surviving woman, though tragically isolated, exhibits a kind of desperate resolution rather than mere resignation. Kollwitz deliberately altered the woman's original gesture of hand-clasping acceptance in an earlier version to that of clench-fisted determination in the final print.[51]

Renouard's drawing, then, is interesting in a number of ways, both in relation to van Gogh, who admired it, and in what it reveals about the limits of political expression in the art of the popular press. This study may also suggest that we rethink the actual position of van Gogh vis-à-vis journalistic illustrators like Renouard. Instead of seeing van Gogh as the important creative artist and the illustrators simply as aesthetically negligible minor sources of his inspiration, perhaps it would be more realistic to think of them all as fellow art workers, interested in the same subjects, moved by similar humanitarian impulses, moving within certain acceptable limits of engagement, and interested in developing similar naturalistic and expressive techniques, in exploiting the possibilities of certain innova-

tive formal devices, akin to those of contemporary documentary photography, to achieve their effects. Van Gogh himself wished to join the brotherhood of graphic artists he so deeply admired. When he wrote to his brother in February 1882, asking him to find out what kind of drawings the magazines would take, and continuing, "I think they could use pen drawings of types from the people, and I should like so much to make something that is fit for reproduction,"[52] there is no reason to doubt his sincerity; nor again, when he writes from The Hague in 1883, ". . . Painting is not my principal object, and perhaps I will be ready for illustrating sooner all by myself than if somebody who would not think of illustrations at all advised me."[53] Part of his closeness during these early years to an artist like his fellow countryman Anthon Rappard is doubtless based on their shared admiration for draftsmen like Herkomer, Holl—or Renouard. If his ambitions later changed and his formal language altered, it was perhaps more Paris and the impact of its potent avant-garde, rather than some kind of innate genius, that was responsible.[54]

Renouard's stock has, of course, dropped drastically in recent years, as has that of all the illustrators who were once so greatly admired by a broad spectrum of the public: their work is generally dismissed as sentimental naturalism, if it is considered at all, irrelevant to mainstream aesthetic achievement; that of photographers doing more or less the same thing, like Riis and Hine, and much later, Walker Evans, has, paradoxically risen. Van Gogh's reputation has of course soared sensationally since the 1880s, while Kollwitz has been dismissed by sophisticated criticism as aside from the point, although her work has always been admired by those who demand explicit statement of feeling and obvious political commitment in art. Whether these relative positions in the history of art are due to purely aesthetic decisions or to the pressure of more complex social and political mediations, or to the interaction of both, I leave the reader to decide.

Notes

1. Vincent van Gogh, *The Complete Letters* (Greenwich, Conn., 1959), II (393), 346–47.

2. Van Gogh, *Letters,* II (388b), 339, which should probably be dated after, rather than before, no. 393 on the basis of internal evidence.

3. Ibid. (394), 348–49. I have combined elements from both the English and French translations of this letter.

4. Albert Bellenger, born 1846, was a member of a family of distinguished wood engravers, whose work appeared in the *Magazine of Art, Le Monde illustré*, and *L'Art*, as well as in *L'Illustration*, where he was the last "graveur attitré." For an account of his achievements, and a view of the high esteem in which members of this profession were held generally, see Pierre Gusman, *La Gravure sur bois en France au XIX^e siècle* (Paris, 1929), pp. 24–26, 48, 201.

5. Only the first of the series, *Un Canut à son métier*, has previously been published, in relation to van Gogh's images of weavers. There is a tendency to confuse this work with the one that van Gogh actually requested from his brother, *Sans Travail*. See, for example, Charles Chetham, *The Role of Vincent van Gogh's Copies in the Development of His Art* (New York, 1976), n. 104, p. 242; and *Les Sources d'inspiration de Vincent van Gogh*, exhibition catalogue, Paris, Institut Néerlandais, 1972, no. 82.

6. For information on and bibliography about these illustrators, see *English Influences on Vincent van Gogh*, exhibition catalogue, University of Nottingham, 1974–75, especially p. 48, although this work is concerned mainly with English illustrators.

7. *Anthon van Rappard: Companion & Correspondent of Vincent van Gogh: His Life & All His Works*, exhibition catalogue, Vincent van Gogh Museum, Amsterdam, 1974, p. 43.

8. Paul Renouard, *Eaux-Fortes, mouvements, gestes, expressions* (Paris, 1907). Renouard had been a student of Pils, and collaborated with his teacher on the ceilings of the Opéra in 1875. There is no recent monograph about his work. It was Béraldi who called him the "Wandering Jew" (Henri Béraldi, *Les graveurs du XIX^e siècle*, Paris, 1885–92, XI, p. 188).

9. Michel Melot, "Paul Renouard, Illustrateur," *Nouvelles de l'estampe*, no. 2 (Feb. 1971): 71. Renouard's style had been admired as early as 1874 by Eugène Veron, in an article in *L'Art*. See Chetham, *Copies*, 136 and nos. 123 and 124.

10. Clément-Janin, "Paul Renouard," *Print Collector's Quarterly* IX (1922): 140.

11. Gabriel Mourey, "A Master Draughtsman: Paul Renouard," *The International Studio* X (1900): 166.

12. Alder Anderson, "Some Sketches by Paul Renouard," *The International Studio* XXIII (1904): 225.

13. Van Gogh, *Letters*, III (R14N), 334. For references to the *Enfants assistés* series, see also specifically (R29), 367, where he mentions *La Crèche* and *Le Change*.

14. Van Gogh, *Letters*, I (250), 500.

15. The *Miners* was reprinted in *L'Illustration* of 1886, LXXXVII, p. 73. Also see van Gogh, *Letters*, III (R19), 345.

16. It is in these works that the influence of Japonisme on Renouard's drawing style comes out most clearly. Significantly enough, it was a Japanese art lover, Tadamasa Hayashi, who put together a complete collection of Renouard's works, which he willed to the Tokyo Museum, where they were exhibited in a special gallery. See Melot, *Nouvelles*, p. 70, and *Catalogue d'une collection de dessins et eaux-fortes par Paul Renouard . . . offerte par Tadamasa Hoyashi* [sic] *à un Musée de Tokio, mai, 1894*.

17. Van Gogh, *Letters*, III (R30), 372.

18. Van Gogh, *Letters*, II (389), 341.

19. See above, p. 97.

20. "La Crise Lyonnaise," *L'Illustration* LXXXIV (Oct. 25, 1884): 267.

21. See above, p. 98 and n. 10.

22. And think of what Ingres would have done with the bulge of that shawl; even Millet would have muted such offensive realism. Only van Gogh goes this far in rendering homeliness, and he, of course, perceives it as moral beauty, which is not quite the same thing.

23. Van Gogh, *Letters*, II (351), 250.

24. Ibid. (393), 347–48. For a similar point made about Renouard's style by Véron in 1874, see above, n. 9.

25. Ibid. (351), 250. Chetham, *Copies*, 117, suggests that van Gogh's interest in weavers may have been stimulated by his devotion to the novels of George Eliot, particularly *Felix Holt* and *Silas Marner*, "both of which dealt with the effects of the industrial revolution on weavers." While this may be true of *Silas Marner*, there seem to be no more than two sentences at the beginning of *Felix Holt* about the subject.

26. The letter "F" in the list of representations of weavers that follows refers to the catalogue numbers in J.-B. de la Faille, *The Works of Vincent van Gogh: His Paintings and Drawings*, rev. ed. (New York, 1970). Paintings: F24, F26–27, F29–30, F32–33, F35, F37, F162. Watercolors and Drawings: F1107–12, F1114–16, F1116a (verso), F1118–25, F1134, F1138, F1140.

27. But van Gogh painted the work that comes closest to *Un Canut, The Loom,* F30, in May 1884, before Renouard had even made his drawing. Renouard's group did, however, inspire a painting by the Norwegian naturalist Sven Jorgensen: *Out of Work,* of 1888, Oslo, National Gallery, is clearly derived from *Sans Travail.*

28. Van Gogh, *Letters*, III (R14), 334–35.

29. This had appeared in the *Graphic* of Feb. 18, 1871. See *English Influences*, fig. 25, and also another variant of the same work, which Herkomer also did as a painting, *The Last Muster* of 1875 that van Gogh owned a copy of. For Renouard's interest in the same theme of the old soldier-pensioner, see his series of the pensioners at the Invalides, *L'Illustration* LXXXVIII (1886): 124–25; 128–29; 137; 144, 145; and fig. 3 here.

30. F1662. Also see *English Influences*, fig. 109.

31. F702. Also see the drawings F997–98.

32. *Père Tanguy*, F363, F364; *The Postman Joseph Roulin*, F432; *Patience Escalier*, F443, and more apposite, F444.

33. Riis's photographs were converted into line drawings when they appeared in the story "How the Other Half Lives" in *Scribner's*, Christmas 1889. Riis, like future documentary photographers, complained bitterly about the way his subjects insisted on posing when *he* wanted a candid picture: "Their determination to be 'took' the moment the camera hove into sight, in the most striking pose that they could hastily devise, was always the most formidable bar to success I met." See Alexander Alland, Sr., *Jacob A. Riis: Photographer & Citizen* (Millerton, N.Y., 1974), pp. 28, 29. The impact of documentary photography on popular illustration and of the latter on the former has not yet been studied systematically as far as I know.

34. *L'Illustration* LXXXIV (Nov. 15, 1884): 318.

35. See Walther Thibaut, *Les Républicains belges* (1787–1914) (Paris, n.d.), pp. 90–91; L. Bertrand, *César de Paepe, sa vie, son oeuvre*, 1908; M. Oukhow, "César de Paepe en de

groei van het sociale bewustzijn in Belgie," *Socialistiche Standpunten,* no. 1 (1962): 76–90; J. Kuypers, "César de Paepe van de Nederlands gezindheid van een internationalist," *Nieuw Vlaams Tijdschrift* 18 (1965): 150–81; as well as the entry on de Paepe in *Encyclopedie van de Vlaamse Beweging;* I am grateful to Kirk Varnedoe for this information. For further information about de Paepe, his activities in the International, and his radical but non-Marxist position on labor, war, and various social issues, see Edouard Dolléans, *Histoire du mouvement ouvrier* (Paris, 1936), I, pp. 303, 312–13, 314, 335, 347; and 1939, II, p. 20. Renouard's connection with Belgium continued, albeit on a very different level, into the twentieth century. He was the artistic director and contributed most of the lithographed plates to the sumptuous limited-edition volume commemorating the seventy-fifth anniversary of Belgian independence, *En Commemoration des fêtes du LXXV^e anniversaire de l'Indépendance de la Belgique et de L'Exposition Universelle de Liège, 1905* (Liège, 1905), which was dedicated mainly to flattering images of the aged King Leopold II and members of the royal household.

36. Of course, we do not know exactly how much freedom Renouard had in choosing particular aspects of his assignments. The editors must have made general suggestions, but how far Renouard could go in emphasizing a personal viewpoint, or indeed how far he wished to go, is open to question. Nor is it clear whether the commentaries that accompanied his drawings were written before or after, or in collaboration with the draftsman's report.

37. See Dolléans, *Histoire,* I, p. 58.

38. For a detailed account of the Lyons uprising of 1831, though by no means an objective one, see Auguste Baron, *Histoire de Lyon pendant les journées des 21, 22, et 23 novembre 1831* (Lyons, 1832).

39. E. Pariset, *Histoire de la fabrique lyonnaise: Etude sur le régime social et économique de l'industrie de la soie à Lyon, depuis le XVI^e siècle* (Lyons, 1901), pp. 395–96.

40. *Bulletin des soies et des soieries de Lyon: Organe internationale de l'industrie de la soie,* Oct. 18, 1884, p. 2.

41. *Les Sources d'inspiration,* no. 95, p. 26.

42. Mathé Ainé, *Les Tisseurs en soie de Lyon, 1769–1900* (Lyons, 1900), pp. 59–60. Also see M. Villermé, *Tableau de l'etat physique et moral des ouvriers employés dans les manufactures de coton, de laine et de soie* (Paris, 1840), I, pp. 352–99, for the physical condition of Lyons workers somewhat earlier in the century; and Y. Lequin, "Classe ouvrière et idéologie dans la région lyonnaise à la fin du XIX^e siècle," *Le Mouvement social,* Oct.–Dec., 1969, for growing political self-consciousness. Lequin's *Les Ouvriers de la région lyonnaise (1848–1914),* 2 vols. (Lyons, 1977), is the essential study of the workers of Lyons.

43. *Oeuvres choisies,* ed. F. Loliée (Paris, n.d.), pp. 201–2. Also see Desbordes-Valmore's letter to Gergerès on the Lyons uprising, Nov. 29, 1831, Lyon, pp. 262–65.

44. Victor Hugo, "Les Ouvriers lyonnais," Sunday, March 25, 1877, in *Oeuvres politiques complètes: Oeuvres diverses,* ed. F. Bouvet (Paris, 1964), pp. 755–56.

45. George Eliot, *Felix Holt: The Radical* (Boston, 1896), I, pp. 7–8.

46. F. Ewen, ed., *The Poetry and Prose of Heinrich Heine* (New York, 1948), p. 38.

47. Hauptmann also made use of Alfred Zimmermann's *Blüte und Verfall des Leinengewerbes in Schlesien* (Breslau, 1885). See Margaret Sinden, *Gerhart Hauptmann: The Prose Plays* (Toronto, 1957), p. 53.

48. Sinden, *Hauptmann*, p. 69.

49. See Gabriel Weisberg, *Social Concern and the Workers*, exhibition catalogue, Utah Museum of Fine Arts, Salt Lake City, 1974, p. 32 and nos. 29, 79. However, the plate reproduced there seems to be of miners rather than weavers.

50. See Otto Nagel, *Käthe Kollwitz* (Greenwich, Conn., 1971), figs. 21 (lithograph, 1898, K1 36), 22 (etching, 1897, K1 32), and 23 (etching, 1897, K1 33).

51. See Nagel, *Kollwitz*, fig. 31 (Sketches and Study for the Print *The End*, c. 1897, Dresden, Print Cabinet), where the artist's final choice of gesture is made explicit in the lower margin.

52. Van Gogh, *Letters*, I (174), 313.

53. Van Gogh, *Letters*, II (292), 56.

54. See B. Welsh-Ovchěrov, *Vincent van Gogh, His Paris Period, 1886–1888* (Utrecht and The Hague, 1976).

7

Léon Frédéric and
The Stages of a Worker's Life

About 1895, the Belgian painter Léon Frédéric created a remarkable and ambitious triptych, *The Stages of a Worker's Life*.[1] I say "ambitious" advisedly, for the work is grandiose in scale, the central panel measuring 162.5 cm × 187 cm and the sides each 162 cm × 94 cm, and is packed to bursting with monumental figures[1]. At the same time, the triptych must be considered ambitious in the sense of being exhaustive in descriptive accuracy, for it is obsessively minute in its detail. Frédéric conceives of pictorial truth as all-inclusive, right down to the defining proletarian detail of the tattoo on the bulging forearm of the bending navvy in the foreground of the left-hand panel. Yet impressive as it is, *The Stages of a Worker's Life* is riddled with contradictions—contradictions, it must be added, that make it all the more interesting for the contemporary viewer. Here is a work, created late in the nineteenth century, that seems to look backward and forward with almost equal intensity: backward to Frédéric's national heritage—to Brueghel, Rubens, and Jordaens—and to the more recent past of proletarian depiction: Courbet, Millet, Bastien-Lepage, and Ford Madox Brown. Yet at the same time, the *Worker's Life* triptych seems to look ahead to both the subject matter and style of the murals of the New Deal, to the techniques of Magic Realism, and even to the obsessive-compulsive vision of Surrealism. Then, too, this is a work that seems at once to be prototypically secular in its fixation on material detail, the defining particularities of texture, light, and surface, as well as in its socially conscious theme, and yet at the same time suggests the religious

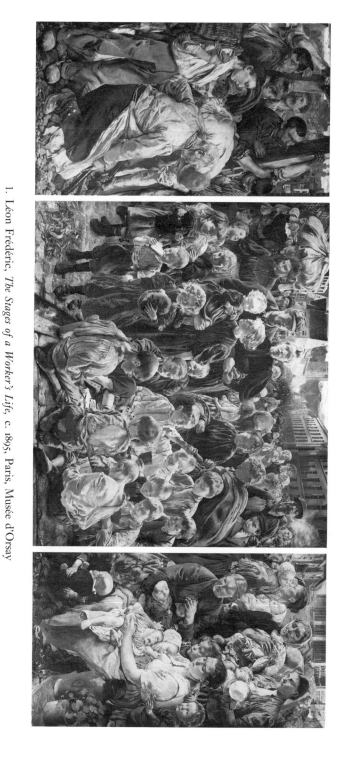

1. Léon Frédéric, *The Stages of a Worker's Life*, c. 1895, Paris, Musée d'Orsay

in its symbolic overtones, its mysterious heightening of effect, and in its very format: the triptych is traditionally associated with Christian art. Still another interesting contradiction: the work is at once linear in the definition of its contours yet fluid and painterly in its coloration. Looking at *The Stages of a Worker's Life,* one is tempted to paraphrase Cézanne's aphorism about making Impressionism something solid and durable like the art of the museums. Frédéric seems to have wanted to make of Realism something solid and durable—like the art of the churches, perhaps, more than that of the museums—but in both cases, it is the monumental impulse, the ambition to go beyond the mere recording of everyday experience, that is striking.

The Stages of a Worker's Life is far from occupying a unique place in its creator's oeuvre. Léon Frédéric (1856–1940), who was once the best-known painter in Belgium,[2] created five other triptychs, several large-scale series, as well as many individual paintings dealing with the subject of peasants and workers during the course of his long and productive career. Nor was Frédéric's monumentality in the depiction of the subject nor his choice of the traditionally religious format of the triptych for its representation unusual at the time. The last two decades of the nineteenth century saw a proliferation of multipartite representations dedicated to the theme of work and workers. The best known of these are the sculptural projects for monuments to labor, like those of Dalou and Rodin in France, Constantin Meunier in Belgium, and the paintings of both Meunier and Eugeen Laermans in the latter country; or the more combative, at times openly revolutionary, print cycles of Käthe Kollwitz in Germany. Nor was Frédéric by any means alone in turning to the triptych to body forth proletarian experience. The last decades of the nineteenth century witnessed a revival or, more precisely, a transformation of the traditionally Christian tripartite format for the representation of contemporary secular subjects.[3] Constantin Meunier's *Triptych of the Mine* transformed the traditional motif of the Road to Calvary into a poignant visual chronicle of the mine worker's brutalizing occupation. Representations of groups of miners entering and leaving the mine shaft flank a more generalized central panel entitled "Mount Calvary," depicting the exhausted workers trudging up a barren, smoky hill to their destination.[4] Eugeen Laermans (1864–1940), another Belgian artist deeply identified with the condition of the working class and committed to a harshly realistic representation of its oppression in his work, used the triptych format in his multifigured

Immigrants of 1894, a depiction of one of those many mass migrations that marked the demography of the end of the century. In this composition the surging crowd of departing poor people which fill the vast breadth of the central panel almost to the distant horizon is flanked by two, more compressed, vertical groups: "The Farewell" to the left and "The Last Look" to the right.[5]

Frédéric himself had turned to the triptych form as early as 1881–83 in his monumental *Chalk Vendors*[2] (now in the Musées royaux des Beaux-Arts, Brussels). Here, the artist plays the synchronic unity of the three-part structure against the implied diachronicity of his subject: the working day of a poor family. The figures are represented in the left-hand panel setting out for work in the morning, coming toward the spectator, and, on the right, returning to their hovel in the evening, with their backs turned to the viewer. In the central panel, the family is depicted as it gathers for the midday meal on the outskirts of Brussels, whose buildings mark the farthest margins of the background. Seated on the ground, their feet thrust before them, the ragged group (with the notable exception of the tired mother and her crying toddler) clasp their hands in prayer, in a sort of plein-air version of the *Potato Eaters*. All the paraphernalia of poverty-painting are present: bare, dirty feet; broken crockery; and awkward poses, but they are brought to life somehow by the way the textures of the worn-out objects, their surfaces roughened or softened with wear, and the crude and individuated structure of hand-wrought containers and utensils, are lovingly discriminated by the artist, as are the stones and weeds on the ground beneath these social outcasts. Each panel suggests one of the times of day; the triptych as a whole, the unending round of hopeless drudgery that is the lot of the *lumpen Proletariat*. Frédéric weaves together a certain compassionate reminiscence of the traditional motif of the Rest on the Flight into Egypt with a lyrical sense of color, light, and differentiated texture— wicker, wood, use-worn cloth or cast iron—and a keen sense of the realities of contemporary desperation, caught in the awkward angles of poses, the snuffly faces of the children, the vulnerable, bald head of the father and his withered, sickly features. Ultimately, it is difficult to decide whether the biblical precedent constitutes a kind of effort on Frédéric's part to soften and diffuse the revolutionary potential of his material, or whether, as seems more likely, it exists as an ironic foil to the grim actualities of present-day marginal existence.

2. Léon Frédéric, *Chalk Vendors*, 1881–83, Brussels, Musées royaux des Beaux-Arts

Frédéric, like many of his socially conscious contemporaries, also turned to another multipartite form, the series, for the depiction of working-class experience. In his *Grain* series, dealing with the production and conversion of grain into bread, and his *Flax* series, dealing with the cultivation of flax and its transformation into linen clothing, the artist renews the traditional motifs of the Labors of the Months with details of modern productive processes in two related series dedicated to the most basic necessities of life: food and clothing. The two series, created from about 1886 to 1889, consist of eleven charcoal panels of the works of the months for each industry united by a central allegorical panel of the twelve months of the year nourished by Mother Earth. The latter was represented by a peasant woman, "heavily handsome," in the words of one contemporary critic, who added: "Her breasts hang huge—breasts which themselves are Worlds. And groveling at her feet, with outstretched arms, clinging in groups to her body, are men, represented as plump, red-haired children. . . ."[6]

These cycles are basically cheerful. Frédéric, like most of his predecessors—Millet and Breton, for example—depicts some of these rural occupations as onerous, but rarely as painful; these farmworkers, unlike the members of the suburban subproletariat represented in the *Chalk Vendors*, do not seem deprived, dirty, or undernourished. Nor is there ever a hint that 40 percent of all those involved in the flax industry at the time were children below the age of sixteen; nor that the weaving industry was in a state of almost perpetual unrest. One can only think, looking at Frédéric's plump and cheerful women and children gathered around the communal oven, or at his stalwart old weaver with children playing at his feet, of the rather different vision of the lot of the rural or industrial worker presented by van Gogh, by Paul Renouard, or by Käthe Kollwitz in her *Weavers* cycle, which constitutes a fierce indictment of the very system Frédéric extolls—or, more accurately simply chooses to ignore as a specific form of social organization—in his series devoted to flax and grain. The presence of the allegorical figures at the center of these two cycles sets the basically reassuring, optimistic—and unrealistic—tone of the work as a whole. Indeed, the realism of the details of agricultural and artisanal technology functions almost as a diversionary tactic. The artist's didacticism, his visual intention to instruct us about the processes of sheaf-binding, hackling, grain-sifting, and so on, work to divert us from the problematic position of the human beings who use these implements,

the social meaning of these processes. The message of these works is ultimately that the earth will provide for her needy children out of the endless riches of her body, and, presumably, the immeasurable generosity of her heart.

The problematic temporal implications of the serial form itself are raised by Frédéric's cycles of grain and flax. Is the timespan implied by the serial form to be understood as *historical* time, time in which revolutionary consciousness may develop and take effect, as it does in Kollwitz's *Peasant War* and *Weavers* series, for example, in which the oppressed workers involved step out of, judge, or challenge the very notion of the "natural cycles" in which they are entrapped? Is the implied temporal sequence of the series form conceived of as the very medium of change itself, or is it rather envisioned as that unalterable periodicity, bodied forth in the Labors of the Months of the Middle Ages, carried on in the calendar pages of the *Très Riches Heures* of the Duc de Berry in the fifteenth century and Brueghel's *Seasons* in the sixteenth, in which peasants go about their foreordained and ever-repeated seasonal activities? Cyclical time, as opposed to historical time, assumes that peasants or workers are completely associated with the natural order itself, fulfilling their tasks according to the rhythm of the seasons. Human beings are thereby imaginatively transformed into unconscious instruments of inalterable processes, anonymous participants in unchanging rituals, rather than being conceived of as rational beings living at specific historical moments with certain choices, prerogatives for change. No ideological structure has had a more powerful hold on the artistic imagination than the one that associates the peasant with nature itself: hence, the enduring vitality of the traditional cyclical form of the series of the seasons, with its essentially conservative implications. Millet's *Seasons* of 1868–74 offer a later nineteenth-century example of the genre, and Monet's *Haystack* series at the end of the century is in a sense a final reiteration of the theme, with the mounds of heaped-up hay or grain, their architectural shape and cultivated substance clearly the product of human effort, now functioning as metonymic references to the absent human agents who created them.

This cyclical conception of peasant life is combined with a typological one in Frédéric's *Stages of Peasant Life*[3], an earlier counterpart of the *Stages of a Worker's Life* triptych, created about 1885–87. Here, in a five-panel series, Frédéric has in effect invented a serial form that at once looks back to the folk tradition of the life-cycle representation, like that

of the nineteenth-century *image d'Epinal*, the *Degrés des ages*, with its clear delineation of the conventionalized type and deportment suitable for each unit of the life cycle, and at the same time looks forward to such attempts as those of the German photographer August Sander to create an empirical, photographic sociology in which human types are categorized by means of exhaustive examples set within a framework of social class, age, and occupation. Indeed, Frédéric's *Stages of Peasant Life* offers an interesting analogy with Sander's project of the Stamm-Mappe, or "Home Album," which the photographer had begun as early as the 1890s, recommenced in 1911, and then finished in Westerwald in 1927, in which the individual examples, arranged according to certain seemingly essential archetypes, were ultimately to reproduce all the characteristics of mankind in general.[7] Such types of "social investigation," combining minutely recorded fragments of empirical fact with an overarching archetypal or symbolic framework, are ultimately ambiguous in their effect, reflecting a kind of ambivalence on the part of their creators toward their peasant or working-class subjects. It is unclear whether we are meant to view these people as individuals or as types; their destinies as natural fatality or as historically determined; their gradual debilitation and withering as something they share with trees or cliffs—for example, blooming and fading, picturesque erosion—or the unhappy results of an unjust class system.

Many of these ambiguities are present in Frédéric's *Stages of Peasant Life* series, and, it must be admitted, give it a certain tension and piquancy that it might not otherwise have. The five panels, each measuring 113 cm × 201 cm (now in the Musées royaux des Beaux-Arts), represent: little girls; little boys; engaged couples; married couples with children; and old people with children and grandchildren. Frédéric has managed to steer amazingly clear of the usual symbolic accompaniments to such groupings, aside from a low-keyed association of women and religious faith in the form of a background church steeple in the *Little Girls* panel. The same daisy-strewn field is used as a setting throughout; there are no withered leaves or sere branches in the old-age panel, an avoidance of the temptations of the pathetic fallacy unusual in such projects. Indeed, poses and compositional strategies in *Stages of Peasant Life* are distinctly related to the formulae of the provincial group photograph: the same combination of formalized frontality; awkward, irregularizing plenitude of unplanned detail; and unconscious individuation of pose or gesture are present here.

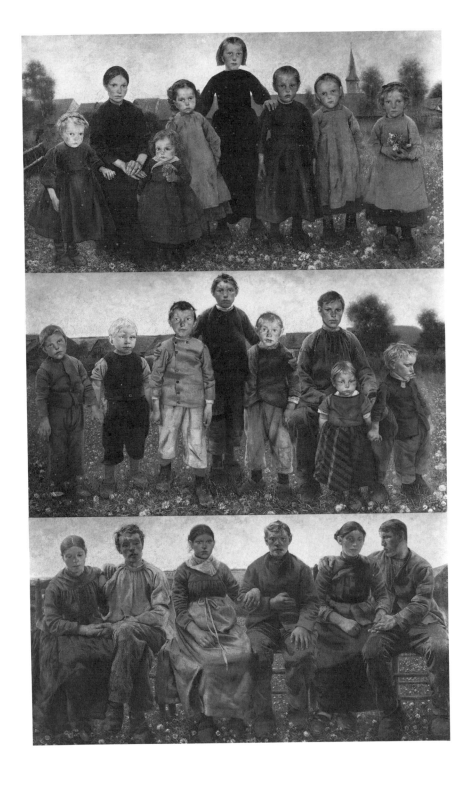

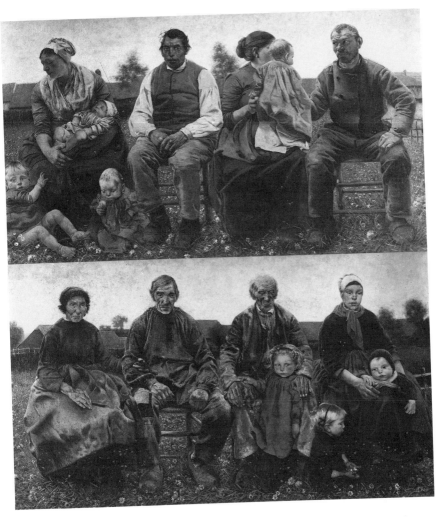

3. Léon Frédéric, *Stages of Peasant Life*, 1887, Brussels, Musées royaux des Beaux-Arts

Frédéric, however, as a painter and draftsman, is freer to concentrate on, overemphasize even, chosen idiosyncrasies: the moony, frozen pose of the little boy on the far left in the *Little Boys* panel, for instance, is subtly emphasized by sophisticated drawing and knowing placement of the figure.

The original participants thin out, diminishing panel by panel. Time is envisioned as the grim reaper as well as the nourisher of the peasant family. There are eight young boys and an equal number of young girls but only three pairs of engaged couples, although imminent increase is

suggested by the subtly swelling breasts and belly of the central engaged girl. There are only two married couples left out of the original group, but their number has been increased by the addition of four babies. In the final panel of old people, only three members of the original group are left, but the fourth chair is now occupied by a grown daughter whose own children, one of them standing between the knees of the time-worn patriarch to the left, are almost the age of the children represented in the original panels. The implications of the final panel are clear: the cycle will begin again in an ever-repeating and inescapable sequence. The fact that it is a young woman who occupies the place left empty by the death of a member of the older generation rather than a young man is significant for Frédéric's iconography generally. It is woman, in his imagery, who, as the instrument of fecundity, insures the continuity of the race; is the essential link in the cyclical recurrence of the stages of peasant life; and, at the same time, provides an analogue for the fecundity of the natural order itself.

Frédéric returned to the triptych form rather than the series to create the urban counterpart for the *Stages of Peasant Life*, *The Stages of a Worker's Life* [1], ten years later. Nevertheless, a strong sense of determining temporality—of the urban worker's life being controlled by the same inexorable teleology as the peasant's—is suggested in the central panel by means of dramatic manipulation of perspective. Here, passage through time is suggested synchronically by movement back into space, toward the high, steadily narrowing and darkening passage leading toward the distant church and mountains at the vanishing point of the high horizon. In the central panel, the ages of the workers are equated with their positions in space. Youth occupies the foreground, maturity the middle ground, and old age the background; death, the ultimate stage of life, is marked by the funeral coach approaching the meeting point of the orthogonals created by the urban architecture; the workers' passage through the stages of life is cleverly equated with their position in pictorial space, an equation in which the "vanishing point" assumes a literal meaning in terms of the life cycle.

Sexual rather than chronological categories determine the composition of the side panels. To the left are grouped men of all ages in the work cycle, from adolescence to old age, engaged in manual labor or observing it; in the right-hand panel are crowded women, conceived of purely in their function of mothers and nurturers, in opposition to the definition of

the male by his function as manual worker. All the women give their breasts to or embrace their offspring; even the pensive old woman in the center of the panel seems to be meditating on her vanished fruitfulness as she clutches a baby to her withered breast and stares down at the nursing mothers at her feet. Behind the laboring men are factories; behind the women, market stalls, so that the very details of the setting intensify and support the gender-linked separation of their appointed realms.

Frédéric's style, in *The Stages of a Worker's Life,* hovers on the border between secular, socially concerned realism on the one hand and a hyper-realism of detail and extreme intensification of expression on the other. It is a style that at once looks back to the Northern tradition in the work of Brueghel, or, above all, Hugo van der Goes, and, at the same time, is extremely contemporary in its coincidence with the supra-empiricist vision of *Symbolisme.* The foreground figures of children carrying bread or nibbling at it, playing cards, or looking back over a pitcher of milk, all superbly blond and with skin transparent as angels', are rimmed, at times drenched, with a light that seems to have no rational source or earthly origin; the youths playing cards in the foreground display their bony backs to us with a vulnerability that seems to declare a fate rather than an ordinary future; the pose, attitude, and pensive expression of the young woman who stares directly out at us, off center, from the confines of her lover's embrace, suggests the inner light of awakening conscience rather than casual dalliance caught at an empirically resolvable moment.

But it is the material of the side panels that most clearly confirms a generically sacred rather than a merely profane reading of the piece, for the workers struggling with heavy beams in the middle ground of the left, "male" panel seem clearly to refer back to the iconography of the Raising of the Cross, while those digging in the foreground, if they serve to remind the viewer of such secular social criticism as that implied by Courbet's *Stone Breakers,* which had indeed been shown in Brussels more than forty years earlier, in this context refer still more strongly to traditional Northern, particularly Rubensian, visual imagery of martyrdom or of Crucifixion. The women in the right-hand panel, for their part, clearly refer to the traditional imagery of Virgin and Child.

It is in its heightened religious overtones, its emphasis on supra-empirical categories—the foreordained stages of life and the gender-defined polarities of working-class occupation—as well as in the freezing and intensification of individual figures and motifs, that Frédéric's *Stages*

of a Worker's Life most sharply distinguishes itself from its nearest anteced-
ent, Ford Madox Brown's innovative *Work* of 1852–65, which surely must
have in some way inspired Frédéric's painting. Brown himself, of course,
had had a Belgian training: he had studied with Baron Wappers at the
Academy in Antwerp. Coincidentally, Brown and Frédéric had made
their only appearances together in the exhibitions of Les Vingt in its final
show of 1893; there the English painter's work, including his *Cordelia's
Portion, Romeo and Juliet,* and *Portrait of Mrs. Madox Brown,* were
"viewed with respectful wonder" by the Belgians, according to one recent
scholar's account.[8] In addition, a reproduction of Brown's *Work* was
published in Ford Madox Hueffer's study of the artist in 1896; and cer-
tainly, as one of the great popular successes of English art of its time,
Brown's *Work* had made an international impact, visual as well as icono-
graphic, before that date. The vulnerable, exposed backs of the children
in the foreground; the impressive musculature and down-to-earth yet
heroic poses of the navvies in the foreground of the left-hand panel; the
visual complexity of the motifs and the heroic ambition to create a work
both innovative and charged with meaning about one of the most prob-
lematic and central issues of modern life—the urban worker and his
condition—seem unthinkable without Brown's precedent. Yet, at the
same time, it is in comparison with Brown's work that the idiosyncratic
features of Frédéric's triptych stand out with the greatest clarity, for
Brown's iconography is clearly secular, a morally charged ethical allegory
of modern work and its social conditions, rather than religious and ulti-
mately fatalistic in its implications like Frédéric's. For Brown, it had been
precisely the juxtaposition of "those who work" with "those who cannot
work" and "those who need not work" that was the main point of the
painting; added touches of social commentary as well as a visual equiva-
lence of intellectual analysis of the problems of work and workers were
provided by the inclusion of such contemporary "brain workers" deeply
concerned with the issue of labor as Thomas Carlyle and the Reverend
F. D. Maurice, head of the Working Men's College, to the right.[9] There
are no similar references to contemporary thought about the working
classes or, indeed, any indication that workers as a class were problematic
in Frédéric's triptych, despite considerable interest in and involvement
with left-wing politics on the part of many advanced Belgian painters and
literary figures at the time,[10] as well as significant action on the part of
Belgian workers themselves to gain power and improve their condition

and status at about the time *Stages of a Worker's Life* was created. The Belgian Workers' Party had been founded in 1885; massive strikes and revolutionary unrest had swept the nation in the following year; in 1890, 80,000 people had demonstrated in Brussels for universal suffrage which was in fact achieved by a week-long general strike organized by the Socialists in 1893. No inkling of this working-class activism, nor indeed of the inner dissensions that split the workers' organization itself during these years, is provided by Frédéric's iconography or his pictorial structure. Hard manual labor for the male half of the proletariat; procreation and nurturing for the female portion; death at the end for all; the binary division of function; the eternal recurrence of preordained roles—these are the leitmotifs of Frédéric's vision of the working class and its condition, or, more correctly, of its transcendent fate.

Frédéric's conception of women, specifically of the peasant woman as a primordial image of fecundity, is determined by a related quasi-religious ideological construction of the human, particularly working-class, condition—one that enjoyed an international vogue among artists and writers at the turn of the century.[11] It was precisely at this time that artists as varied in other respects as Mary Cassatt, Giovanni Segantini, Teofilo Patini, Fritz Mackenson, and Paula Modersohn-Becker turned to the theme of the Mother and Child[4]. Cassatt envisioned the contemporary woman and her offspring, usually but not invariably upper-middle class, as a kind of modern Madonna motif. The Swiss Segantini, in his *Two Mothers* of 1889, exploited the analogy uniting the peasant woman with the unconscious instinctualism of the animal world in his image of the woman who has fallen asleep nursing her child in the barn side by side with the cow nursing her calf.[12] The Italian Patini, in his *Mattock and Milk* of 1883, based his iconography on the same "natural" division of function as that represented in *The Stages of a Worker's Life:* the husband tills the arid soil on which the wife, a modern—and literal—Madonna of Humility sits to give suck to their child.[13] The German artist Fritz Mackenson seats his peasant woman on a wheelbarrow in the midst of a field as she gives her infant the breast, connecting the nursing mother with the soil by means of an agricultural implement.[14] It is within this context of the peasant woman envisioned as a natural principle of generation and nurturance that Paula Modersohn-Becker's somewhat later imagery of maternity assumes its proper position. Her peasant woman, pressed to the surface of the picture space, confronting the viewer inexorably with distended breast

and blindly suckling infant; or even more, her naked nursing mother curled like a protective animal about her nursing infant on the floor; or, in another version of the theme, kneeling naked, large-breasted and hieratic in an undefined, circular, central space—all are simply final distillations and intensifications of a generic motif of her time, relieved of its naturalistic appurtenances, freed from the constrictions of historicity or contextual definition to function purely in the realm of the archetypal.

Yet Frédéric's detailed and sensually charged concentration on fecundity as the defining—and only defining—feminine role in *The Stages of a Worker's Life* may have had more specifically situational and particularly Belgian determinants. The rich, damp flesh, the plethora of distended, naked breasts, the greedy or sleepily satiated infants, the curled toes, the broken pitcher, the spreading flowers, the whole atmosphere of subterranean sexuality that suffuses the entire panel with a kind of undifferentiated voluptuousness, a sensuality underscored by the very refinement and nuance of the pictorial language itself, may have a specifically Belgian source and motivation. By this I mean not merely Flemish pictorial precedent in the form of such allegories of fecundity as Jordaens's *Fruitfulness* or his *Riches of Autumn,* with their swelling, tightly packed forms and sensual flesh, fruit and flowers, but, more mundanely, a well-publicized and critical demographic issue of Frédéric's time: the drastic decline in the Belgian fertility rate. This decline had occurred in conjunction with the rapid modernization and industrialization that had occurred particularly in the urban areas of Belgium between the years 1890 and 1910. This reduction of fertility, as the Belgian sociologist Ron J. Lesthaeghe has pointed out in his study *The Decline of Belgian Fertility, 1800–1970,* [15] is directly correlated with one social variable above all others: an increasing degree of secularization. Says Lesthaeghe: "Of all the variables that have emerged as indicators of fertility reduction in late-nineteenth-century Belgium, secularization seems to be the one that can be singled out, both as the most powerful variable at the outset of the fertility decline and as the one with the longest lasting effect or the highest degree of persistence."[16] Or, to put it another way, as this authority does in explaining why Belgium should have experienced one of the earliest and consistently highest declines in marital fertility of all the countries of Europe: "Traditional ethical and religious constraints had to yield to a more rational outlook before fertility was brought within the calculus of conscious

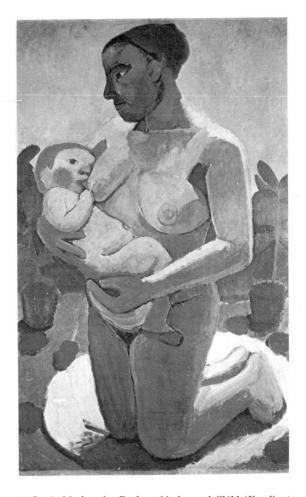

4. Paula Modersohn-Becker, *Mother and Child (Kneeling)*, 1907 Bremen, Ludwig-Roselius Sammlung

choice, and before the direct impact of socioeconomic development could be felt."[17]

Frédéric, then, in his triptych *The Stages of a Worker's Life*, was hypostatizing the values of patient, unquestioning manual labor and natural, mindless reproduction when a large section of the urban working classes of his country had already abandoned just those ideological underpinnings—religious acquiescence and fatalistic acceptance of one's lot—

that had made them viable ways of life in the past. In short, in a painting dealing with a working-class subject, he was preaching time-honored religious values when the working classes had already opted for essentially secular ones. One might speculate that his audience, like the artist himself, was predominantly middle class, and that his vision of fruitful women and industrious workers was based more on wishful thinking and aesthetic fantasy than on contemporary social reality.

If, in *The Stages of a Worker's Life,* Frédéric's realistic language, in its intensification of detail and irrational lighting, verges on the visionary inventions of *Symbolisme,* and his apparently empirical synthesis of various aspects of proletarian life actually hovers on the brink of mythology, then we should not be surprised to find the artist adopting Symbolist representational conventions wholeheartedly concomitantly with, or shortly after, his creation of this triptych. Indeed, such is the case. In *La Nature* of 1897, the problematic aspects of the human condition are resolved through an imagery of sheer fecundity, the question of realistic allegory discarded in favor of decorative enrichment of form. In this pentaptych, Frédéric carries his notion of fertility as the solution to human problems, as well as his essentially conservative cyclical notion of time, to their ultimate conclusions. Fact and the naturalistic recording of contemporary situations are discarded in favor of—or more accurately, overridden by—the unchecked energy of burgeoning growth itself. Four of the panels represent the seasons: Spring receives nourishment and bestows seed; Summer is decked out in the products of nature's generosity; Autumn is weighted down by the sheer richness of the harvest and its fruits; Winter is asleep in fading but still abundant foliage.[18] Here, the cycle of the seasons no longer has any relation to human effort, planning and labor, as it did in the *Series of Flax* or the *Series of Grain,* but is envisioned as a "natural," presumably automatic, process, although the pictorial means employed are, of course, paradoxically artificial in the extreme. Just as the facts of the human condition are abandoned in favor of allegorical fantasy, so the style of late-naturalistic fidelity to concrete, observed detail is abandoned in favor of a hallucinatory richness and decorativeness of style. In *Nature,* the social issue of the fate of the worker, urban or rural, is simply dissolved in jungle foliage, the question of accuracy of representation replaced by a kind of vitalist opulence of form. The tension between Naturalism and Symbolism inherent to Frédéric's more socially conscious works of the previous decade is here resolved in favor of the latter.

This shift to a purely *Symboliste* aesthetic, to a purely allegorical subject matter, is particularly evident in the fifth and central panel of the series, representing "La Nature" herself in the form of a nursing mother[5] who is feeding, or has already fed to stupefied repletion, all the little Child-Seasons who had been represented in the other four sections of the cycle. In an image perhaps inspired by the precedent of Botticelli and the Florentine primitives, whose work had impressed him during the course of a trip to Italy, and which certainly looks forward to the metamorphic, intensely colored children and foliage of Tchelitchew's *Hide and Seek* in the twentieth century, Frédéric has carried the implications of the right-hand panel of nursing women in *The Stages of a Worker's Life* to their highest pitch of expression. In the central panel of *La Nature* [5], the nurturing female, based ultimately on the precedent of the Caritas figures of tradition, seems to be drowning the passive recipients of her generosity—victims rather than beneficiaries—in the richness of her bounty. Social need has been resolved by a repressive, indeed, stupefying, overabundance of flowers and fruits, birds and insects, as well as milk.

As Francine-Claire Legrand has pointed out, "The leftist tendencies of certain Symbolists did nothing to prevent the disciples of the movement from becoming reactionaries by instinct."[19] In the case of Léon Frédéric, we can witness the transition from Social Realism to Symbolism—or even their simultaneous coexistence—within the oeuvre of a single artist. Yet his essentially conservative position was, in a sense, implicit from the very beginning in his realistic yet ambivalent depictions of working-class and peasant life themselves. In his relatively unquestioning acceptance of the natural order and the transcendent rather than the historical determinants of proletarian existence, Frédéric prepared the way for his ultimate acceptance of Symbolist doctrine and praxis at the end of the century. Nevertheless, some of the temporal and social implications of his multipartite works, *The Stages of a Worker's Life* particularly, seem to have been picked up, transformed, and revitalized in the early work of the young Futurists-to-be in Italy, who, like Frédéric, were particularly drawn to the modern potential of the traditional triptych form. Giacomo Balla's innovative three-part painting *The Worker's Day* of 1904 perpetuates the notion of labor as defined by temporal cycles, characteristic of Frédéric's multipartite socially oriented paintings generally and *The Stages of a Worker's Life* in particular.[20] It is perhaps in the dynamic and expressive innovations of the Futurists, and, above all, in the technologically sophisticated "serial-

5. Léon Frédéric, *La Nature* [central panel], 1897, Ypres, Collection Van Raes

ity" of the film, that the possibilities of Frédéric's ambitious, realistic, multipartite compositions achieve their fullest development.

Notes

1. The triptych is now in the Musée d'Orsay, Paris. The work is dated 1895 but is generally thought to have been painted from 1895–1897. The best recent study of Frédéric's work, including this painting, is that of Maria M. Müller, "Léon Frédéric: Darstellung des Landlebens und der Unterschichten" in the exhibition catalogue, *Arbeit und Alltag: Soziale Wirklichkeit in der Belgischen Kunst: 1830–1914*, Berlin, Neue Gesellschaft für Bildende Kunst, 1979, pp. 248–57. Also see the exhibition catalogue, *Belgian Art: 1880–1914*, Brooklyn Museum, 1980, pp. 102–6, and bibliographical references, p. 252; and the article by Fernand Khnopff, "A Belgian Painter: Léon Frédéric," *The International Studio* 31 (1907): 171–81. I am grateful to Jean F. Buyck, David Stark, and Kirk Varnedoe for their assistance in the preparation of this article.

2. In a 1925 newspaper poll, he was voted Belgium's most popular living artist (*Belgian Art: 1880–1914*, p. 103). Nevertheless, critics were not always positive in their opinion of Frédéric's work. See, for example, the rather negative and patronizing account in Paul Colin's *La Peinture belge depuis 1830* (Brussels, 1930), pp. 254–58.

3. For a study of this phenomenon, see Klaus Lankheit, *Das Triptychon als Pathosformel*, in *Abhandlungen der Heidelberger Akademie der Wissenschaft*, 4, 1959.

4. For an illustration of this work, see Bettina Brand, "Belgische Kunst der zweiten Hälfte des 19. Jahrhunderts in der Auseinandersetzung mit Religion und Kirche," in *Arbeit und Alltag*, fig. 14, p. 208.

5. For an illustration, see Anita Schwandt, "Leben auf dem Lande: Eugeen Laermans, soziale Wirklichkeit und Bildaussage," in *Arbeit und Alltag*, fig. 3, pp. 260–61.

6. This euphoric description is cited by Khnopff, *The International Studio*, p. 176. There is much more.

7. Gunther Sander, *August Sander; Photographer Extraordinary*, trans. M. Oberli-Turner (London, 1973), n.p.

8. Bruce Laughton, "The British and American Contributions to *Les Vingt*, 1884–1893," *Apollo* 69 (Nov. 1967): 375.

9. Ford Madox Hueffer's study, entitled *Ford Madox Brown: A Record of His Life and Work*, reproduced *Work* opposite p. 189. The painting is now in the City Art Gallery, Manchester. For a lengthy account of the painting, see the exhibition catalogue, *Ford Madox Brown, 1821–1893*, Walker Art Gallery, Liverpool, 1964, no. 25, pp. 18–20.

10. *Belgian Art*, pp. 30–33, and *Arbeit und Alltag*, passim.

11. See Nancy Mowll Matthews's doctoral dissertation on Mary Cassatt and the modern Madonna image (New York University, Institute of Fine Arts, 1980) for an interesting discussion of this phenomenon, which the author also convincingly relates to literary works of the time, like Zola's *Fécondité* of 1889 (p. 194).

12. For a reproduction, see Corrado Maltese, *Realismo e verismo nella pittura italiana dell'ottocento* (Milan, 1967), pl. XLIX.

13. For a reproduction, see Maltese, *Realismo*, pl. XXXVI.

14. The painting, created in 1892, is now in the Bremen Kunsthalle.

15. Ron J. Lesthaeghe, *The Decline of Belgian Fertility, 1800–1970* (Princeton, N.J., 1977). I am grateful to Miriam Cohen of the Vassar College History Department for this reference.

16. Ibid., p. 230.

17. Ibid., p. 231.

18. See Khnopff, *The International Studio,* for reproductions of all four of the Seasons from this pentaptych, pp. 178 and 179.

19. *Belgian Art,* p. 61.

20. See Gerald D. Silk's interesting article, "Giacomo Balla's 'The Worker's Day,' " *Arts Magazine,* Jan. 1979, pp. 130–36, for a discussion of this work. Silk discusses the temporal implications of the triptych format, and that of the multipartite work generally from a viewpoint analogous to but somewhat different from mine. See especially pp. 131–32.

8

Degas and the Dreyfus Affair: A Portrait of the Artist as an Anti-Semite

Anti-Semitism is a free and total choice of oneself, a comprehensive attitude that one adopts not only toward Jews but toward men in general, toward history and society; it is at one and the same time a passion and a conception of the world.

—JEAN-PAUL SARTRE, *Anti-Semite and Jew*

At the time of the Dreyfus Affair, many members of the artistic avant-garde took sides: Monet and Pissarro, with their old friend and supporter Zola, were pro-Dreyfusard, as were the younger radical artists Luce, Signac, and Vallotton and the American Mary Cassatt; Cézanne, Rodin, Renoir, and Degas were anti-Dreyfus. Monet, who had been out of touch with Zola for several years, nevertheless wrote to his old friend two days after the appearance of "J'Accuse" to congratulate him for his valor and his courage; on January 18, Monet signed the so-called Manifesto of the Intellectuals on Dreyfus's behalf.[1] Despite the fact that at the outset of the Affair many anarchists were unfavorably disposed toward Dreyfus—an army officer and wealthy to boot—Pissarro, who was an ardent anarchist, nevertheless quickly became convinced of his innocence. He too wrote to Zola after the appearance of "J'Accuse," to congratulate him for his "great courage" and "nobility of . . . character," signing the letter "Your old

comrade."[2] Renoir, who managed to keep up with some of his Jewish friends like the Natansons at the height of the Affair, nevertheless was both an anti-Dreyfusard and openly anti-Semitic, a position obviously linked to his deep political conservatism and fear of anarchism. Of the Jews, he maintained that there was a reason for their being kicked out of every country, and asserted that "they shouldn't be allowed to become so important in France." He spoke out against his old friend Pissarro, saying that his sons had failed to do their military service because they lacked ties to their country.[3] Earlier, in 1882, he had protested against showing his work with Pissarro, maintaining that "to exhibit with the Jew Pissarro means revolution."[4]

None of the former Impressionists, however, was as ardently anti-Dreyfusard and, it would seem, as anti-Semitic as Edgar Degas. When a model in Degas's studio expressed doubt that Dreyfus was guilty, Degas screamed at her, "You are Jewish . . . you are Jewish . . ." and ordered her to put on her clothes and leave, even though he was told that the woman was actually Protestant. Pissarro, who continued to admire Degas's work, referred to him in a note to Lucien as *"the ferocious anti-Semite."* He later told his friend Signac that since the anti-Semitic incidents of 1898, Degas, and Renoir as well, shunned him. Degas, at the height of the Affair, even went so far as to suggest that Pissarro's painting was ignoble; when reminded that he had once thought highly of his old friend's work he replied, "Yes, but that was before the Dreyfus affair."[5]

Such anecdotes provide us with a bare indication of the facts concerning vanguard artists and the Dreyfus Affair, and they tend to create an oversimplified impression of an extremely complex historical situation. Certainly, there seems to be little evidence in the *art* of any of these artists, of such essentially *political* attitudes as anti-Semitism or Dreyfusard sympathies.[6] Yet there are certain ways of reading the admittedly rather limited visual evidence that can lead to a more sophisticated analysis of the issues involved. Two concrete images reveal, better than any elaborate theoretical explanation, the complexity of the relation of vanguard artists to Jews and "Jewishness" and, at the same time, the equally complex relation which obtains between visual representation and meaning. The first, a work in pastel and tempera on paper of 1879 is by Edgar Degas, and it represents Ludovic Halévy,[7] the artist's boyhood friend and constant companion, writer, librettist, and man-about-town. Halévy is shown backstage at the opera with another close friend, Boulanger-Cavé[1]. The

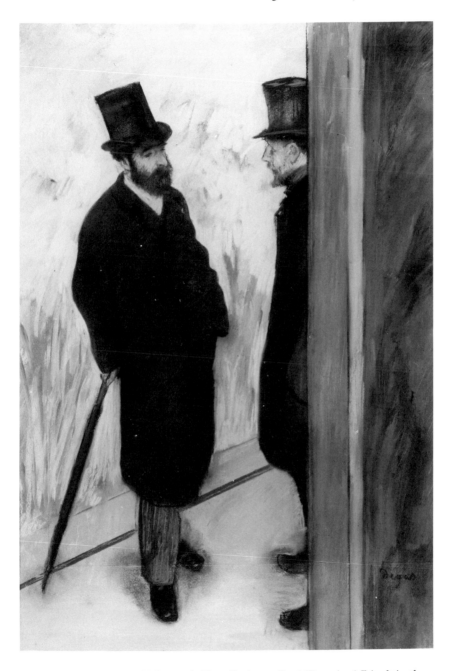

1. Edgar Degas, *Ludovic Halévy and Albert Boulanger-Cavé (Portrait of Friends in the Wings)*, 1879, Paris, Musée d'Orsay

image is a poignant one. The inwardness of mood and the isolation of the figure of Halévy, silhouetted against the vital brilliance of the yellowish blue-green backdrop, suggest an empathy between the middle-aged artist and his equally middle-aged subject, who leans, with a kind of resigned nonchalance, against his furled umbrella.[8] The gaiety and make-believe of the theater setting only serves as a foil to set off the essential solitude, the sense of worldly weariness, established by Halévy's figure. Halévy himself commented on this discrepancy between mood and setting in the pages of his journal: "Myself, serious in a frivolous place: that's what Degas wanted to represent."[9] The only touch of bright color on the figures is provided by the tiny dab of red at both men's lapels: the ribbon of the Legion of Honor, glowing like an ember in the dark, signifying with Degas's customary laconicism the distinction appropriate to members of his intimate circle—though Degas himself viewed such institutional accolades rather coolly.[10] Halévy, of course, was a Jew; a convert to Catholicism, to be sure, but a Jew, nevertheless, and when the time came, a staunch Dreyfusard. His son, Daniel, one of Degas's most fervent admirers, was to be, with his friend Charles Péguy, one of the most fervent of Dreyfus's defenders.[11] No one looking at this sympathetic, indeed empathetic, portrait would surmise that Degas was (or would become) an anti-Semite or that he would become a virulent anti-Dreyfusard; indeed, that within ten years, he would pay his last visit to the Halévys' home, which had been like his own for many years, and never return again, except briefly, on Ludovic's death in 1908, to pay his final respects.[12]

The second image to consider is a pen-and-ink drawing, one of a series of twenty-eight by Camille Pissarro, titled *Turpitudes sociales*[2]. Created in 1889–90,[13] the series, representing both the exploiters and the exploited of his time, was intended for the political education of his nieces Esther and Alice Isaacson.[14] The drawing in question is titled *Capital* and represents, in a highly caricatural style, reminiscent of Daumier or the English graphic artist Charles Keene, the statue of a fat banker clutching a bag of gold to his heart. The features of the figure—the prominent hooked nose, protruding ears, thick lips, slack pot belly, soft hands, and knock-knees—could almost serve as an illustration for the description of the prototypical Jew concocted by the anti-Semitic agitator Drumont.[15] In a letter accompanying *Turpitudes sociales*, Pissarro describes this drawing as follows: "The statue is the golden calf, the God Capital. In a word it represents the divinity of the day in a portrait of a Bischoffheim [*sic*], of an Oppen-

2. Camille Pissarro, *Capital*, from *Turpitudes sociales*, 1889, Geneva, Collection Daniel Skira

heim, of a Rothschild, of a Gould, whatever. It is without distinction, vulgar and ugly."[16] Lest we think that this stereotypically Jewish caricature glossed by a list of specifically Jewish names is a mere coincidence, figures with the exaggeratedly hooked noses used to pillory Jews appear prominently in the foreground of another drawing from the series, *The Temple of the Golden Calf*, a representation of a crowd of speculators in front of the Bourse. A third drawing, originally intended for the *Turpitudes sociales* album but then omitted, is even more overtly anti-Semitic in its choice of figure type. The drawing represents the golden calf being borne in procession by four top-hatted capitalists, the first two of whom are shown with grotesquely exaggerated Jewish-looking features while

several long-nosed attendants follow behind in the cortege. The whole scene is observed by a group of working-class figures with awed expressions.

It is hard for the modern viewer to connect these anti-Semitic drawings with what we know about Pissarro: the fact that he was, after all, a Jew himself; that he was an anarchist; that he was an extremely generous and unprejudiced person; and, above all, with the fact that when the time came he became a staunch supporter of Dreyfus and the Dreyfusard cause.

Yet lest we reach the paradoxical conclusion that the anti-Dreyfusard Degas was more sympathetic to his Jewish subjects than the Jewish Dreyfusard Pissarro, one must examine further both the art and the attitudes of the two artists. What, for instance, are we to make of a Degas painting, almost contemporary with the Halévy portrait, titled *At the Bourse*[3]? It represents the Jewish banker, speculator, and patron of the arts Ernest May, on the steps of the stock exchange in company with a certain M. Bolâtre.[17] At first glance, the painting seems quite similar to the *Friends on the Stage*, even to the way Degas has used some brilliantly streaked paint on the dado to the left to set off the black-clad figures, but if we look further, we see that this is not quite the case. The gestures, the features, and the positioning of the figures suggest something quite different from the distinction and empathetic identification characteristic of the Halévy portrait: what they suggest is "Jewishness" in an unflattering, if relatively subtle way. If *At the Bourse* does not sink to the level of anti-Semitic caricature, like the drawings from *Turpitudes sociales*, it nevertheless draws from the same polluted source of available visual stereotypes. Its subtlety owes something to the fact that it is conceived as "a work of art" rather than a "mere caricature." It is not so much May's Semitic features, but rather the gesture that I find disturbing—what might be called the "confidential touching"—that and the rather strange, close-up angle of vision from which the artist chose to record it, as though to suggest that the spectator is spying on rather than merely looking at the transaction taking place. At this point in Degas's career, gesture and the vantage point from which gesture was recorded were everything in his creation of an accurate, seemingly unmediated, imagery of modern life. "A back should reveal temperament, age, and social position, a pair of hands should reveal the magistrate or the merchant, and a gesture should reveal an entire range of feelings," the critic Edmond Duranty declared in the discussion of Degas from his polemical account of the nascent

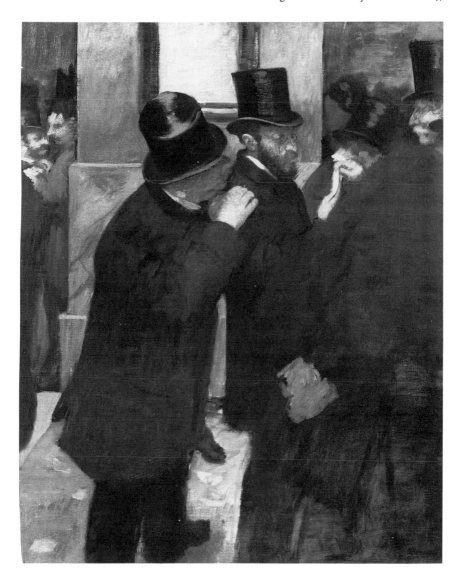

3. Edgar Degas, *At the Bourse, (Portraits at the Stock Exchange)*, c. 1879, Paris, Musée d'Orsay

Impressionist group, *The New Painting* (1876).[18] What is "revealed" here—perhaps unconsciously, through May's gesture, as well as the un- seemly, inelegant closeness of the two central figures and the demeanor of the vaguely adumbrated supporting cast of characters, like the odd

couple, one with a "Semitic nose," pressed as tightly as lovers into the narrow space at the left-hand margin of the picture—is a whole mythology of Jewish financial conspiracy. That gesture—the half-hidden head tilted to afford greater intimacy, the plump white hand on the slightly raised shoulder, the stiff turn of May's head, the somewhat emphasized ear picking up the tip—all this, in the context of the half-precise, half-merely adumbrated background, suggests "insider" information to which "they" are privy, from which "we" the spectators (understood to be Gentile) are excluded. This is, in effect, the representation of a conspiracy. It is not too farfetched to think of the traditional gesture of Judas betraying Christ in this connection, except that here, both figures function to signify Judas; Christ, of course, is the French public, betrayed by Jewish financial machinations.

I am talking, of course, of significances inscribed, for the most part unconsciously or only half-consciously, in this vignette of modern commerce. If my reading seems a little paranoid, one might compare the gesture uniting the Jewish May and his friend with any of those in Degas's portraits of members of his own family, who, after all, were also engaged in commerce—banking on the paternal side, the cotton market on his mother's—where there is never the slightest overtone of what might be thought of as the "vulgar familiarity" characteristic of the gesture of May and Bolâtre in their images. Instead, Degas's family portraits, like *The Bellelli Family* or, in a very different vein, *The Cotton Market in New Orleans,* suggest either aristocratic distinction or down-to-earth openness of professional engagement.

Yet I am not suggesting that Degas was an anti-Semite simply through my reading of a single portrait any more than I would suggest that Pissarro was an anti-Semite because of the existence of a few drawings with nefarious capitalists cast as the imagery of Jewish stereotype. The real evidence for anti-Semitism, in Degas's case, or against it, in Pissarro's, is both more straightforward and, as far as Degas is concerned, more contradictory. Both artists reenact scenarios of their class and class-fraction positions; both of their practices in relation to what might be called the "signifying system" of the Dreyfus Affair are fraught with inconsistencies: they are not total, rational systems of behavior but rather fluctuating and fissured responses, changing over time, deeply rooted in class and family positions but never identical with them.[19]

Let us start to look at the evidence for Degas's attitudes toward Jews, Jewishness, and the Dreyfus Affair in greater detail, keeping in mind the fact that the Degas who sided with the anti-Dreyfusards in the late nineties was no longer the same Degas who sympathized with the fate of the vanquished Communards in 1871 or worked with the Jewish Pissarro in the eighties.[20] Attitudes change over time, vague propensities stiffen into positions; events may serve as potent catalysts for extremist stances.

First, then, evidence of what might be called "pro-Jewish" attitudes and behavior on Degas's part prior to the Dreyfus Affair—and there is a good deal of it. It is, to begin with, undeniable that Degas's circle of intimate friends, as well as that of his acquaintances, included many Jews, not merely Ludovic Halévy and his son Daniel, who, as a young man, worshiped Degas,[21] but Halévy's cousin Geneviève, daughter of his uncle Fromenthal and widow of Georges Bizet, who, as Madame Straus, wife of a lawyer for the Rothschild interests, ran one of the important Parisian salons of the later nineteenth century. The Halévy circle included such prominent Jewish figures as Ernest Reyer, the music critic for *Le Journal des débats;* Charles Ephrussi, founder of the *Gazette des beaux-arts;* and Charles Haas, the elegant Jewish man-about-town who served as a model for Proust's Swann.[22] And of course, Degas was intimately associated with the Jewish artist Pissarro, both in connection with the organization of the Impressionist exhibitions, in which both played an important role and to which both exhibited untiring loyalty, and in the practice of print-making later.[23] Degas was one of the first to have bought Pissarro's paintings, and Pissarro admired Degas above all the other Impressionists, maintaining that he was "without doubt the greatest artist of the period."[24]

Indeed, it would have been difficult to participate in the vanguard art world of the later nineteenth century without coming into contact with Jews in one way or another;[25] even so, the number of Degas's Jewish friends and acquaintances was unusually large. It is equally undeniable that he portrayed a considerable number of Jewish sitters. In addition to the depictions of Halévy and May considered above, there are such portraits as those of a painter friend, Emile Lévy (1826–1890), a study for which dates from August 1865–1869; Monsieur Brandon, father of the painter Edouard Brandon (1831–1897), who was also a friend of Degas's, of the mid-seventies; and the *Portrait of the Painter Henri Michel-Lévy* (1844–1914), another friend of Degas's, with whom he exchanged portraits. The

painter, a minor Impressionist and son of a wealthy publisher, is represented slouching rather morosely in the corner of his studio, with a large mannequin at his feet and his paintings on the walls behind.[26] Degas, in a letter, mentions sketches for a portrait of Charles Ephrussi, but the work itself has not been identified.[27] Perhaps most surprising of all, in view of Degas's later political stance, there is the double portrait *General Mellinet and Chief Rabbi Astruc* of 1871[4]. Astruc, an authority on Judaic history, was chief rabbi of Belgium and assistant to the chief rabbi of Paris. Mellinet, a staunch republican, anticlerical, and a Freemason, worked with Astruc in the ambulance service during the siege of Paris, caring for the wounded. They asked Degas to paint them together to "recall their fraternal effort." The result is a striking little picture, loosely handled, casual and unpretentious, in which Degas, although emphasizing the comradely unity between the two men, nevertheless brings out contrasts of age, type, and character by means of subtle elements of composition and quite striking ones of color.[28]

4. Edgar Degas, *General Mellinet and Chief Rabbi Astruc*, 1871, Mairie de Gérardmer, France

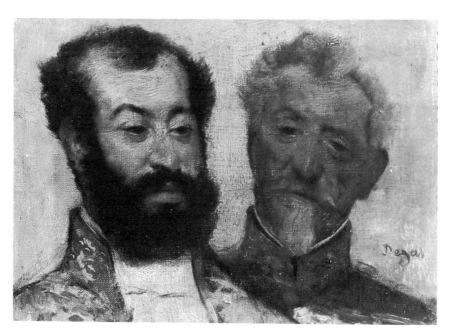

Yet it is the Halévys who figure over and over again in Degas's work, both as subject and as site, as it were, of his practice as an artist. "We have made him," declared Daniel Halévy in his journal in 1890, "not just an intimate friend but a member of our family, his own being scattered all over the world."[29] It could, of course, be maintained, that as completely assimilated Jews, Halévy and his sons could hardly be considered "Jewish" at all. While it is true that Ludovic Halévy does not talk about his Jewishness in the pages of his *Carnets*,[30] and seems to have been without any particular religious beliefs or practices, there is at least one piece of evidence, long before the Dreyfus Affair brought him to greater self-consciousness and activism, that Ludovic Halévy in fact considered himself to be, irrevocably, a Jew. That evidence is in the form of a letter that appeared in the *Archives israélites*, a publication dedicated to Jewish political and religious affairs, in 1883, a time when Degas was having Thursday dinner and two or three lunches a week with Ludovic Halévy and his family at 22 rue de Douai. The occasion of the letter was an obituary for Ludovic's father, Léon Halévy. After thanking the editor for the article, Halévy states: "You are perfectly right to think and say that the moral link between myself and the Jewish Community has not been broken. I feel myself to be and will always feel myself to be of the Jewish race. And it is certainly not the present circumstances, not these odious persecutions [the current pogroms in Russia and Hungary] that will weaken such a feeling in my soul. On the contrary, they only strengthen it."[31]

Although Halévy may have been guarded about expressing such sentiments to Degas, it is hardly likely that the artist could have been completely unaware of them—or of the fact that, from an anti-Semite's point of view, his close, indeed, one of his closest, friends was a Jew "by race," whether or not Halévy chose to be one. If Degas were in fact an anti-Semite at this time, it would appear that the virus was in a state of extreme latency, visible only in the nuances of a few works of art and intermittently at that.[32] Or perhaps one might say that before the period of the Dreyfus Affair, Degas, like many other Frenchmen and women, and even like his erstwhile Impressionist comrade Pissarro, was anti-Jewish only in terms of a certain *representation* of the Jew or of particular "Jewish traits," but his attitude did not yet manifest itself in overt hostility toward actual Jewish people, nor did it yet take the form of a coherent ideology of anti-Semitism.

In the case of the Halévys, Degas felt enough at home among them to work as well as to enjoy himself in their affectionate company. It was at their house on the rue de Douai that Degas made the drawings contained in the two large "Halévy Sketchbooks," in one of which Ludovic Halévy wrote: "All the sketches of this album were made at my house by Degas."[33] The Halévys made frequent appearances in Degas's *oeuvre*. Besides the backstage portrait discussed above, both Ludovic and his son Daniel figure in one of Degas's most complicated group portraits, *Six Friends at Dieppe,* a pastel made in 1885, during a visit to the Halévys at this seaside resort. It is a strange picture. Most of the sitters are jammed against the right-hand margin, and Degas was not flattering to many of his subjects. The sitters include Halévy's son Daniel peeking out at the spectator from under a straw boater; the English painter Walter Sickert; the French artists Henri Gervex and Jacques-Emile Blanche; and Cavé, "the man of taste," as Degas called him, whom the artist had portrayed before with Halévy behind the scenes at the Opéra. In this rather heterogeneous company, Ludovic Halévy stands out as a special case. As Jean Sutherland Boggs put it: "In the noble head of the bearded Halévy in the upper right of the pastel we can suspect a possible idealization which would reveal the easily satirical Degas' admiration and respect."[34]

At other times, however, Degas seems to have been less respectful of his old friend, most notably in the series of monotype illustrations he created for Halévy's lighthearted but pointed satire of backstage mothers and upwardly mobile young ballet dancers, *La Famille Cardinal,* in the late seventies. Taking Halévy's first-person narration quite literally, Degas has his friend appear in at least nine of the compositions,[35] most notably in the one entitled *Ludovic Halévy Meeting Mme Cardinal Backstage*[5]. Here, Degas's mischievous sense of caricature and his synoptic, suggestive drawing style are put to good use in the way he contrasts the stiff, reticent pose of the narrator with the more vulgar expansiveness of the mother of the two young dancers, whose careers, on stage and off, are the subject of the book. In another illustration, it is Degas himself, perhaps, who chats with the girls in the company of Halévy and another gentleman backstage; in still another, Halévy visits Madame Cardinal in the dressing room.[36] Halévy evidently failed to appreciate Degas's illustrations, and his refusal to accept them for publication evidently put some strain on their friendship.[37] Various reasons have been put forth for Halévy's displeasure; the author is said to have thought Degas's illustrations to have been "too

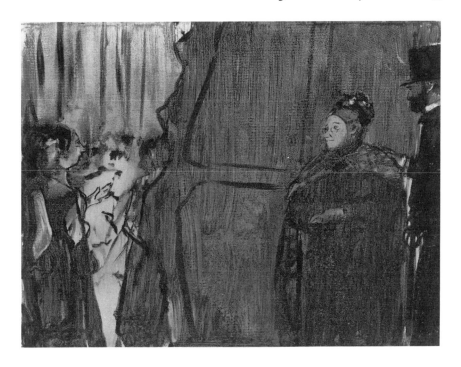

5. Edgar Degas, *Ludovic Halévy Meeting Mme Cardinal Backstage*, illustration for *La Famille Cardinal* by Ludovic Halévy, c. 1878

idiosyncratic" or "more a recreation of the spirit and ambience of Halévy's book than authentic illustrations."[38] While both these reasons may be true, it seems to me that other considerations may also have figured in Halévy's rejection of his friend's pictures: that in some of them, he appears too *engaged*, too much a part rather than a mere spectator, of the rather *louche* business of selling young women's bodies behind the scenes at the Opéra. Did Halévy notice a disturbing resemblance between himself, as represented in the *Famille Cardinal* monotypes, and the single male visitor, leaning on a cane or umbrella, who is a constant, though often partial, presence in the famous *Brothel* monotypes of the same period, monotypes which the *Famille Cardinal* prints often resemble so closely?[39] Degas was perhaps not reticent enough in suggesting, through visual similarity, a more material connection between the life of the ballet dancer and that of the prostitute, plain and simple, than Halévy had been willing to make explicit in his man-of-the-world text about parental venality and female

availability.[40] And as a final reason for the author's rejection of his friend's illustrations, is it too farfetched to suppose that Halévy saw a fleeting resemblance between himself as represented by Degas in the *Cardinal* monotypes and some of the coarse Semitic-featured "protectors" who appeared leering down the décolletages of ballet girls in caricatures of the time? Obviously, a certain amount of tension existed between Halévy and Degas, as it so often does in extremely close male friendships, where a competitive relation with the world may conflict with intense intimacy.[41] Love and hate, support and antagonism are often not so far apart. Clearly, Degas's representation of Halévy in the *Cardinal* illustrations is a quite different, and more ambiguous, one than that embodied in the "noble head" from the Dieppe group portrait.[42]

The Halévys also played a significant role in Degas's intense if not always successful engagement with photography. Not only did Ludovic's wife, Louise, serve as the developer of his plates—he jokingly referred to her as "Louise la révéleuse" in one of his letters—[43] but members of the Halévy family posed for many of his prints and photographed *tableaux vivants*, among them the memorable parody of Ingres's *Apotheosis of Homer*, in which the two "choirboys," as Degas called them, worshiping in the foreground are Elie and Daniel Halévy.[44] In addition, Degas photographed Daniel Halévy, in a thoughtful pose, seated in an armchair, his hand supporting his chin; Madame Ludovic Halévy, pensive, in the same antimacassar-backed armchair; Elie in a leather chair with his mother reclining on a nearby sofa, several intriguing pictures of ballet dancers on the wall behind them[6]. In another photograph, Ludovic is featured in a double exposure with other members of his family.[45]

All this came to an end, more or less abruptly, as the time of the Dreyfus Affair. As Daniel Halévy wrote: "An almost unbelievable thing happened in the autumn of 1897. Our long-standing friendship with Degas, which on our mother's side went back to their childhood,[46] was broken off. Nothing in our past relationship indicated that politics could cause such a break. Degas never seemed to have any political opinions."[47] Daniel Halévy describes the circumstances of the break in considerable detail: "Thursday, 25 November 1897. Last night, chatting among ourselves at the end of the evening—until then the subject [the Dreyfus Trial] had been proscribed as Papa was on edge, Degas very anti-Semitic—we had a few moments of delightful gaiety and relaxation. . . . It was the last of our happy conversations," Daniel Halévy declares in his retrospective

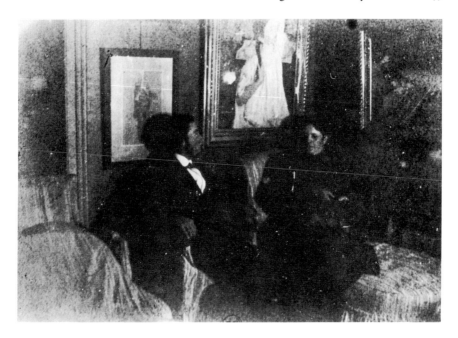

6. Edgar Degas, *Elie Halévy and Mme Ludovic Halévy in Degas's Living Room,* c. 1896–97, Paris, Bibliothèque Nationale

commentary on this journal entry. "Our friendship was to end suddenly and in silence. . . . One last time Degas dined with us . . . Degas remained silent. . . . His lips were closed; he looked upwards almost constantly as though cutting himself off from the company that surrounded him. Had he spoken it would no doubt have been in defense of the army, the army whose traditions and virtues he held so high, and which was now being insulted by our intellectual theorizing. Not a word came from those closed lips, and at the end of dinner Degas disappeared."[48]

The break with the Halévys was in many ways less sudden than it appeared, nor could it be attributed solely to the intensification of the Dreyfus Affair at the time it occurred, although without the Affair, it might not have taken place. One might almost liken the process of becoming an anti-Semite to that of falling in love, a process, according to Stendhal, in his famous essay on the subject, culminating in "crystallization": anti-Semitism may perhaps be thought of as "falling in hate," a process in which all the negative structures come together, and the subject assumes a new identity vis-à-vis the Other. This requires an often startling redefi-

nition of former friends and associates: for example, in Degas's case, of Pissarro, with whom he had worked, whom he had admired and who admired him in return, or of Ludovic Halévy. The Dreyfus Affair was, of course, one of these crystallizing agencies, pushing equivocators over the brink, spurring to action people like Degas who before had perhaps merely grumbled and read Drumont with a certain degree of approval, but who didn't have a *cause* until the Affair served as a catalyst.

By 1895, Degas had already become, in addition to being a violent nationalist and uncritical supporter of the army, an outspoken anti-Semite.[49] He had begun to have his maid Zoé read aloud at the breakfast table from Drumont's *La Libre Parole* and from Rochefort's scurrilous *L'Intransigeant,* which he thought was "full of a miraculous sort of good sense."[50] He became closer to people who shared his ideas: the painter Forain, who viciously caricatured the Dreyfusards in the weekly *Psst . . .;*[51] his old friend Henri Rouart, and the four Rouart sons, the latter of whom were anti-Dreyfusard extremists.[52] With such companions, the aging Degas could, so to speak, let himself go: "In the town house in the Rue de Lisbonne [the Rouarts' home] Monsieur Degas was completely himself. . . . With people of whose friendship he was sure he unbridled his frenzy as a dispenser of condemnations, as a fanatic, as a flag-waver from a past era. The others humored him in his manias and shared his prejudices."[53]

Degas, as a devoted follower of *La Libre Parole,* must have read the so-called *Monument Henry,* published in its pages in 1898–99. This was a subscription on behalf of the widow and child of Lieutenant-Colonel Henry, who had committed suicide when his fabrication of evidence incriminating Dreyfus was discovered, and who was made into a martyr of the anti-Dreyfusard cause; many subscribers sent overtly anti-Semitic messages along with their donations. One wonders what Degas made of them, how he managed to reconcile these obscenities with his actual experience of Jewish friends and supporters. Did Degas think of Ludovic Halévy when Zoé read to him at the breakfast table such sentiments as "for God, the Nation and the extermination of the Jews"[54] or "for the expansion of the race of traitors"[55] or "French honor against Jewish gold"?[56] Did he think of the happy evenings spent at the rue de Douai when he read the comment from an inhabitant of Baccarat "who would like to see all the yids, yiddesses and their brats in the locality burned in the glass furnaces here"?[57] Did he think of Pissarro, once his companion in the Impressionist venture, his fellow experimenter in new printmaking tech-

niques, and one of his most sincere admirers, when he read the numerous entries, such as the following, betraying what Stephen Wilson has termed "personal sadistic involvement in detailed tortures. . . ."? "A military doctor . . . who wishes that vivisection were practiced on Jews rather than on harmless rabbits"; or this: "a group of officers on active service. To buy nails to crucify the Jews." Or this: "to make a dog's meal by boiling up certain noses"?[58] Or, for that matter, what might Degas, an artist deeply concerned about his own rapidly failing vision, have thought about the anti-Dreyfusard donor from Le Mans who "would like all Jews to have their eyes put out"?[59] Or what might his reaction have been to the highly imaginative recommendation, again involving eyes and blinding, offered by Rochefort in the pages of L'Intransigeant in October of 1898 for the treatment of the magistrates who purportedly favored revision of the Dreyfus case: "A specially trained torturer should first of all cut off their eyelids with a pair of scissors. . . . When it is thus quite impossible for them to close their eyes, poisonous spiders will be put in the half-shells of walnuts, which will be placed on their eyes, and these will be securely fixed by strings tied round their heads. The hungry spiders, which are not too choosy about what they eat, will then gnaw slowly through the cornea and into the eye, until nothing is left in the blind sockets."[60] One would like to think that Degas was horrified or contemptuous of such grotesque lucubrations, which, for the modern reader, have clear sexual connotations in their use of eye symbolism,[61] yet there is nothing to suggest that he was: on the contrary, Degas was a faithful reader of both journals, and evidently agreed with and took satisfaction in what they printed.

One must conclude that although Degas was indeed an extraordinary artist, a brilliant innovator, and one of the most important figures in the artistic vanguard of the nineteenth century, he was a perfectly ordinary anti-Semite. As such, he must have been capable of amazing feats of both irrationality and rationalization, able to keep different parts of his inner and outer life in separate compartments in order to construct for himself what Sartre has referred to as a personality with the "permanence of rock," a morality "of petrified values," and an identity of "pitiless stone"— choices, according to Sartre, constitutive of the anti-Semite.[62] To comprehend the mechanisms of Degas's anti-Semitism, one must conceive of the processes of displacement and condensation taking place on the level of the political unconscious functioning in a manner not dissimilar to those of the dreamwork on the level of the individual psyche, processes in which

contradictory elements can be effortlessly amalgamated, painful conflicts torn asunder and safely kept apart. The sleep of reason produces monsters, and "The Jew" was produced in the sleep of Enlightenment ideals of reason and truth and justice, in the minds of nineteenth-century anti-Semites like Degas, secure in the knowledge that most of their more outrageous aggression-fantasies would be fulfilled on the level of text rather than in practice.[63] "Text" is the key word here. For it was editors, columnists, and pamphleteers who constructed the anti-Semitic identity of men like Degas. Without the discourse of the popular press—books, pamphlets, and journals, some of it to be sure, with high claims to "intellectual distinction" and "scientific objectivity"—which formulated and stimulated it, Degas's anti-Semitism would be unthinkable.[64] It was at the level of the printed word that anti-Semitism, flowing from yet at the same time fueling the fantasies of the individual psyche, achieved a social existence and took a collective form.[65]

There was a specific aspect of Degas's situation in the world that might have made him particularly susceptible to the anti-Semitic ideology of his time: what might be called his "status anxiety."[66] According to Stephen Wilson: "The French anti-Semites' attacks on social mobility, and their ideal of a fixed social hierarchy, suggest that such an interpretation applies to them, particularly when these ideological features are set beside the marginal situation of many of the movement's supporters."[67] Degas was precisely such a "marginal" figure in the social world of the late nineteenth century and had ample reason, by the decade of the nineties, to be worried about his status.

Although it is asserted in most of the literature that Degas came from an aristocratic family, recent research has revealed that the Degas family fortune in fact had originated in rather shady adventurism less than fifty years before the birth of the artist. Degas's grandfather René-Hilaire Degas made his money first as a professional speculator on the grain market during the Revolution, at a time when food shortages were provoking riots in Paris; then as a money changer, first in Paris, later in the Levant; and then as a banker and real estate operator in Naples.[68] In other words, the Degas family moved up in the world by precisely the same questionable means Jews were accused of employing: speculation and money changing. Neither did Degas possess the "pure" French blood or the age-old roots in the French soil valorized by Drumont, Barrès, and the

ultranationalists. His paternal grandmother was an Italian, Aurora Freppa, and his mother, Célestine Musson, was a native of New Orleans, where her father was a wealthy and adventurous entrepreneur, whose main activity was cotton export, but who also speculated in Mexican silver mining.[69] Although members of the Degas family in both Naples and in Paris began to sign themselves "de Gas" in the 1840s, thereby implying that they were entitled to the *particule*—that is, the preposition indicating a name derived from land holdings—and although one Paris relative even hired a genealogist to create a family tree legitimizing such pretensions, in point of fact, these forebears were, to borrow the words of Roy McMullen, "indulging in the foolish little parvenu trickery that was laughed at . . . as 'spontaneous ennoblement.' " When Degas began signing himself "Degas" rather than "de Gas" after 1870, he was not rejecting an aristocratic background; he was simply signing his name as it really was. The parish register for the year 1770 that records the birth of Degas's grandfather lists his great-grandfather as "Pierre Degast, *boulanger.*" Degas, far from being a scion of the aristocracy, was the descendant of a provincial baker,[70] and the class into which he was born was in fact the *grande bourgeoisie,* a *grande bourgeoisie* of rather recent date and uncertain tenure haunted by memories of revolution and displacement. It was a family that moved a lot, even in Paris, during Degas's childhood, rather than being rooted in a permanent family *hôtel.* By the time of Auguste Degas's death in 1874, the Degas bank was near collapse;[71] by 1876, it had failed; and two years later, the artist's brother René, then living in New Orleans, reneged on his debt to the Paris bank, abandoned his blind wife and six children, and ran off with another woman. The family, in short, disintegrated, both morally and materially.[72] Degas's position at the time of the Dreyfus Affair offers a classic example of the "status anxiety" associated with anti-Semitism.[73] Not only had he chosen the marginal existence of an artist—and a nonconformist artist at that—but the family banking fortune had vanished; the family honor was besmirched, and the artist was obliged to sacrifice his comfortable private income to pay his brother's debts. Degas, then, had come from a background as *arriviste* as that of any of the nouveau riche Jews his fellow anti-Semites vilified, but by 1898, even this recently acquired upper-class position had become an insecure one, despite Degas's success as an artist.[74] Anti-Semitism served not only as a shield against threatening downward social mobility but as a mechanism

of denial, firmly differentiating Degas's fragile *haut bourgeois* status from that of the newly wealthy, recently cultivated upper-class Jews whose position was, to his chagrin, almost indistinguishable from his own.

What effect did Degas's anti-Semitism have on his art? Little or none. With rare exceptions, one can no more read Degas's political position out of his art, in the sense of pointing to specific signifiers of anti-Jewish feeling within it, than one can read a consistent anti-Semitism out of Pissarro's use of stereotypically Jewish figures to personify capitalist greed and exploitation in the *Turpitudes sociales* drawings. In Pissarro's case, it was simply that no other visual signs worked so effectively and with such immediacy to signify capitalism as the hook nose and pot belly of the stereotypical Jew.[75] There is, of course, always something repugnant about such representations, as there is always something suspect in representations in which women are used to signify vices like sin or lust, because in such figures there is inevitably a slippage between signifier and signified, and we tend to read the image as "all Jews are piggish capitalists" or "all women are seductive wantons" instead of reading it in a purely allegorical way.

The representation of anti-Semitism was a critical issue in the work of neither Pissarro nor Degas. In general, the subjects to which they devoted themselves did not involve the representation of Jews at all. By the time of the Dreyfus Affair, Degas had more or less completely abandoned the contemporary themes that had marked his production from the late 1860s through the early 1880s, a period when, of all the Impressionists, he had been "mostly deeply involved in the representation of modern urban life," to borrow the words of Theodore Reff.[76]

There was, however, one sustained work of art by a vanguard artist at the time of the Dreyfus Affair in which the question of anti-Semitism plays a central role, and that is the set of illustrations that Toulouse-Lautrec did for Clemenceau's *Au Pied du Sinaï* (1898), a series of vignettes of Jewish life. Although this is not the place for a detailed examination of Lautrec's ambiguous position vis-à-vis Jews, anti-Semitism, and the Dreyfus Affair—a subject well worth pursuing—certain aspects of his representation of Jews in these rather undistinguished lithographs are relevant to the present investigation. Once again, it is difficult to tell the artist's position from the images alone, without knowing something of their context: how they are to be read; who is doing the reading; and at what moment in history the reading is taking place.[77]

Clemenceau's collection of stories and anecdotes is mainly about Eastern European Jews, not about educated French ones; it is related to the popular fin-de-siècle genre of the travel book. It tends to puzzle the few modern readers who bother to look at it, because it's almost impossible to tell whether the book is meant as a sympathetic picture of specific Jewish types or a piece of anti-Semitic slander. Clemenceau, on some level, meant this as a plea for greater understanding of the Jews of Eastern Europe who were then being threatened with systematic persecution.[78] In contrast to the racists of his time, Clemenceau insists on the racial diversity of the Jewish types he met in Carlsbad, where he went for the cure and with whose colony of Polish Orthodox Jews he is largely concerned. He insists nevertheless on one trait he deems common to all Jews—something he denominates "the subtile ray which seeks the weak point like the flash of a fine blade of steel."[79] Although he implies that the religious ceremonies of the Chassidim are bizarre, even grotesque, and consistently emphasizes the "sharp practices" of all Jews, rich and poor, his descriptions are in no way different from those of other travel writers of the time taking on the picturesque customs of exotic peoples. Readers familiar with the travel literature of the nineteenth and the early twentieth century devoted to the Near East or North Africa would find nothing surprising in Clemenceau's descriptions of unwashed clothing or irrational behavior on the part of the "natives"; it is simply that this time the natives are Jewish. Modern Jews, not unreasonably, associate such discourses with those of anti-Semitism, rather than seeing them as one aspect of a wider phenomenon: the late-nineteenth-century construction of the Other—Blacks, Indians, Arabs, the Irish—any relatively powerless group whose customs are different from those who control the discourse. Indeed, Clemenceau tries to redeem himself at the end of his section on the Chassidim with a plea for religious tolerance, asking whether it is "any more ridiculous to shake one's head like a duck, than to do any other movements in honor of God?" He answers his own question by saying: "I do not think so. Christians and Jews are of the same human stock."[80] Lautrec provided some rather amorphous vignettes of Polish Jews, with the side locks, beards, and prayer shawls exhaustively detailed by Clemenceau, but there is one lithograph in the series that stands out: the one titled *A La Synagogue,* for Clemenceau's story "Schlome the Fighter".[81] This story tells of a poor Jewish tailor who is drafted into the Russian army owing to the cowardice of his richer and more powerful co-religionists. He endures his years of con-

scription, returns to make his enemies pay for their betrayal, and then assumes his former humble role. It is the sort of David and Goliath fable beloved of Yiddish humorists like Sholem Aleichem, stories where the wily little Jew triumphs over more powerful adversaries in the end, except "Schlome the Fighter" is a story with a piquant irony at its heart, because it is the detested Russian army that is instrumental in strengthening the Jew in question, and it is his co-religionists, not the Russian oppressors, who are assigned the role of villains in the piece. Schlome the Fighter can take charge of his life—can become a folk hero, in fact—only when he becomes "un-Jewish" at the dramatic climax of the story; when his manly deed is done, he reverts to his previous state of impotence and humility.

Lautrec has chosen to illustrate the scene when Schlome forces the wealthy Jews gathered in the synagogue for the Day of Atonement to pay him a large indemnity. He represents Schlome exactly as Clemenceau describes him; with his prayer shawl flung over the shoulder of his uniform, he stands on the top step of the temple, the point of his saber against the floor, addressing the terrified crowd.[82] It is a kind of witty, reversed *Ecce homo,* where the persecuted figure actively confronts his tormentors, takes the floor, and demands justice. Lautrec plays the forceful curve of his hero's left arm and saber against the curve of the plume on his cossack's helmet; with his muscular legs and strong back appealingly revealed by his tight-fitting uniform, Schlome is a virile and eminently attractive figure. This is the only time that a Jew is represented as strong and sympathetic in the series—when the figure is totally unrecognizable *as* a Jew. We have to discover from the context, and the label, that this is a Jew, not a cossack or, rather, that this is an anomaly: a Jewish cossack. This is a token not so much of Lautrec's personal anti-Semitism as it is of the fact that there was no visual language available with which he might have constructed an image at once identifiably Jewish and at the same time "positive" in terms that would be generally legible. The signifiers that indicated "Jewishness" in the late nineteenth century were too firmly locked into a system of negative connotations: picturesqueness is the closest he could get to a relatively benign representation of Jews who *look* Jewish.[83] As a result, the *Pied du Sinaï* illustrations make us uneasy. We don't know quite how to take them: as anti-Semitic caricatures or as misguided but basically well-intentioned vignettes of life in an exotic foreign culture.

Degas, in his last years, when the storm of the Dreyfus Affair had subsided, seems to have drawn back to some degree from overt anti-Semitism, although the evidence is equivocal. According to Thadée Natanson, publisher of *La Revue blanche,* Degas's voice trembled with emotion whenever he had to pronounce Pissarro's name.[84] Although he did not attend Pissarro's funeral in 1903, he sent Lucien Pissarro his regrets, saying that he had been too ill to be present: "I was in bed Sunday, dear sir, and I could not go to take the last trip with your poor father. For a long time we did not see each other, but what memories I have of our old comradeship."[85] Nevertheless, in another letter, probably referring to the recently deceased Pissarro, he talks about the embarrassment one felt, "in spite of oneself," in his company and refers to his "terrible race"—hardly phrases he would have used if Pissarro's Jewishness had ceased to be an issue.[86] And while it is true that Degas paid a final visit to the Halévys' house on the occasion of Ludovic's death[87] and continued to see the adoring Daniel for the rest of his life, he persisted in cherishing his anti-Dreyfusard opinions. "There are no signs," according to his most recent biographer, Roy McMullen, "that he ever thought he had taken the wrong side in the great clash of the two Frances."[88] When his old friend Madame Ganderax complimented him in front of one of his paintings, saying "Bravo Degas! This is the Degas we love, not the Degas of the Affair," Degas, without blinking an eyelash, replied, "Madame, it is the whole Degas who wishes to be loved."[89] He was implying, with a touch of bitter humor, that one could not love the artist without loving the anti-Dreyfusard as well.

This is of course not the case. One can separate the biography from the work, and Degas has made it easy for us by keeping, with rare exceptions, his politics—and his anti-Semitism—out of his art. Unless, of course, one decides it is impossible to look at his images in the same way once one knows about his politics, feeling that his anti-Semitism somehow pollutes his pictures, seeping into them in some ineffable way and changing their meaning, their very existence as signifying systems. But this would be to make the same ludicrous error Degas himself did when he maintained that he had thought Pissarro's *Peasants Planting Cabbage* an excellent painting only *before* the Dreyfus Affair; Degas at least had the good grace to laugh at his own lack of logic in that instance.[90]

Notes

1. For the letter of January 14, 1898, see Daniel Wildenstein, *Claude Monet: Biographie et catalogue raisonné* (Lausanne: La Bibliothèque des Arts, 1979), 3, no. 1399, p. 296. There are several other letters in which Monet expresses his admiration for Zola, in one of which he says, "C'est de l'héroisme absoluement" (to Geffroy, no. 1403, p. 296). He refused, however, to become a member of the Ligue des Droits de l'Homme. See Wildenstein, 3, pp. 82–83, for an analysis of Monet's position.

2. Cited in Ralph E. Shikes and Paula Harper, *Pissarro: His Life and Work* (New York: Horizon Press, 1980), p. 306. For a general account of Pissarro's course of action during the Affair, see ibid., pp. 304–9.

3. Barbara Ehrlich White, *Renoir, His Life, Art, and Letters* (New York: Abrams, 1984), pp. 210–11.

4. Ibid., p. 121.

5. Shikes and Harper, *Pissarro: His Life and Work*, pp. 307–8. The italic is Pissarro's.

6. I am excluding from this discussion artists of the second rank, like Forain, or draftsmen like Caran d'Ache, whose work was overtly anti-Semitic on a large scale and who functioned, in effect, as anti-Semitic caricaturists.

7. Halévy, besides being a popular and highly esteemed dramatic author and novelist, had also served as secretary-editor of the French Legislature, a post he abandoned in 1865 to devote himself exclusively to his literary career. His best-known libretti were written in collaboration with Henri Meilhac and included *La Belle Hélène, La Grande-Duchesse de Gérolstein,* and *La Vie parisienne,* all with music by Offenbach. He was awarded the Legion of Honor and was the first Jewish member of the Académie Française. For good accounts of Degas's relation with Halévy, see Roy McMullen, *Degas: His Life, Times, and Work* (Boston: Houghton Mifflin Company, 1984), pp. 369–70, 383–86, 436, 440–41, 460; and Theodore Reff, *Degas: The Artist's Mind* (New York: Harper & Row, 1976), pp. 182–88. For a good brief account of Halévy's career, see the *Universal Jewish Encyclopedia* (1941), 5, pp. 179–80, and *La Grande Encyclopédie,* 19, pp. 756–57. For a more extended account, see Alain Silvera, *Daniel Halévy and His Times: A Gentleman-Commoner in the Third Republic* (Ithaca, N.Y.: Cornell University Press, 1966), pp. 1–41, passim.

8. Ludovic Halévy, like Degas, was born in 1834; both men were therefore forty-five years old at the time the picture was painted.

9. L. Halévy, "Les Carnets de Ludovic Halévy," *Revue des deux mondes* 42 (1937): 823.

10. For the importance of the decorations and how they were obtained, see Ludovic Halévy. *Carnets,* intro. by D. Halévy (Paris: Calmann-Lévy, 1935), 2, p. 9, August 15, 1869: "I can say that I did not steal it [the Legion of Honor ribbon], for I worked hard for ten years at the Ministry of Algiers and the Colonies and at the Chamber. These were not sinecures!"

11. For Daniel Halévy, see Silvera, *Daniel Halévy and His Times.*

12. For a moving account of this last visit, see Daniel Halévy, *My Friend Degas,* trans. of *Degas parle,* trans. M. Curtiss (Middletown, Conn.: Wesleyan University Press, 1964), pp. 104–5.

13. This is the dating of Shikes and Harper, *Pissarro*, p. 232. Other authorities date the *Turpitudes sociales* to 1890. See *Pissarro*, exhibition catalogue, Hayward Gallery, London, 1980–81 cat. no. 142, and Richard Bretell and Christopher Lloyd, *A Catalogue of the Drawings of Camille Pissarro in the Ashmolean Museum, Oxford* (Oxford: Oxford University Press, 1980), no. 170, p. 210.

14. Shikes and Harper, *Pissarro*, p. 231.

15. Edouard Drumont, in *La France juive*, published in 1886, identified the Jew by "the well-known hooked nose, the blinking eyes, clenched teeth, projecting ears, fingernails that are square instead of round and almond-shaped, an excessively long torso, flat feet, round knees, extraordinarily turned-out toes, and the soft, velvety hand of a hypocrite and a traitor." Cited in McMullen, *Degas*, p. 422.

16. Shikes and Harper, *Pissarro*, p. 232. "Gould" may be a mistranscription of "Fould," a wealthy Jewish supporter of Napoleon III.

17. In a letter of 1879, Degas wrote to Bracquemond, saying, "M. Ernest May . . . Il se marie, va prendre un petit hôtel, je crois, et arrange en galerie sa petite collection. C'est un Juif, il a organisé une vente au profit de la femme de Monchot, devenu fou. Vous voyez, c'est un homme qui se lance dans les Arts." See Jean Sutherland Boggs, *Portraits by Degas* (Berkeley and Los Angeles: University of California Press, 1962), p. 123. Degas also did two drawings of Madame Ernest May, in 1881. See Götz Adriani, *Degas: Pastels, Oil Sketches, Drawings* (New York: Abbeville Press, 1985), nos. 139 and 140. May was evidently to be one of the backers of the Impressionists' ill-starred print publication *Jour et nuit*, in which Degas was deeply involved. See McMullen, *Degas*, pp. 355–56. There is some confusion about just which of these figures is actually May. Jean Sutherland Boggs in *Portraits by Degas* says left; McMullen says right. It would seem that it must be the latter: May is the one who is clearly identifiable and portrayed; the bending figure to the left seems an auxiliary.

18. Exhibition catalogue, *The New Painting: Impressionism, 1874–1886* (San Francisco: The Fine Arts Museums, and Washington, D.C.: National Gallery of Art, 1986), p. 44.

19. Indeed, it is important to stipulate that anti-Semitism, far from being immediately identifiable with a class position, actually functions ideologically, as Sartre pointed out in *Anti-Semite and Jew*, trans. J. G. Becker (New York: Schocken Books, 1965), to smooth over and obliterate actual class distinctions and antipathies in a spurious national or racial unity or harmony: "I may be only a shop-keeper and he an aristocrat, but we are both Frenchmen and as such, we both hate Jews," pp. 29–30.

20. For Degas's sympathy with the Communards, see McMullen, *Degas*, p. 199.

21. See Silvera, *Daniel Halévy and His Times*, p. 36: "Beyond doubt the single person who left the most permanent impression on the young Halévy was the painter Degas." Also see ibid., p. 39: "The importance of Degas in shaping Halévy's development can scarcely be exaggerated." Ibid., pp. 36–39, stresses the importance of Degas's political, artistic, and social beliefs for shaping Daniel Halévy's development. Of course, Daniel Halévy's *My Friend Degas* is a testimonial to Degas's importance for Daniel Halévy.

22. McMullen, *Degas*, p. 386.

23. See Michel Melot, "La Pratique d'un artiste: Pissarro graveur en 1880," *Histoire et critique des arts*, no. 2 (June 1977): 14–38. Also, Shikes and Harper, *Pissarro*, pp. 161–75.

24. *Letters*, May 9, 1883. Cited in Shikes and Harper, *Pissarro*, p. 162.

25. See, for example, the important role played by the Jewish and pro-Dreyfusard Thadée Natanson, both as a publisher (of the *Revue blanche*) and as a *salonnier*. For a good brief account of the Natanson brothers and their circle, see Gerstle Mack, *Toulouse-Lautrec* (New York: Alfred A. Knopf, 1938), pp. 263 ff.

26. For the identification of the painting and a discussion of the sitter, see Reff, *Degas*, pp. 125–30. There is some doubt about whether the painting was actually exhibited in the Fourth Impressionist Exhibition in 1879 or was merely listed in the catalogue. See the exhibition catalogue *The New Painting: Impressionism, 1874–1886* (San Francisco: Fine Arts Museums, and Washington, D.C.: National Gallery of Art, 1986), p. 258.

27. See Boggs, *Portraits by Degas*, p. 117. The letter was to Henri Rouart and is dated May 1, 1880.

28. See McMullen, *Degas*, p. 194, for information about the subjects. One can also consult the *Jewish Encyclopedia* for information about Elie-Aristide Astruc. Astruc wrote a study of anti-Semitism, *Origines et causes historiques de l'anti-Sémitisme*, in 1884. Jean Sutherland Boggs, *Portraits by Degas*, pp. 34–35, analyzes this painting in considerable detail and compares the figure of Mellinet to an El Greco.

29. Daniel Halévy, 1965, entry of December 30, 1890, p. 45.

30. See, for example, Ludovic Halévy, *Carnets*, and idem, "Les Carnets de Ludovic Halévy," *Revue des deux mondes* XLII (1937): 811–43 and XLIII (1938): 95–126, 375–403, 589–613.

31. *Archives Israélites: Recueil politique et religieux* XLIV (1883): 310.

32. See Stephen Wilson, *Ideology and Experience: Anti-Semitism in France at the Time of the Dreyfus Affair* (Rutherford, N.J.: Fairleigh Dickinson University Press, 1982), p. 5: "What the Affair reveals . . . is the wide extent and great importance of anti-Semitic prejudice in France, latent, but ready to manifest itself when circumstances allowed or encouraged it."

33. For information about the Halévy Sketchbooks, which were originally owned by Ludovic Halévy and which contained sketches relating to the famous weekly dinners arranged by Henry Meillac and Albert Wolff at the Pavillon Henri IV, see Theodore Reff, *The Notebooks of Edgar Degas: A Catalogue Raisonné of the Thirty-Eight Notebooks in the Bibliothèque Nationale and Other Collections* (Oxford, 1976), I, pp. 1–3, and 128–33. Also *Edgar Degas, 1834–1917*, exhibition catalogue, D. Carritt, London, no. 21.

34. Boggs, *Portraits by Degas*, p. 70.

35. Eugenia Parry Janis, *Degas Monotypes: Essay, Catalogue and Checklist*, exhibition catalogue, Cambridge, Mass.: Fogg Art Museum, Harvard University, 1968, p. xxii.

36. Janis, in her catalogue of the Degas monotypes, lists 12 monotypes relating to the *Famille Cardinal* series that include Ludovic Halévy in the scene. See idem, *Degas Monotypes*, nos. 195–215. For a good account of the illustrations, see Reff, *Degas*, pp. 184–86. Reff, p. 187, also refers to another collaboration between the two friends, the stage production of Halévy's and Meilhac's *The Grasshopper*, a satirical comedy about contemporary artistic life.

37. See, for instance, Pierre Cabanne, *Degas* (Paris: Pierre Tisné, 1957), cat. nos. 99–100, 118. But for a different opinion, see Ronald Pickvance, *Degas 1879: Paintings, Pastels, Drawings, Prints and Sculpture . . .*, exhibition catalogue, Edinburgh: National Gallery of Scotland, 1979, p. 68, who states: "The project was dropped. Without acrimony, Degas quietly kept his designs in portfolios."

38. For the first of these explanations, see Pickvance, *Degas 1879*, p. 68; for the second, Reff, *Degas*, p. 186. Also see Janis, *Degas Monotypes*, p. xxii, for a similar explanation.

39. Halévy's reticence and his choice of other illustrators—Edmond Morin; Henri Maigrot, called Henriot; and later, E. Mas—to do the pictures for his popular *Cardinal* stories, rather than using Degas's more pointed and personal ones, may have something to do with the different degree of "actuality" occasioned by printed as opposed to visual discourse. While one can "be there" in the sense of being the narrator of the story without acute embarrassment, there is something different about being *depicted* in the sexually questionable situations related by the same text, something more concrete perhaps, and more implicative of the physical self: Halévy must have seen himself objectified, becoming, like a woman, the "object of the gaze" in Degas's monotype illustrations. It would be interesting to see if the other illustrators included Halévy in their pictures, and with such unflattering directness as Degas did.

40. For the relationship between ballet dancers and prostitutes in the context of Degas's work, see Eunice Lipton, *Looking into Degas: Uneasy Images of Women and Modern Life* (Berkeley, Los Angeles, London: University of California Press, 1986), pp. 73–115.

41. For an important investigation of the representation of male homosociality and its tensions, specifically in literature of the eighteenth and nineteenth centuries, see Eve Kosofsky Sedgwick, *Between Men: English Literature and Male Homosocial Desire* (New York, 1985).

42. Degas could be rather cutting about his friend's literary ability. He evidently criticized Halévy's novel *The Abbé Constantin* (1882) for sentimentality, leading the latter to note in his *Carnets*: "My friend Degas is indignant about *L'Abbé Constantin*, nauseated would be more like it. He is disgusted with all that virtue, with all that elegance. He said insulting things to me this morning. I must always do things like *Madame Cardinal*, dry little things, satirical, skeptical, ironic, without heart, without emotion. He called me Father Halévy." Ludovic Halévy, "Les Carnets de Ludovic Halévy," 42, p. 398.

43. Letter of September 29, 1895, to Ludovic Halévy, *Lettres de Degas*, ed. M. Guérin (Paris: Bernard Grasset, 1945), p. 208.

44. Degas calls them "choirboys" in a letter of September 1885 (*Lettres*, 1945, p. 112). The photograph is by Barnes and was taken at Bas-Fort-Blanc near Dieppe in 1885.

45. McMullen, *Degas*, p. 431.

46. Ludovic Halévy's wife, Louise Bréguet, had been a childhood friend of Degas's sister, Marguérite (Fèvre).

47. Daniel Halévy, *My Friend Degas*, p. 97.

48. Ibid., pp. 100–1. Degas sent a letter to Madame Halévy the next morning, which she read without comment. Daniel's friendship with Degas nevertheless continued after this incident, although he had to visit Degas at the latter's home.

49. See the entry in Daniel Halévy's diary for November 5, 1895: "Degas is very sad. . . . He has become a passionate believer in anti-semitism." Cited in McMullen, *Degas*, p. 427.

50. See McMullen, *Degas*, p. 427.

51. Forain explained that in creating his anti-Semitic cartoons he was "acting . . . quite simply, as the echo of the public"; see Stephen Wilson, *Ideology and Experience*, p. 606.

52. Daniel Halévy *(My Friend Degas)* claims that Rouart himself was "extremely moderate about the affair." His sons, however, were fanatics. See Halévy's journal entry of August 10, 1899, p. 102.

53. Jacques-Emile Blanche, "Propos de Peintre," cited in McMullen, *Degas*, p. 440.

54. Wilson, *Ideology and Experience*, p. 148.

55. Ibid., p. 155.

56. Ibid., p. 149.

57. Ibid., p. 156.

58. Ibid.

59. Ibid.

60. Cited in ibid., p. 589.

61. This is Wilson's suggestion, p. 589.

62. Sartre, *Anti-Semite and Jew*, pp. 27, 54.

63. Wilson, *Ideology and Experience*, p. 589.

64. "The 'new' antisemitism found expression primarily in newspapers, journals, pamphlets and books, and its proponents were writers and journalists." "The main vehicle of antisemitism was the newspaper press, symbol, symptom and maker of a homogeneous national culture." Ibid., pp. 606 and 639.

65. See ibid., *Ideology and Experience*, p. 589.

66. For a somewhat different interpretation of Degas's status anxiety, see Lipton, *Looking into Degas*, pp. 190–95.

67. Wilson, *Ideology and Experience*, p. 637.

68. This information comes from the new and very full account of Degas's family history provided by McMullen, *Degas*, pp. 2–3.

69. Ibid., pp. 5–6.

70. Ibid., pp. 8–9.

71. Ibid., p. 243.

72. Ibid., p. 260.

73. Says Wilson (p. 637) of the anti-Semites at the time of the Dreyfus Affair: "It seems that, losing status themselves, they were obsessed by the rising status of others, and symbolically of the Jews; here it should be recalled that the criteria of status were themselves in question, both objectively, causing authentic disorientation, and also, to some degree, because antisemites deliberately refused to accept criteria which gave them low status. As has been argued . . . antisemitism in France offered a compensation for this anxiety. Uncertain of their place in a real world that was changing, more or less unattached to it, antisemites 'belonged' to 'the nation,' and, if they were militants, they 'belonged' to the movement.' "

74. In the terms of anti-Semitic paranoia even, a successful artist might consider himself insecure in relation to the Jews. Forain, Degas's close friend at the time of the Affair, complained to a friend: "We artists, like you writers, we live from hand to mouth; we only earn just enough to stay alive and keep on working, while the most

insignificant little Jew who sets up in business is the possessor of a fortune at the end of a year or two." Cited in ibid., p. 608 and n. 61.

75. In the accompanying text, Pissarro had hastened to add: "The masses . . . dislike the Jewish bankers, and rightly, but they have a weakness for the Catholic bankers, which is idiotic." As Shikes and Harper have pointed out in their biographical study of Pissarro, "Pissarro hated all bankers, Jewish and Christian." *Pissarro*, pp. 232, 234.

76. Reff, *Degas*, p. 164. One might of course link Degas's rejection of an explicit subject matter of modern life with his increasing conservatism and with a certain aspect of anti-Semitic ideology as well: its emphatic anti-modernism. See Wilson, *Ideology and Experience*, pp. 612 ff., for a discussion of the anti-modernist stance of anti-Semitism and its espousal of the values and aesthetics of "Old France." But Degas never returned to a historicizing subject matter, and his rejection of the painting of modern life by the 1890s cannot necessarily be considered "conservative" in terms of the art practice of the period, in which Symbolism rather than Realism might be considered "advanced"; yet, during the same period, the politically radical Neo-Impressionists, like Seurat, Signac, Luce, and Pissarro, who became one of their members, certainly insisted on contemporary, often socially significant, subject matter.

77. Of course it must be kept in mind that these are not based on Lautrec's original ideas, but are *illustrations*, dependent on specific incidents in Clemenceau's narrative.

78. See Riva Castleman in *Henri de Toulouse-Lautrec: Images of the 1890s*, exhibition catalogue, New York: The Museum of Modern Art, 1985, p. 15 and n. 10.

79. Georges Clemenceau, "In Israel," in *At the Foot of Sinai*, trans. A. V. Ende (New York: Bernard G. Richards Company, 1922), p. 65. (Originally published in Paris by Henri Flouri, 1898, with 16 lithographs by Henri de Toulouse-Lautrec.)

80. Ibid., pp. 62–79, and passim.

81. For the story, see ibid., pp. 39–61.

82. Ibid., p. 54.

83. See, for example, his illustrations *Juifs polonais* (LD 240) and *La Prière* (LD 241).

84. Shikes and Harper, *Pissarro*, p. 308.

85. Cited in ibid., p. 308.

86. Shikes and Harper and McMullen disagree about whether the letter in question (*Lettres*, CXXXIII) actually refers to Pissarro or whether it refers to some other Jewish friend. Shikes and Harper believe that it refers to Pissarro, nn. 308, 347; McMullen, *Degas*, p. 444, believes that it does not.

87. According to Ludovic Halévy's son Daniel, Degas demanded to see his old friend, asked for lots of light, and peered intently into the dead man's face, saying, "This is indeed the Halévy whom we have always known with the additional grandeur that death gives. This must be kept—recorded." Daniel Halévy, 1965, p. 105.

88. McMullen, *Degas*, p. 444.

89. Daniel Halévy, *My Friend Degas*, p. 111.

90. The incident was recounted by Vollard. See Shikes and Harper, *Pissarro*, p. 308.

9

Seurat's *La Grande Jatte:* An Anti-Utopian Allegory[1]

The idea that Seurat's masterpiece *La Grande Jatte*[1] was in some sense anti-Utopian came to me when I was reading a chapter entitled "Wishful Landscape Portrayed in Painting, Opera, Literature" in *The Principle of Hope*, the magnum opus of the great German Marxist Ernst Bloch. Here is what Bloch, writing in the first half of our century, had to say:

> The negative foil to Manet's *Déjeuner sur l'herbe*, or rather its mood of gaiety gone sour, is embodied in Seurat's promenade piece: *Un Dimanche à la Grande-Jatte*. This picture is one single mosaic of boredom, a masterful rendering of the disappointed longing and the incongruities of a dolce far niente. The painting depicts a middle-class Sunday morning [*sic*][2] on an island in the Seine near Paris; and that is just the point: it depicts this merely with scorn. Empty-faced people rest in the foreground; most of the others have been grouped into wooden verticals like dolls from the toy box, intensely involved in a stiff little walk. Behind them is the pale river with sailboats, a sculling match, sightseeing boats—a background that, despite the recreation going on there, seems to belong more to Hades than to a Sunday. A great load of joyless leisure is in the image, in the bright matt glare of its atmosphere and in the expressionless water of the Sunday Seine, the object of an equally expressionless contemplation. . . . As the workaday world recedes, so does every other world, everything, recede into watery torpidness. The result is endless boredom, the little man's hellish utopia of skirting the Sabbath and holding onto it too; his Sunday succeeds only as a bothersome must, not as a brief taste of the Promised Land. Middle-class Sunday afternoons like these are landscapes of painted suicide which does not come

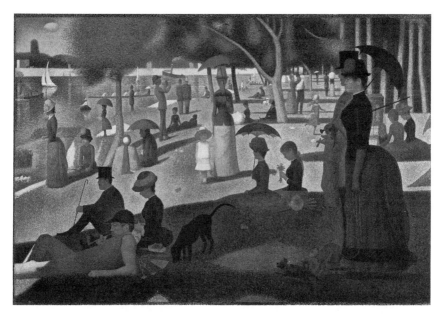

1. Georges Seurat, *Sunday on the Island of La Grande Jatte*, 1884–86, Chicago, Art Institute of Chicago, Helen Birch Bartlett Memorial Collection

off [even at that] because it lacks resolve. In short, this dolce far niente, if it is conscious at all, has the consciousness of an absolute non-Sunday in what remains of a Sunday utopia.[3]

This anti-Utopian signification about which Bloch wrote is not merely a matter of iconography, of subject matter or social history transcribed to canvas. Seurat's painting should not be seen as only passively reflecting the new urban realities of the 1880s or the most advanced stages of the alienation associated with capitalism's radical revision of urban spatial divisions and social hierarchies of his time. Rather, the *Grande Jatte* must be seen as actively *producing* cultural meanings through the invention of visual codes for the modern experience of the city. Here is where the allegory stipulated in my title—"an anti-Utopian *allegory*"—comes in. It is through the pictorial construction of the work—its formal strategies—that the anti-utopian is allegorized in the *Grande Jatte*. This is what makes Seurat's production—and the *Grande Jatte*—unique. Of all the Postimpressionists, he is the only one to inscribe the modern condition itself—with its alienation, anomie, the experience of living in the society of the spectacle, of making a living in a market economy in which ex-

change value took the place of use value and mass production that of artisinal production—in the very fabric and structure of a picture.

Or, to put it another way, if Seurat rather than Cézanne had been positioned as the paradigmatic Modernist painter, the face of twentieth-century art would have been vastly different. But such a statement is of course itself Utopian, or at the very least insufficiently historical, for it was part of advanced art's historical destiny in the later nineteenth and early twentieth century to retreat from the worldly, the social, and above all the negative and objectively critical position iterated in the *Grande Jatte*—or Seurat's *Parade* or the *Chahut*—and establish the realm of the atemporal, the nonsocial, the subjective, and the phenomenological—in other words, a "pure" painting—as synonymous with Modernism. This paradoxical instating of pure visibility and the flat surface of the canvas as synonymous with the modern is, as we shall see, at the polar opposite of Seurat's achievement in the *Grande Jatte* and in his other works as well.

It had been the project of ambitious Western art from the High Renaissance onward to establish a pictorial structure which suggested a rational narrative and, above all, an expressive coherence relating part and part, and part and whole, at the same time that it established a meaningful relationship with the spectator. The painting was understood to "express," to externalize by means of its structural coherence, some inner meaning, to function as the visible manifestation of a core or a depth of which the representational fabric constituted but a surface appearance, albeit an all-important one. In a Renaissance work like Raphael's *School of Athens,* for example, the figures are constructed to react and interact, thereby suggesting, indeed determining, a meaning beyond the mere surface of the painting, to create an expression of complex meaning that is at once comprehensible yet at the same time transcends the historical circumstances which produced it.

In a sense, Manet's *Déjeuner sur l'herbe* constitutes the end of that Western tradition of high art as expressive narrative: the shadow begins to thicken up, the priority accorded to the surface denies the implication of transcendence, the gestures fail of their usual dialogic mission. But even here, as Bloch pointed out in the same chapter in which he discusses the *Grande Jatte,* there remain Utopian emanations. Indeed, Bloch reads the *Déjeuner* as a counterfoil to the *Grande Jatte,* interpreting it as a ". . . wishful scene of epicurean happiness," describing it in the most lyrical of terms: "Soft light, as only Impressionism could create, flows through the

trees, surrounds the two couples, the naked woman and the one undressing to bathe, the dark male figures. What is portrayed," Bloch continues, "is an extraordinarily French, extraordinarily lingering situation, full of innocence, supreme ease, unobtrusive enjoyment of life, and carefree seriousness." Bloch assigns the *Déjeuner* to the same category as that of the *Grande Jatte*—the *Sunday picture;* "its subject is: an immediate other world beyond hardship. Though this subject can no longer easily be painted in the nineteenth century, Manet's 'Déjeuner sur l'herbe' forms an exception precisely because of its naïveté and presence. Its wholesome Sunday would already hardly be possible [that is to say, in 1863, when it was painted] with petit-bourgeois subjects; thus it could not exist without artists and their models." Then Bloch goes on to the negative description of the *Grande Jatte* with which I opened this essay: "The real bourgeois Sunday, even a painted one, thus looks even less desirable or varied. The *negative* foil to Manet's 'Déjeuner sur l'herbe,' in other words, the *merriness that has become powerless* is given in *Seurat's* promenade piece: 'Un dimanche à la Grande-Jatte.' "⁴ Not until the 1880s, it would seem, was it possible to produce a work that so completely, brilliantly, and convincingly inscribed the condition of modernity itself.

In Seurat's painting, there is almost no interaction among the figures, no sense of them as articulate and uniquely full human presences: above all, there is no sense of a deep inner core to these painted personages. The Western tradition of representation is here undermined if not nullified by a dominant language which is resolutely anti-expressive, rejecting the notion of a hidden inner meaning to be externalized by the artist. Rather, in these machine-turned profiles, these regularized dots we may discover coded references to modern science and to modern industry with its mass production; to the department store with its cheap and multiple copies; to the mass press with its endless pictorial reproductions; in short, a critical sense of modernity embodied in sardonic, decorative invention and in the emphatic, even overemphatic, contemporaneity of costumes and accouterments.⁵ For the *Grande Jatte*—and this too constitutes its anti-Utopianism—is resolutely located in history rather than being atemporal and universalizing. This objective historical presence of the painting is above all embodied in the notorious dotted brushstroke—the *pointillé*—which is and was of course the first thing everyone noticed about the work, and which in fact constitutes the irreducible atomic particle of the new vision. For Seurat, with the dot, resolutely and consciously removed

himself as a unique being projected into the work by means of a personal handwriting. He himself is absent from his stroke. There is no sense of the existential choice implied by Cézanne's constructive brushwork; or of the deep, personal angst implied by van Gogh's; or of the decorative, mystical dematerialization of form of Gauguin.[6] The paint application is matter-of-fact, a near- or would-be mechanical reiteration of the functional "dot" of pigment. Meyer Schapiro, in what is perhaps the most perceptive single article written about the *Grande Jatte*, referred to Seurat as a "humble, laborious, intelligent technician," coming from the "sober lower middle class of Paris from which issue the engineers, the technicians, and the clerks of industrial society," and pointed out that Seurat "derived from the more advanced industrial development of his time a profound respect for rationalized work, scientific technique and progress through invention."[7]

Before examining the *Grande Jatte* in detail to see how anti-Utopianism is inscribed in every aspect of the painting's stylistic structure, I want to examine what counted for "Utopian" in the visual production of the nineteenth century. It is only by contextualizing the *Grande Jatte* within that which was seen by Seurat and his contemporaries as Utopian that the oppositional character of his creation can be fully understood.

There is, of course, the classical Utopia of the flesh established by Ingres in his *Golden Age*. Harmonious line, smooth, ageless bodies, a pleasing symmetry of composition, a frictionless grouping of inoffensively nude or classically draped figures in a landscape of Poussinesque unspecificity—this is not so much a representation of Utopia as it is nostalgia for a distant past that never was and never can be recaptured—not so much Utopia as U-chronia. Completely lacking is the social message we usually associate with Utopian discourse. This is rather a Utopia of idealized desire. The same, incidentally, might be said of Gauguin's much later renditions of the tropical paradise. There, it is not distance in time but geographic distance that functions as the Utopian catalyst; but as in Ingres's version, it is the naked or lightly veiled human body, female above all, in noncontemporary costume, that constitutes the Utopian signifier; still, as in the work by Ingres, this is manifestly an apolitical Utopia, whose reference point is male desire, whose signifier is female flesh.

Far more apposite in constructing a context of Utopian representation to serve as a foil to Seurat's anti-Utopian allegory is a work like Dominique Papety's *Un Rêve de bonheur* (A Dream of Happiness) of 1843[2]. Utopian in form and content, this work is explicitly Fourierist in its

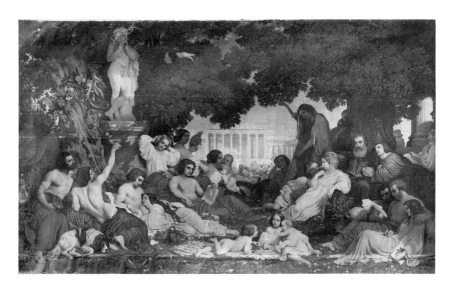

2. Dominique Papety, *Un Rêve de bonheur* (Dream of Happiness), 1843, Compiègne, Musée Vivenel

iconographic intentions and classically idealizing in its style, which is not very different from that of Ingres, Papety's master at the French Academy in Rome.[8] Yet there is a significant difference between Papety's and Ingres's Utopian conceptions. Although the Fourierists considered the present—the so-called realm of civilization—depraved and unnatural, the past for them was little better. The true golden age lay not in the past, but in the future:[9] hence the title "A *dream* of felicity or happiness." The explicitly Fourierist content of this Utopian allegory is corroborated by the inscription "Harmony" on the base of the statue to the left, which refers "both to the Fourierist state and to the music of the satyr" and a second inscription, "Unité Universelle," on the book studied by the youthful scholars, a direct allusion to Fourierist doctrine and the name of one of Fourier's theoretical treatises as well.[10] Indeed, it is possible to read certain aspects of the *Grande Jatte* as an explicit refutation of Fourierist Utopianism or, more accurately, of Utopianism *tout court.* In Papety's painting, Utopian ideals were personified by a poet "singing harmony"; a group embodying "maternal tenderness"; another referring to friend-ship under the graces of childhood; and, at the sides, various aspects of love between the sexes. All are conspicuous by their omission in the *Grande Jatte.*[11] Papety's architecture is resolutely classical, although the painting

at one time suggested the futurity of this Utopian vision by the inclusion of a steamboat and an electric telegraph, later removed by the artist.[12] Once more, the figures are smooth and harmonious, classical, or, more precisely, neoclassical in their poses; the paint is conventionally applied; the signs of modernity, at least in the present version, erased in favor of a Utopian dream which, however Fourierist, is firmly rooted in references to a long-vanished past and an extremely traditional, not to say conservative, mode of representation.

More materially related to Seurat's anti-Utopian project than Papety's obscure Utopian image is the work of his older contemporary Pierre Puvis de Chavannes. Indeed, one might say that, without the precedent provided by Puvis, in works like the *Sacred Grove*,[13] exhibited at the Salon of 1884, the very year that Seurat began work on the *Grande Jatte*, the latter might never have come into being, or might have been different. From a certain standpoint, the *Grande Jatte* may be considered a giant parody of Puvis's *Sacred Grove*, calling into question the whole validity of such a painting and its relevance to modern times—in both its form and its content. For Puvis's timeless muses and universalized classical setting and drapery, Seurat has substituted the most contemporary fashions, the most up-to-date settings and accessories. Seurat's women wear bustles, corsets, and modish hats rather than classical drapery; his most prominent male figure holds a coarse cigar and a cane rather than the pipes of Pan; the architectural background is in the mode of modern urbanity rather than that of pastoral antiquity.

A work like *Summer*[3], painted by Puvis in 1873, two years after the defeat of France in the Franco-Prussian War and the terrible, socially divisive events of the Commune and its aftermath, represents the Utopian vision at its purest. Although the recognizable depiction of a distant past, the imagery of *Summer* suggests, as Claudine Mitchell has recently pointed out, a more general, even a universal, time scale, the representation of what is true of human society generally. To borrow the words of the critic and man of letters Théophile Gautier, who pondered Puvis and his works deeply, "Puvis seeks the ideal beyond time, space, costumes, or particular details. He likes to paint primitive humanity, as they [*sic*] perform one of those functions which we could call sacred so close to Nature they are." Gautier praised Puvis for avoiding the contingent and the accidental, pointing out that his compositions always have an abstract and general title: Peace, War, Repose, Work, Sleep—or, in this case, Summer.

3. Pierre Puvis de Chavanne, *Summer*, 1873, Chartres, Musée des Beaux-Arts

Gautier suggested that for Puvis, the signifiers of a distant, primitive, purer past serve to define a more universal order, the order of Nature itself.[14]

 This then, is the nineteenth century's prototypical pictorial version of classical Utopia, equating "u-troops" (no place) and "u-chronos" (no time) with the time and space of a rather vaguely defined classical antiquity. If Puvis's world is beyond time and place, Seurat's *Grande Jatte* is definitively and even aggressively of his. Indeed, one wonders whether the mundane specificity of Seurat's title—*Sunday on the Grande Jatte (1884)*—in its chronological and geographical specificity does not constitute an anti-Utopian critique of Puvis's and other allegorical classicists' vague and idealized names for paintings. It is, however, the Utopian harmoniousness of Puvis's construction that Seurat most forcefully challenges in his canvas. Although Puvis may have deployed his figures in separate groups, this in no sense implies social fragmentation or psychic alienation. Rather, the painting serves to idealize the value of the family and that of communal productivity, in which each trade, each age, and, above all, each gender serves its allotted task. In effect, Puvis's work functions ideologically to

produce an aesthetic harmony out of what in contemporary society is precisely a source of disharmony, conflict, and contradiction: issues like the position of the worker, the class struggle, or the status of women. Thus, for example, in the formal structure of *Summer*, the moral value of maternity for women and that of work for men are represented as inscribed in—indeed, indistinguishable from—the order of Nature rather than figured as highly volatile, contentious issues. In Seurat's painting, as we shall see, the classical elements are disharmonized: exaggerated into self-revealing artifice or deliberately frozen and isolated; this is part of its anti-Utopian strategy, its bringing of contradictions into focus.

But it is not only the classical and more traditional work of Puvis that offers a contrast to Seurat's anti-Utopianism. More advanced painters, like Renoir, had created semi-Utopian visions based on contemporary reality, images of the joys of ordinary urban existence posited on the pleasures of healthy sensuality and youthful joie de vivre in works like the *Moulin de la Galette* of 1876, where the melting colors, broken brushwork, and swirling, dynamic compositional rhythms play out in formal terms, in their joyous intermingling, the eradication of class and gender divisions in a context of idealized recreation in contemporary Paris. As such, Renoir's work offers the most pointed opposition to Seurat's sardonic view of the New Leisure. Renoir *naturalizes* daily life in the great modern city; Seurat, on the contrary, makes it strange and refuses this naturalization.

Paradoxically, it is the work of Seurat's disciple and fellow Neo-Impressionist Paul Signac that is most apposite in establishing a context of Utopian imagery against which the *Grande Jatte* stands out most forcefully. Signac was fully aware of the social import of his friend's oeuvre. In an article of June 1891, which appeared in the anarchist publication *La Révolte*, he declared that, by painting scenes of working-class life "or, better still, the pleasures of decadence . . . as the painter Seurat did, who had such a vivid perception of the degeneration of our transitional era, they [artists] will bring their evidence to the great social trial that is taking place between workers and Capital."[15] Signac's *In the Time of Harmony* [4], an oil sketch for a mural of about 1893–95, created for the town hall of Montreuil, would seem to have been constructing a response to the specifically capitalist conditions of anomie and absurdity—in other words, the "Time of Disharmony"—represented by his late friend's most famous painting.[16] In a lithographed version, intended for Jean Grave's *Les Temps nouveaux*, Signac created his anarchist-socialist version of a classless Uto-

4. Paul Signac, *In the Time of Harmony (The Pleasures of Summer)*, for *Les Temps Nouveaux*, 1895–96, Cleveland, The Cleveland Museum of Art, Dudley P. Allen Fund

pia, substituting wholesome recreation and human interaction for the stasis and figural isolation of the *Grande Jatte*, emphasizing the joys of the family in place of Seurat's muting of them, and replacing the suburban setting with a more pastoral, rural one in keeping with the Utopian character of the project as a whole. Clearly, the style of the figures, despite the more or less contemporary clothing they wear, owes more to Puvis in its flowing idealization than to Seurat's stylishness. The curvilinear composition and its decorative iterations suavely replay the theme of togetherness—of the couple or the community as a whole—in some Utopian future. Even the hen and the rooster in the foreground play out the theme of mutual aid and interaction spelled out by the work as a whole, and so deliberately excluded by Seurat's vision.

But it is not merely by contrasting Seurat's painting with appropriate Utopian imagery of his time that I have arrived at an anti-Utopian interpretation of the work. The critical reactions of Seurat's contemporaries also serve to corroborate a reading of the painting as a negative critique

of the modern condition.[17] To borrow the words of Martha Ward in a recent catalogue essay, "Reviewers interpreted the expressionless faces, isolated stances, and rigid postures to be a more or less subtle parody of the *banality and pretensions of contemporary leisure* [emphasis mine]."[18] For example, one critic, Henry Fèvre, remarked that after looking at the image for a while "one understands then the rigidity of Parisian leisure, tired and stiff, where even recreation is a matter of striking poses."[19] Another critic, Paul Adam, equated the stiff outlines and attitudinizing postures of the figures with the modern condition itself: ". . . Even the stiffness of these people, their punched-out forms, help to give the sound of the modern, to recall our badly cut clothes, clinging tight to our bodies, the reserve of our gestures, the British cant we all imitate. We strike attitudes like people in a painting by Memling."[20] And still another critic, Alfred Paulet, maintained that "The artist has given his figures the automatic gestures of lead soldiers moving about on regimented squares. Maids, clerks and troopers all move around with a similar slow, banal, identical step, which catches the character of the scene exactly. . . ."[21]

This notion of the monotony, the dehumanizing rigidity of modern urban existence as the founding trope of the *Grande Jatte* inscribes itself even in the relentlessly formal analysis of the most important of the *Grande Jatte*'s critics, Félix Fénéon, when he describes the uniformity of the technique as "a monotonous and patient tapestry"—the pathetic fallacy with a vengeance. Yes, he is describing the brushwork, but the "monotony" and "patience" are read into the technique of Pointillism, allegorized as the dominant quality of modern urban life itself. The formal language of Seurat's masterpiece is thus skillfully elided with both an existential condition and a material technique in Fénéon's memorable figure of speech.[22]

And what of Seurat's formal language in the *Grande Jatte*? How does it mediate and construct and, in some sense, allegorize, the social malaise of its time? Daniel Catton Rich was correct when, in his 1935 study of the painting, he stressed the primacy of Seurat's formal innovations in what he terms the "transcendent" achievement of the *Grande Jatte*[23]—using two reductive diagrams—"Curved Line Organization of *Grande Jatte*" and "Straight Line Organization of *Grande Jatte*,*"* diagrams typical of that moment of formalist "scientific" art analysis—to reduce further Seurat's already diagrammatic compositional structure.[24] But as Meyer Schapiro pointed out in his brilliant rebuttal to this study, Rich was wrong to

eliminate, on the basis of the precedence of formal concerns, the all-important social and critical implications of Seurat's practice. Equally misguided, in Schapiro's view, was Rich's correlative attempt to impose a spurious classicizing, traditionalist, and harmonizing reading on the work, thereby, in the best art-historical fashion, assimilating Seurat's provocative innovations to the peaceful and law-abiding "mainstream" of pictorial tradition.[25]

The peculiarly modern notion of "system" must be dealt with in separating Seurat from that mainstream of tradition and approaching his formal innovations, "system" to be understood under at least two modalities: (1) the systematic application of a certain color theory—scientific or would-be scientific, according to the authority one reads[26]—in his "chromo-luminarist" method; or (2) the related pointillist system of paint application in small, regularized dots. In both cases, Seurat's method would seem to allegorize modern techniques of mass production, and to produce thereby effects of distancing far from either Impressionist and Expressionist signifiers of subjectivity and involvement of the self in art production or from the harmonious generalization of surface characteristic of classical modes of representation. As Norma Broude has pointed out in a recent article, Seurat may actually have borrowed his systematic paint application from one of the most recent techniques of mass diffusion in the visual communication industry of his time, the so-called *chromotypogravure.* The choice of this "mechanical" technique served to critique the objectified spectacle of modern life and thereby, to borrow Broude's words, "proved understandably offensive not only to the public at large but also to many artists of the Impressionist and Post-Impressionist generations, artists whose attachment to a romantic conception of originality and spontaneous self-expression in painting was threatened by the apparently impersonal attitude of Seurat and his followers." "It was, in fact," as Broude pointed out, "precisely the 'mechanical' aspect of the technique, so foreign to contemporary notions of fine taste and 'high art,' that, in these terms, may ultimately have proved attractive to Seurat, whose radical political leanings and 'democratic' predilection for popular art forms had already become important formative factors in the evolution of his attitudes toward his own art."[27] One might go even further, and say that in some sense, *all* of the systematizing factors in Seurat's project, from his pseudoscientific color theory to his mechanized technique, to his later adaption of Charles Henry's "scientifically" legitimated aesthetic protrac-

tor to achieve equilibration of compositional factors and expressive effects—all could ultimately serve a democratizing purpose. Seurat sought a method—a foolproof method—of creating a successful art which, theoretically, could be available to everyone, a sort of democratically oriented, high-type painting-by-dots which would totally wipe out the role of genius, the exceptional creative figure, in the making of art, even "great art" (although the very term might become superfluous under the regime of Total Systematization).[28] This is a Utopian project indeed, from a radical standpoint, although a totally banalizing and anti-Utopian one from a more elitist one.

Nothing could be more revealing of Seurat's deliberate rejection of charming spontaneity in favor of incisive distancing than a comparison of elements from the large final sketch for *La Grande Jatte* (in the Metropolitan Museum of Art, New York)[5] with those of the final version. Can anything be further from the generalizing tendencies of classicism than the diagrammatic concision and up-to-date stylishness of Seurat's construction of, say, the foreground couple, a concision as potent in

5. Georges Seurat, sketch of *La Grande Jatte*, c. 1886, New York, Metropolitan Museum of Art, Bequest of Sam A. Lewisohn

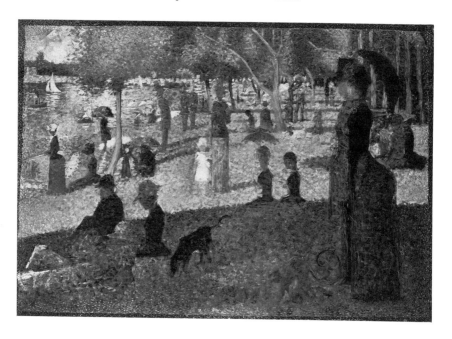

nailing down a concrete referent as any advertising logo? Can any image be further from the bland idealization of a late Neoclassicist like Puvis than the sharp critical detailing of the motif of the hand holding the cigar and the mechanical roundness of the head of the cane, both forms aggressively signifying the class-coded masculinity of the male "diagram" as opposed to the systematically circular shapes iterated by the clothing, almost topiary in its relentless shearing down of the living raw material, of his equally socially specific female companion? Gender difference, too, is objectified and systematized by means of obvious artifice.

I would like to demonstrate with one figure, that of the wet nurse, the way Seurat worked on one character in his sardonic pageant of frozen recreation, honing the image down to its signifying minimum, reducing the vital, and charming, irregularity of the original painted sketch to a visual hieroglyph. Martha Ward, in a word-picture as beautifully concise as the image itself, has described the final version as "a faceless configuration: an irregular quadrangle bisected by a triangular wedge and capped with circumscribed circles."[29] The *nourrice,* more familiarly known as the "Nounou," had become a stock character in the proliferation of visual typologies disseminated by the popular press during the second half of the nineteenth century. Seurat of course avoided the pitfalls of this sort of vulgar caricaturing, as he did those of the naturalistic representation of the wet-nursing profession, a relatively popular theme in the Salon art of the time. And unlike Berthe Morisot, who, in her representation of her daughter Julie being fed by a wet nurse, a painting of 1879, presents us with the activity of breast-feeding itself, and where the figure is frontal, exposed, spontaneously painted, and, although reduced as solid form, nevertheless evokes a vivid sort of biological immediacy, Seurat erases all concrete evidence of the wet nurse's professional activity, and her relation with a suckling infant, leaving us with a minimal sign, not a human process.[30]

Seurat really worked on this figure; we can see the process of reduction in a series of conté crayon drawings, ranging from a relatively descriptive and empathetic one (now in the Goodyear Collection) to a monumental back-view one, *Bonnet with Ribbons* (Thaw Collection)[6]. Despite the fact that the body is constructed of a few black and white curves and rectangles, joined by the most subtle nuances of tone marking the wet nurse's identifying ribbon (doubling as a kind of tonal spinal column), the wet nurse is nevertheless represented as connected to her charge, pushing a pram. In another version (now in the Rosenberg Collec-

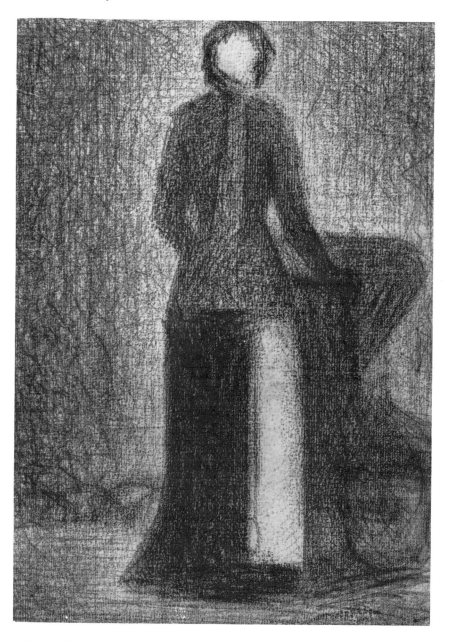

6. Georges Seurat, *Nurse with Carriage (Bonnet with Ribbons)*, c. 1884, New Jersey, Collection of Mr. and Mrs. Eugene V. Thaw

tion), although the baby is present, it has become a faceless echo of the circular shape of the nurse's cap; her body, though still standing, begins to assume that symmetrical wedge-shaped form of the wet nurse in the final version of the *Grande Jatte*. The series ends with a drawing (now in the Albright-Knox Gallery), specifically related to the wet-nurse group in the *Grande Jatte*. Of this drawing, Robert Herbert has remarked: "The nurse, seen from behind, is as chunky as a boulder. Only her cap and ribbon, flattened into the vertical plane, make us sure she is indeed a seated woman."[31] Seurat, in short, has reduced the wet nurse to a minimal function. There is no question, in the final version, of the wet nurse's role as a nurturer, of a tender relation between suckling infant and "seconde mère," as the wet nurse was known. The signs of her trade—cap, ribbon, cloak—*are* her reality: it is as though no others exist to represent the individual in mass society. Seurat, then, may be said to have reduced forms not to classicize or generalize, as Rich would have had it, but to dehumanize, to transform human individuality into a critical index of social malaise. Types are no longer figured as picturesquely irregular, as in the old codes of caricature, but reduced to laconic visual emblems of their social or economic roles, a process akin to the workings of capitalism itself, as Signac might have said.

I must, then, end as I began, reading the *Grande Jatte* darkly, seeing in its compositional stasis and formal reduction an allegorical negation of the promises of modernity—in short, an anti-Utopian allegory. To me, the *Grande Jatte* would seem, as it did to Roger Fry in 1926, to represent "a world from which life and movement are banished and all is fixed for ever in the rigid frame of its geometry."[32]

And yet there is a detail which contradicts this reading—small, but inflecting its meaning with a dialectical complexity, and lying at the very heart of the *Grande Jatte:* the little girl with the hoop. This figure was hardly conceived in its present, obviously contradictory form in the large final sketch. In the earlier version, it is hard to tell she is running at all. The figure is less diagonal, more merged with surrounding strokes; it seems connected to a brown-and-white dog, which is displaced in the final version. The little girl is unique in that she is a dynamic figure, her dynamism emphasized by her diagonal pose, her flowing hair, and her fluttering sash. She exists in total contrast to the staid little girl to her left, constructed as a tubular vertical of passivity and conformism and related by dependency and a sort of cloning isomorphism to her umbrella-shaded

mother in the center of the painting. The running little girl is, on the contrary, free, mobile, and goal-directed, chasing after something we cannot see. She also constitutes one apex of a triangle formed by the prancing dog in the foreground and a soaring, reddish butterfly to the left.[33] This figure, I would say, signifies Hope, in Ernst Bloch's terms, the Utopian impulse buried in the heart of its dialectical opposite, the antithesis of the thesis of the painting.[34] How different is Seurat's dynamic figuration of Hope—not really an allegorical figure at all but a figure that can be allegorized—from Puvis's stiff and conventional post–Franco-Prussian War and Commune version. Puvis's hope, one might say, is hopeless, if we conceive of hope as the possibility of change, of an unknown but optimistic futurity rather than a rigid, permanent essence, couched in a classical language of embarrassed nudity or chaste drapery.[35]

Seurat's figuring of the child as hope, active in the midst of a sea of frozen passivity, brings to mind a similar figuration: the child artist busily at work, hidden away in Courbet's *The Painter's Studio* of 1855, subtitled "a real allegory." [See Figure 1, Chapter 1.] It is the nineteenth-century work that comes closest to Seurat's in the way it envisions Utopia as a problem rather than a ready-made solution, as well as in its resolutely contemporary setting, and, paradoxically, in its static, frozen composition. Like the *Grande Jatte*, *The Painter's Studio* is a work of great power and complexity in its inextricable blending of Utopian and non- or anti-Utopian elements, and indeed, its representation of the Utopian and anti-Utopian as dialectically implicated in each other. In the gloomy cavern of the studio, the child artist, half hidden on the floor to the right, is the only active figure aside from the working artist himself.[36] His alter ego, the little boy admiring Courbet's handiwork and occupying center stage, according to the artist himself, stands for the admiration of future generations; like Seurat's little girl, this child can be read as a figuration of hope—hope as embodied in an unknown future.[37]

Yet the negative vision of modernity, specifically urban modernity, predominates in Seurat's oeuvre. His project of social critique through the construction of a new, partly mass-based, systematized formal language continued throughout his short but impressive career. In the *Poseuses* (Barnes Collection), a sardonically humorous statement of the contradictions involved in modern society in the relation between "life" and "art," contemporary models peel off their clothes in the artist's studio, baring their reality in the presence of an art work, a fragment of the *Grande Jatte,*

which is more "contemporary," more socially circumstantial than they are. Which element stands for art? The traditional nudity of the "three graces," systematically presented in frontal, profile, and back view, or the grand painting of modern life that foils them?[38] In the *Chahut* of 1889–90 (Kröller-Müller Museum), commodified entertainment, the coarse product of a still-nascent mass-culture industry, is represented in terms of hollowness and artifice, rather than as spontaneous pleasure, as Renoir might have figured it, or even as spontaneous sexual energy, in the manner of Lautrec. The transformation of the nose of the man on the right into a piglike snout overtly emphasizes this greedy consumption of pleasure. The dancers are standardized types, decorative diagrams, high-class advertisements for slightly dangerous recreation.

In *The Circus* of 1891[?], it is the modern phenomenon of spectacle and its concomitant, passive spectatorship that are at issue.[39] The picture parodies the production of art, allegorized as a type of public performance, dazzling in its technique, frozen in its gestures, turning somersaults to gratify an immobilized audience. Even the performers seem frozen in poses of dynamism, coerced into standardized arcs, disembodied diagrams of movement. There are even more sinister readings available for interpreting the relation of spectators to spectacle in *The Circus*. As well as standing for the public of art consumers, that audience, fixed in a state approaching hypnotic trance, may be read as signifying the condition of the mass public in relation to its manipulative masters. Thomas Mann's sinister "Mario and the Magician" comes to mind, or Hitler and the crowd at Nuremberg, or, more recently, the American electorate and the performer-candidates who mouthed slogans and gesticulated with practiced artistry on television. *The Circus*, as an anti-Utopian allegory, has a certain predictive potential, in addition to inscribing the social problematic of its own day.

If, as I believe, the *Grande Jatte* and Seurat's work generally have too often been enlisted in the "great tradition" of Western art, force-marched from Piero to Poussin to Puvis, they have all too little been related to some of the more critical strategies characteristic of the radical art of the future. For example, in the work of an obscure group of political radicals, working in Germany in the 1920s and early 1930s—the so-called Cologne Progressives—Seurat's radical formulation of modern experience finds its inheritance—not its "influence" or continuation—in the twentieth century, although the Progressives went further in their anti-Utopianism

7. Georges Seurat, *The Circus*, 1891, Paris, Musée d'Orsay

than did Seurat. Political activists, they were equally against art for art's sake and the contemporaneous Expressionist equation of social malaise with agitated paint surfaces or expressive distortion, which they felt to be simply individualist hyperbole. The group—including Franz Wilhelm Seiwert[8], Heinrich Hoerle, Gerd Arntz, Peter Alma, and the photogra-

pher August Sander—turned to the dispassionate diagramming of social iniquity and class oppression in a style appropriated from the flowcharts used by capitalists, as a weapon of revolutionary consciousness-raising.[40]

Anti-Utopians par excellence, they, like Seurat, used the codes of modernity to question the legitimacy of the contemporary social order. Unlike Seurat, they called the legitimacy of high art itself into question; yet one might say that this too is inherent in certain aspects of the artist's practice. With his emphasis on the anti-heroic rather than the gestural; on the "patient tapestry," with its implications of machinelike repetitiveness rather than the impatient slash and scumble of what Fénéon denominated "virtuoso painting";[41] and on social critique rather than transcendent individualism, Seurat may be seen as the ancestor of all those who reject the heroic and apolitical sublimity of modernist art in favor of a critical practice of the visual. The photomontage of Berlin Dada or the collaged constructions of Barbara Kruger are, from this vantage point, more in the line of Neo-Impressionist descent than the innocuous oil paintings of those who happened to use little dots of paint to construct otherwise conventional landscapes or sea scenes and called themselves Seurat's fol-

8. Franz Wilhelm Seiwert, *Bauernkrieg* (Peasants' War), 1932, Wuppertal, Van der Heydt Museum der Stadt

lowers. The anti-Utopian impulse lies at tne heart of Seurat's achievement—in, as Bloch saw it, the "single mosaic of boredom," the "empty-faced dolls," the "expressionless water of the Sunday Seine"—in short, the "landscape of painted suicide which does not come off only because it lacks resolve." And it is this legacy that Seurat left to his contemporaries and to those who followed after him.

Notes

1. This essay was originally presented in October 1988 as a talk initiating the Norma U. Lifton Memorial Lecture Series at the Art Institute of Chicago.

2. Seurat himself did not specify the time of day in the painting when he first exhibited it, at the Eighth Impressionist Exhibition in 1886.

3. Ernst Bloch, *The Principle of Hope*, trans. Neville Plaice, Stephen Plaice, and Paul Knight (Cambridge, Mass., The MIT Press, 1986), II, p. 814. This passage has also been cited, in a different context, in the recent catalogue edited by Erich Franz and Bernd Growe, *Georges Seurat: Zeichnungen*, Kunsthalle Bielefeld and Staatliche Kunsthalle Baden-Baden, 1983–84, pp. 82–83. The translation has been altered to render it more readable.

4. Bloch, *The Principle of Hope*, II, pp. 813–14. The emphasis is Bloch's. The translation has been somewhat altered.

5. The satiric exaggeration of structure itself constitutes an anti-Utopian strategy, allegorizing the failure of formal harmony in more traditional paintings of the time and calling into question, like the so-called social harmony it refers to, the whole idea of a "paradise on earth."

6. Seurat did not simply remove the process of pictorial construction from the painting, neutralizing his handiwork into nonexistent smoothness and "universality," as did a Neoclassical artist such as Ingres. The facture is, unremittingly, present. It has simply been mechanized, positively depersonalized, and made anti-expressive.

7. Meyer Schapiro, "Seurat and 'La Grande Jatte,'" *Columbia Review* XVII (1935): 14–15.

8. On Papety see Nancy Finlay, "Fourierist Art Criticism and the *Rêve de bonheur* of Dominique Papety," *Art History* 2, no. 3 (September 1979): 327–38. Finlay refers (p. 330) to the *Rêve de bonheur* as having "its message of Fourierist utopia conveyed by standard classical formulas in a classicizing style. . . ."

9. See Finlay, "Fourierist Art Criticism," p. 328.

10. Ibid., p. 331.

11. Love between the sexes, if not totally omitted, is certainly muted: The only two figures who might be read as lovers are relegated to the background of the composition. Papety's painting also included other embodiments of virtuous satisfaction, such as the "laborieux penseurs" (working thinkers) engaged in studies, a beautiful woman asleep in the bosom of her husband, and a noble old man stretching his hand out in blessing over the head of his daughter and her fiancé.

12. Finlay, "Fourierist Art Criticism," p. 334.

13. The *Sacred Grove* in the Art Institute of Chicago is a smaller version of the huge canvas in the Musée des Beaux-Arts in Lyons.

14. Théophile Gautier, *Moniteur universel*, June 3, 1867, cited in Claudine Mitchell, "Time and the Ideal of Patriarchy in the Pastorals of Puvis de Chavannes," *Art History* 10, no. 2 (June 1987): 189.

15. Anon. [P. Signac], "Impressionnistes et révolutionnaires," *La Révolte*, June 13–19, 1891, p. 4. Cited in Richard Thomson, *Seurat* (Oxford: Phaidon Press; Salem, N.H.: Salem House, 1985), p. 207, and n. 82, p. 233.

16. The very use of the term "harmony" in the title makes reference to the specifically Fourierist and, later, more generally socialist and anarchist designation of social Utopia. A famous Utopian colony established in the United States in the nineteenth century was known as New Harmony.

17. Indeed, if we look at the criticism of the time, it becomes clear that it is the expressive-formal structure of the painting rather than the social differences marking its cast of characters—or, more exactly, the unprecedented juxtaposition of working- and middle-class figures so emphasized by T. J. Clark in his recent account of the work (T. J. Clark, *The Painting of Modern Life: Paris in the Art of Manet and His Followers* [New York: Alfred A. Knopf, 1985], pp. 265–67)—that made the most forceful impression on articulate viewers of the 1880s and made them read the *Grande Jatte* as pointed social critique. As Martha Ward has recently pointed out, contemporary critics "acknowledged diversity but did not attend to its implications. Most were far more concerned to explain why all of the figures appeared to be rigid, stiff, expressionless, and posed...." Martha Ward, in *The New Painting: Impressionism 1874–1886*, exhibition catalogue, Fine Arts Museums of San Francisco and National Gallery of Art, Washington, D.C., 1986, p. 435.

18. Ward, *New Painting*, p. 435.

19. Cited by Ward, *New Painting*, p. 435, and n. 80, p. 442. Thomson cites the same passage, translating it rather differently, however: "Little by little one familiarizes oneself, one guesses, then one sees and admires the great yellow patch of grass eaten away by the sun, the clouds of golden dust in the treetops, the details of which the retina, dazzled with light, cannot make out; then one understands the starchiness of the Parisian promenade, regulated and stultified, where even relaxation is affected." Cited in Thomson, *Seurat*, p. 115, and n. 30, p. 229. Thomson is citing H. Fèvre, "L'Exposition des impressionnistes," *Revue de demain*, May–June 1886, p. 149.

20. Paul Adam, "Peintres impressionnistes," *Revue contemporaine littéraire, politique et philosophique* 4 (Apr.–May 1886): 550. Cited by Ward, *New Painting*, p. 435, and n. 81, p. 442.

21. The entire passage by Paulet reads as follows: "The painting has tried to show the toing and froing of the banal promenade that people in their Sunday best take, without any pleasure, in the places where it is accepted that one should stroll on a Sunday. The artist has given his figures the automatic gestures of lead soldiers moving about on regimented squares. Maids, clerks and troopers all move around with a similar slow, banal, identical step, which catches the character of the scene exactly, but makes the point too insistently." Alfred Paulet, "Les Impressionnistes," *Paris*, June 5, 1886, cited in Thomson, *Seurat*, p. 115; n. 31, p. 229; and n. 33, p. 230.

22. Félix Fénéon, "Les Impressionnistes en 1886 (VIIIe Exposition impressionniste)," *La Vogue*, June 13–20, 1886, pp. 261–75, trans. by Linda Nochlin, *Impressionism and Post-Impressionism, 1874–1904, Sources and Documents in the History of Art* (Englewood Cliffs, N.J.: Prentice Hall, 1966), p. 110. Fénéon's striking figure of speech, bringing together as it does the idea of patience and that of weaving, of course brings to mind the gendered image of the patient weaver Penelope and a host of tales and metaphors implicating women and the textile arts, not the least of which is Freud's famous account of women and weaving, in which, in his essay "Femininity," he describes weaving as women's only contribution to civilization (Sigmund Freud, "Femininity," *New Introductory Lectures on Psychoanalysis*, trans. J. Strachey, 1933; Reprint, New York: Norton, 1965, p. 131). For a full account of the gendered tropes and narratives associated with weaving, tapestry, and the textile arts, see Nancy K. Miller, "Arachnologies: The Woman, the Text, and the Critic," in her *Subject to Change: Reading Feminist Writing* (New York: Columbia University Press, 1988), pp. 77–101.

Fénéon's "patient tapestry" can also be read as a counterfigure to those more customary metaphors consecrating modernist creation by troping the masterful vigor, spontaneity, and emotionality of the (male) artist's creative practice, metaphorizing his brush as a thrusting or probing phallus, emphasizing the slashing, swirling rapidity, and, as it were, rapaciousness of the paint application or, on the other hand, its delicacy and sensitivity. Within this discursive context, Fénéon's phraseology may be read as a deconstruction of the master imagery of modern vanguard production, a deflationary figure in short.

23. Daniel Catton Rich, *Seurat and the Evolution of "La Grande Jatte"* (Chicago: University of Chicago Press, 1935), p. 2.

24. One need only think, for example, of the famous diagrams of Cézanne's paintings in Erle Loran, *Cézanne's Composition: Analysis of His Form with Diagrams and Photographs of His Motifs* (Berkeley and Los Angeles, 1943), diagrams later recycled by Roy Lichtenstein in such works as *Portrait of Madame Cézanne* of 1962. A portion of the book was published as early as 1930 in *The Arts*. See John Rewald, *The History of Impressionism*, rev. ed. (New York: Museum of Modern Art, 1961), p. 624.

25. Schapiro, "Seurat and 'La Grande Jatte,'" pp. 11–13.

26. For the most recent verdict on Seurat's "scientific" color theories, see Alan Lee, "Seurat and Science," *Art History* 10, no. 2 (June 1987): 203–26. Lee concludes unequivocally; "Far from being scientifically well founded, his 'chromo-luminarist' method was pseudoscience: it was specious in its theoretical formulation, and was applied with an indifference to any critical appraisal of its empirical validity" (p. 203).

27. *Seurat in Perspective*, ed. Norma Broude (Englewood Cliffs, N. J.: Prentice-Hall, 1978), p. 173.

28. Ironically, Seurat could be quite fierce in defending his own priority in the invention of Neo-Impressionism and attempting to deny Signac and others the right to build on "his" technique. See Thomson, p. 130 and pp. 185–87, for a discussion of strains within the Neo-Impressionist group. I am here considering the possibilities inherent in Neo-Impressionism as a practice, not Seurat's personal protectiveness of his own position as the leader of a movement. Obviously, there was a contradiction between the theoretical potential of Neo-Impressionism and the particular interpretations of it made by Seurat and his followers.

29. Martha Ward, *New Painting*, pp. 434–35.

30. The choice of the back, rather than the front, view of this figure is in itself significant. From the front, a wet nurse can be read as any nursing woman; from the rear, because of the presence of the circular cap and the signifying ribbon and cloak, the figure can be read only as a wet nurse. The back view reduces ambiguity of signification along with human relationship. For a full-scale analysis of Morisot's *Wet Nurse*, see Linda Nochlin, "Morisot's *Wet Nurse:* The Construction of Work and Leisure in Impressionist Painting," in *Women, Art, and Power and Other Essays* (New York: Harper & Row, 1988), pp. 37–56.

31. Robert Herbert, *Seurat's Drawings* (New York: Sherwood Publishers, 1962), cited in Broude, *Seurat in Perspective*, p. 129.

32. Roger Fry, cited in John Russell, *Seurat* (New York and Washington, D.C.: Frederick A. Praeger, 1965), p. 157.

33. Indeed, the pose of the pug—like the running child, added late in the process of composition—seems to have been invented as a response to that of the dynamic contour of the little girl. But the dog's pose would seem to be a parodic version of the capriole, one of the traditional positions of equestrian dressage, and as such signifies artificed constriction itself.

34. For Ernst Bloch's ideas on the Utopian implications of the part or fragment, see "The Conscious and Known Activity within the Not-Yet-Conscious, the Utopian Function" (1959) in his *The Utopian Function of Art and Literature: Selected Essays*, trans. by J. Zipes and F. Mecklenburg (Cambridge, Mass. The MIT Press, 1988), p. 139.

35. See the two versions by Pierre Puvis de Chavannes: *Hope* (nude), 1872, Musée d'Orsay, Paris, and *Hope* (clothed), 1872, Walters Art Gallery, Baltimore.

36. For the most complete analysis of the role of the child artist in this painting and in nineteenth-century representation generally, see Pierre Georgel, "L'Enfant au bonhomme" in *Malerei und Theorie: Das Courbet-Colloquium 1979*, ed. K. Gallwitz and K. Herding (Frankfurt: Städelschen Kunstinstitut, 1980), pp. 105–116.

37. For the negative contradiction of Courbet's figuration of hope in the *Studio*, in the form of the Irish beggar woman, see Linda Nochlin, "Courbet's Real Allegory: Re-reading 'The Painter's Studio,' " in Sarah Faunce and Linda Nochlin, *Courbet Reconsidered* exhibition catalogue, Brooklyn Museum, 1988, pp. 26–29.

38. In the seated profile study for the *Poseuses*, 1887 (now in the Musée d'Orsay), the formal language itself embodies contradiction, a clash of systems, so to speak, in the non-coincidence of the simple, diagrammatic form of the body, which is standardized in its curves and angles, with the systematized veil of multicolored dots which obscures the boundaries of the form with an atomized diffuseness.

39. For the concepts of "spectacle" and "spectacular society," see Clark, *The Painting of Modern Life*, pp. 9–10. Clark explains that they were developed in the 1960s by the Situationist International group in France, and especially by Guy Debord.

40. See, for example, Gerd Arntz's *Four Prints from Twelve Houses of the Age*, woodcut, 1927. For information about the Cologne Progressives and illustrations of their work, see the exhibition catalogue *Politische Konstruktivisten, 1919–33: Die "Gruppe progressiver Kunstler," Köln*, Berlin, Neue Gesellschaft für Bildende Kunst, June–July, 1975.

41. Félix Fénéon, cited by Joan Ungersma Halperin, *Félix Fénéon: Aesthete and Anarchist in Fin-de-Siècle Paris* (New Haven and London: Yale University Press, 1988), p. 83.

Index

Page references in italics refer to illustrations.

A La Synagogue lithograph (Toulouse-Lautrec), 161–62
Abd-el-Kader, 54
Abd-el-Rahman, Sultan, 54–56
Adam, Paul, 180
Aleichem, Sholem, 162
Algeria, 49–50, 53, 54–56
Ali-Ben Ahmed, 56
alienation, in avant-gardism, 12–17
allegorical subjects, 7, 12, 17; in Frédéric's paintings, 125; and Pissarro's *Apple-Picking*, 67; Seurat's anti-Utopian *Grande Jatte*, 174, 180–81, 185
Allegory of Modern Woman (Cassatt), 67
Alma, Peter, 188
Ambre, Emilie, 80
American Ballet (Kertesz), 89
anarchism, 142; Pissarro and, 28, 61–62, 141
André, Edmond, 84
Anti-Semite and Jew (Sartre), 141
anti-Semitism: and Clemenceau's *Au Pied . . .*, 161; Degas and, 142, 151, 155–60, 163; Lautrec and, 160–62; and Pissarro's

drawings, 144–46; process of "falling in hate," 155; and "status anxiety," 158–59
anti-Utopianism, 170–90; and German radicals, 187–90
Apotheosis of Homer (Ingres), 12, 154
Apple-Picking, Eragny-sur-Epte (Pissarro), 67; *68*
Apples and Basket (Cézanne), 29
Archives israélites, 151
Arntz, Gerd, 188
art historians, 10
Astruc, Rabbi Elie-Aristide, 150
At Eternity's Gate (van Gogh), 105
At the Bourse (Degas), 146–48; *147*
Au Pied du Sinai (Clemenceau), 160–62
Au Temps d'Harmonie (Signac), 67
Aus dem schlesischen Gebirge (Freiligrath), 113
avant-garde: Courbet and Realism, 3, 7, 12; and Manet, 12–17; original usage of term, 2–3; and van Gogh, 115

Bab Mansour, Menkes, 39–41; *40*
Baily, Bernard, 89
The Ball at the Opera (Bosio), 87–88
Balla, Giacomo, 137
ballet dancers, 152–53
Balzac, Honoré de, 7, 37
A Bar at the Folies-Bergère (Manet), 17, 79, 89; *90*
Barres, Maurice, 158
The Barricade (Manet), 75
Barthes, Roland, 38
Bastien-Lepage, 24, 120
Baudelaire, Charles, 3, 7, 11, 13
Bauernkrieg (Peasants' War) (Seiwert), *189*
Bazaine, Marshall, 86
Belgium, 122; decline in national fertility, 134–35; depiction of workers in, 132–33; Labor Party, 110–11
The Bellelli Family (Degas), 148
Bellenger, Albert, 96, 103
Bendiner, Kenneth, 38
Berger, John, 26
Berlin Dada, 189
Bersani, Leo, 37
Bézard, 7

Bizet, Georges, 149
Black Barber of Suez (Bonnat), 52
blacks, 49
Blanche, Jacques-Emile, 152
blague, 13–14, 16, 81
Blind Men (Renouard), 99
Bloch, Ernst, 170–73, 186, 190
Bodegón tradition, 30
Boggs, Jean Sutherland, 152
Bois Sacre (Chavannes), 7
Bolatre, M., 146, 148
Bonnat, Leon, 52
Bonnet with Ribbons (Seurat), 183; 184
Bords de la Marne en hiver (Pissarro), 63, 63
Bosio, Jean-Francois, 87–88
Botticelli, 137
Boulanger-Cavé, Albert, 142–43, 152
Boulevard Montmartre, mardi-gras (Pissarro), 68; 69
Boulevard vu d'en haut (Caillebotte), 73
bourgeoisie, 13, 159–60
Bourse (Renouard), 99
Boy with a Sword (Manet), 79–80
Brandon, Edouard, 149
Breton, Jules, 24, 51, 67, 125
Brettell, Richard, 65
The Bridal Preparations (Courbet), 21
Brothel monotypes, 153
Broude, Norma, 181
Brown, Ford Madox, 120, 132
Brueghel, 120, 126, 131
brushwork: of Cézanne, 174; of Gérôme compared with Delacroix, 44; of Pissarro, 28, 68–69; of Seurat, 173–74, 180–82
Bruyas, Alfred, 8, 11
The Burial at Ornans (Courbet), 8, 20–21, 51, 77; 21
Burial of Count Orgaz (El Greco), 87
Byron, George Gordon, 43

Cachin, Françoise, 84
Café Concerts (Degas), 35
Caillebotte, 73
Cairo, 38–39, 50
Cantonment of 1856, 53

Capital from Turpitudes sociales (Pissarro), 144; 145
capitalism, 144–45, 171, 188–89
Capture of the Smala of Abd-el-Kader at Taguin, May 16, 1843 (Vernet), 53–54
Cardinal, Madame, 152
caricatures, 7, 21, 78, 85–86; Jewish, 144–45; and Toulouse-Lautrec's illustrations, 162
Carlyle, Thomas, 132
Carnets (Halévy), 151
Cassatt, Mary, 67, 133, 141
Cézanne, Paul, 29–30, 122, 141, 172; brushwork, 174; and Pissarro, 60–61
Chabrier, Emmanuel, 84–85
Chabut (Seurat), 172, 187
Chalk Vendors (Frédéric), 123–25; 124
Champfleury, 11
Chant et chansons (Dupont), 3
Chassériau, Théodore, 55–56
Chassidim, 161
Chatterton (Vigny), 3
Chenavard, Paul-Joseph, 7
Chesneau, Ernest, 87
children: and Fourierism, 11; Seurat's little girl with hoop, 185–86
Christ on the Sea of Galilee (Delacroix), 16
Christian triptych format, 122
chromotypogravure, 181
The Circus (Seurat), 187; 188
Cité ouvrière (Renouard), 108
cityscapes, 71–73
class, sense of, 24, 77
Clemenceau, Georges, 160–62
Cologne Progressives, 187
Colonel Contreras (Oller), 24
colonialism, 34–37, 49–50
commedia dell'arte, 80
Commune, the, 85–86, 176; fall of, 30
Constable, John, 19–20
Constantinople, 36, 39
Cordelia's Portion (Brown), 132
Corot, Jean Baptiste, 60
The Cotton Market in New Orleans (Degas), 148
Courbet, Gustave, 1–2, 62, 120, 131, 186; Fourierism and Papety, 7–11; Painter's

Studio, 3–8, 10–12, 17; 4; painting of Proudhon, 25–26; Realism as "avant-garde," 3; and sense of place, 19, 20–21, 24, 77; still lifes in prison, 30
Crystal Palace, London, 63–64
Cubism, 60
cut-off view, in painting, 81–82, 89, 91

Dagnon-Bouveret, 51
Dalou, 122
Daly, César, 2–3
Dans la Rue: Par Un Jour funèbre de Lyon (Desbordes-Valmore), 113
D'Aumale, Duc, 53
Daumier, Honoré, 2, 81, 95, 99, 104, 144
Day of the God (Gauguin), 51
De la Mission de l'art et du rôle des artistes (Laverdant), 2
Death of a Misunderstood Man of Genius (Etex sculpture), 3
Death of Chatterton (Wallis), 5
Death of Sardanapalus (Delacroix), 41–44; 41
Debat-Ponsan, 49
The Decline of Belgian Fertility, 1800–1970 (Lesthaeghe), 134
Degas, Auguste, 159
Degas, Edgar, 35, 65, 84, 141–69; and anti-Semitism, 142–44, 146–56; effect on art, 160, 163; and Dreyfus Affair, 141–42, 146, 151, 154–58, 160, 163; friendship with Halévys, 149, 151–56; and photography, 154; and Pissarro, 142, 149, 163; "status-anxiety," 158–60
Degas, René, 159
Degas, René Hilaire, 158
Déjeuner sur l'herbe (Manet), 13–14; 14; compared with Grand Jatte, 170–73
Delacroix, Eugene, 2, 5, 16; compared with Gérôme, 37–38, 56; and Morocco, 51–52, 54–55; Orientalist painting and erotic fantasy, 41–43, 56; and the picturesque, 51–52
Demarsy, Jean, 90
demimonde, 79, 90

DePaepe, César, 110–11
Departure of the Volunteers
 (Rude), 108
Desbordes-Valmore, Madame,
 113
Die Weber (Hauptmann), 113–14
Discours de M. Gambetta
 (Renouard), 99
Donatello, 5
Doré, Gustave, 73, 78, 97
D'Ou venons-nous? Que
 sommes-nous? Ou
 allons-nous? (Gauguin), 67
Dream of Happiness (Papety),
 7. See also Un Rêve de
 Bonheur
Dreyfus, Alfred. See Dreyfus
 Affair
Dreyfus Affair, 141–46, 148, 151,
 156–57, 163; anti-Semitism
 and "status anxiety," 159–60;
 and Degas/Halévy
 friendship, 154–56
Dreyfusards. See Dreyfus
 Affair
Driault, Edouard, 36
Drumont, 144, 156, 158
Duchamp, Marcel, 14
Dupont, Pierre, 3
Duranty, Edmond, 88–89,
 146–47
Duret, Théodore, 77, 82, 84–85

Eaux-Fortes, Mouvements,
 gestes, expressions (Renouard
 etchings), 98
1848 Revolution, 1–2, 5, 8
1830 uprising, 2, 5, 111
El Greco, 87
El velorio (Oller). See The
 Wake (Oller)
Elie Halévy and Mme Ludovic
 Halévy in Degas's Living
 Room (Degas), 155
Eliot, George, 113
Enfants Assistés (Renouard), 99
Ephrussi, Charles, 149–50
erotica, 41–49. See also
 Sexuality
The Escape of Rochefort
 (Manet), 14–16; 15
Etex, Antoine, 3
Ettinghausen, Richard, 38
Evans, Walker, 115
The Execution of Maximilian
 (Manet), 14

Execution Without Judgment
 Under the Caliphs of
 Granada (Regnault), 52
Expressionism, 188

Façades of Rouen Cathedral
 (Monet), 70
Fantín-Latour, Henri, 29–30
Faure (actor), 80
Faure (singer), 77
Felix Holt: The Radical (Eliot),
 113
Fénéon, Félix, 180, 189
Férat, Jules, 97, 106
Fevre, Henry, 180
Fildes, Luke, 97
Flaubert, Gustave, 13, 38
Flax series (Frédéric), 125–26,
 136
flesh market (Fleischborse), 45,
 76
folkloric art, 21, 23, 77
Forain, 156
Fourier, F. M. C., 9. See also
 Fourierism
Fourierism, 7–11; and Papety's
 Dream of Happiness, 174–76
fragmentation, in art, 79, 88–89
France, 20, 23–24; artistic
 influence on Oller, 29–30;
 and Orientalist painting,
 33–57; Republican Party,
 85–86, 111
Franco-Prussian War, 63,
 85–86, 176
Frédéric, Léon, 120–39;
 religious aspects of work,
 120–11, 131–32, 135–36; secular
 aspects, 120, 131–33
Freiligrath, Ferdinand, 113
Freppa, Aurora, 159
Fried, Michael, 91
Fromenthal, 149
Fruitfulness (Jordaens), 134
Fry, Roger, 185
Funeral Preparations (Courbet),
 21
Futurism, 62, 137

Gambetta, Léon, 86, 98
Ganderax, Madame, 163
Garbage (Renouard), 106; 109
Gauguin, Paul, 29, 67, 174;
 denial of picturesque, 51; and
 Pissarro, 60–61; Pissarro's
 criticism of, 71

Gautier, Théophile, 1–2, 176
Gautier Benítez, José, 24–25
Gavarni, Paul, 77, 97, 99
Geibel, Emanuel, 113
General Mellinet and Chief
 Rabbi Astruc (Degas), 150; 150
Germany, 113–14, 187
Gérôme, Jean-Léon, 34–42,
 56–57; and Oriental erotica,
 44–51
Gervex, Henri, 152
Gilles (Watteau), 17
Gleyre, 5
Goes, Hugo van der, 131
Golden Age (Ingres), 7, 174–75
Goncourt, Edmond de, 87
Grain series (Frédéric), 125–26,
 136
Grande Jatte (Seurat), 67,
 170–87; 171; compared with
 Dejeuner sur l'herbe, 170–73;
 contrasted with Utopian
 paintings, 174–79; critics' and
 reviewers' comments, 180–81;
 pointillé brushwork of,
 173–74; preliminary sketches,
 182, 182–85; "single mosaic of
 boredom," 170, 190; symbol
 of Hope in little girl with
 hoop, 185–86; and wet nurse
 figure, 183–85
The Graphic, 97
Graves, Jean, 178
The Great Oak of Flagey
 (Courbet), 20, 26–27
Greece Expiring on the Ruins of
 Missolonghi (Delacroix), 5
Gregory, E. J., 97
Grevin, Alfred, 78
Guavas (Oller), 29
Guérin, 5
Guesde, Jules, 111
Guillaudin, 84–85
guillotining, 52

Haas, Charles, 149
Halévy, Daniel, 144, 149, 151,
 152, 154, 163
Halévy, Elie, 154
Halévy, Léon, 151
Halévy, Louise, 154
Halévy, Ludovic, 142–44, 156,
 163; friendship with Degas,
 149, 151–56
"Halévy Sketchbooks"
 (Degas), 152

Harmonians, 8, 12
Harper's Weekly, 97
Hauptmann, Gerhard, 113–14
Haystack series (Monet), 126
Hecht, Albert, 84
Heine, Heinrich, 113
Henriette Maréchal (Goncourt), 87
Henry, Charles, 181
Henry, Lieutenant-Colonel, 156
Herbert, Robert, 185
Herkomer, Hubert, 97, 105, 115
Hide and Seek (Tchelitchew), 137
Hine, 115
Hitler, Adolf, 187
Hoerle, Heinrich, 188
Holl, Frank, 97, 115
"Home Album" (Sander), 127
Hübner, Carl, 113
Hueffer, Ford Madox, 132
Hugo, Victor, 113

Ibels, Henri-Gabriel, 114
identity, sense of, 26, 28, 32
The Illustrated London News, 97
illustrators (journal), 95–115
imagerie d'Epinal, 21, 127
Immigrants (Laermans), 123
Impressionism, 35, 88, 122. See *also* Impressionists; Manet and, 78; and Manet's brushwork, 16; Pissarro and, 61–65, 71
Impressionists. See *also* Impressionism: and fragmentation, 79; Pissarro's admiration for Degas, 149; rejection of values and structures, 62; and Seurat's impersonal attitude, 181; and use of cut-off view, 81
In the Time of Harmony (Signac), 178–79; *179*
"Industrial Crisis in Lyon" series (Renouard), 106, 110
Ingres, Jean, 7, 12, 47, 49, 154, 174–75
Isaacson, Esther and Alice, 144
Islam, 34
Isly, Battle of, 54

J'Accuse (Zola), 141
Jakobson, Roman, 78–79

Janin, Clément, 98
Japanese prints, 81
Jeanron, Philippe Auguste, 5
Jews: and anti-Semitic French press, 156–57; French artists and Dreyfus Affair, 142, 144–48; and Toulouse-Lautrec's illustrations, 160–62; traits and characteristics of, 148, 151, 154, 160
Jordaens, Jacob, 120
José Gautier Benítez (Oller), 24–26; *25*
Journal (Goncourts), 87
Journet, Jean, 9
Jouvin, Hippolyte, 73
Julius Caesar, 26

Keene, Charles, 144
Kertész, André, 89
Kitsch dilemma, 48–49
Koëlla, Léon, 79
Kollwitz, Käthe, 110, 114–15, 122, 125–26
Kruger, Barbara, 189

La Crise industrielle a Lyon: Sans travail (Renouard). See *Sans travail*
La Crise lyonnaise: Intérieur d'un tisseur en sôie (Ferat), 106
La Cueillette des pommes, Eragny-sur-Epte (Pissarro), 67
La Famille Cardinal (Degas), 152–54
La gloria (Philip), 22
La Libre Parole, 156
La Nouvelle Peinture (Duranty), 88
La Question d'Orient (Driault), 36
La Révolte, 178
La rue Montorgueil fete du 30 juin (Monet), 68
labor unions, 110–12
Labors of the Month motif, 125–26
Laemlein, 7
Laermans, Eugeen, 122–23
Laforgue, Jules, 62, 64–65
Lançon, Auguste, 97
Landscape with Royal Palms (Oller), 27–28; *27*

L'Angelus (Millet), 67
L'Artiste, 1, 8
The Last Evening of Slavery (Papety), 8
Laundress (Oller), 24
Laurent, Méry, 90
Laverdant, 2
Le Constitutionel, 2
Le Monde illustré, 97
Le Monde judiciare (Renouard), 99
Le Nouvel Opéra (Renouard), 97
Le Rappel des glaneuses (Breton), 67
Le Roman (Maupassant), 88
Le Temps, 85
Le Ventre de Paris (Manet), 14
L'Egalité, 111
Legrand, Francine-Claire, 137
Leiris, Alain de, 87
L'Enfant (Valles), 98
Lepage, 95, 104
Les Glaneuses (Millet), 66–67
Les Glaneuses (Pissarro), 65–67
Les Invalides series (Renouard), 99; *101*
Les Temps nouveau, 178–79
Les Turpitudes sociales series (Pissarro), 144–46, 160; *45*
lesbianism, 49
Lesthaeghe, Ron J., 134
Lévy, Emile, 149
Liberty at the Barricades (Delacroix), 2, 5
L'Illustration, 95–97, 102, 108, 112
L'Intransigeant, 156–57
The Little Patriots: A Souvenir of July 1830 (Jeanron), 5, *6*
Lordship Lane Station (Pissarro), 64
Loups (Dore), 79
Luce, 141
Ludovic Halévy Meeting Mme Cardinal Backstage (Degas), 152–54; *153*
Lycée of Galata-Serai, 36
Lyons, 96–97, 99, 102–6, 110–14

Mackenson, Fritz, 133
MacMahon, Marshal, 85–86
Madame Bovary (Flaubert), 32
Magic Realism, 120
Mallarmé, Stéphane, 45, 77, 80–81, 89

Manet, Edouard, 12–17, 19, 35, 49, 170. *See also Masked Ball at the Opera;* and cut-off compositions, 81; politics of, 14, 85–86
Manette Salomon (Goncourt brothers), 13
Mangóes (Oller), 29; *29*
Manifesto of the Intellectuals, 141
Mann, Thomas, 187
"Mario and the Magician" (Mann), 187
marionette theater, 91
Marx, Karl, 113
Masked Ball at the Opera (Manet): discussion of, 75–91; male figures in, 82–87; prostitutes in, 45–47, 86–87; Salon rejection of, 75–77, 91; subversive quality of, 90–91
masked balls, 75. *See also Masked Ball at the Opera*
The Massage (Debat-Ponsan), 49
Mattock and Milk (Patini), 133
Maupassant, Guy de, 88
Maurice, Reverend F. D., 132
May, Ernest, 146–49
McMullen, Roy, 159, 163
Meier-Graefe, Julius, 45, 76
Mellinet, Emile, 150
Mendiants le jour de l'an (Renouard), 99
Mene Tekel (Geibel), 113
Meunier, Constantin, 122
Meurent, Victorine, 80
Millet, Jean, 1–2, 95, 104, 120, 125–26; *Les Glaneuses* compared with Pissarro's, 66–67
Mitchell, Claudine, 176
models (artist), 42, 44, 142
Modernism, 28, 172
modernity, 32, 61–63, 186–87, 189
Modersohn-Becker, Paula, 133
Mon coeur mis à nu (Dupont), 3
Monet, Claude, 30, 62, 68, 126; compared with Pissarro, 69; and Dreyfus Affair, 141–42; Pissarro's criticism of, 65; Rouen Cathedral *Façades*, 70
Monument Henry, 156

Moorish Bath (Gérôme), 47–49; *48*
"Moral Order," 86, 90
Morisot, Berthe, 183
Mornay, Comte de, 51, 54
Morocco, 51–52
Mother and Child (Kneeling) (Modersohn-Becker), 133–34; *135*
Mother and Child theme, 133
Moulay-Abd-el-Rahman, Sultan of Morocco (Delacroix), 54–55; *55*
Moulin de la Galette (Renoir), 178
Mullen's Alley, New York City (Riis), *107*
multipartite compositions, 120–39
Munch, Edvard, 73
Music in the Tuileries (Manet), 79, 81; *80,* 84
Musset, Alfred de, 7
Musson, Celestine, 159

Nabis, 71
Nana (Manet), 79, 81; *83*
Napoleon III, 26, 36
Nash, John, 97
Natanson, Thadée, 142, 163
Naturalism, 88, 136
Nature (Frédéric), 136–37; *138*
Near East. *See* Orientalist art
Neo-Impressionism, 60, 67, 189
New Deal murals, 120
New Harmony (Fourierism), 8–10
The New Painting (Duranty), 147
North Africa, 51–56
Notes d'Harmonie (Bruyas), 8
nourrice ("Nounou"), 183
Nurse with Carriage (Bonnet with Ribbons) (Seurat), *184*

Old Musician (Manet), 81
Oller, Francisco, 19–32; portraits, 24–26; and sense of place, 22–28, 30, 33; still life paintings, 28–30
Olympia (Manet), 13, 49, 79, 81
Opéra House, Paris, 77, 82
The Orchestra During a Performance of a Tragedy (Daumier), 81

Orientalism: The Near East in French Painting, 1800–1880 exhibition, 34
Orientalist art, 33–57; art historians and, 56–57; bath scenes, 47–49; and erotica, 41–45; mystification and "reality," 35–41; violence and the picturesque, 49–53, 56
"orphan men," 105–6
Ottoman government, 36
Ouled Rechaich tribe, 53

The Painter's Studio: A Real Allegory of Seven Years of My Life as an Artist (Courbet), 3–8, 10–12, 17; *4;* child artist as symbol of Hope, 186
Papety, Dominique, 7–11; and Utopian imagery, 174–76
Parade (Seurat), 172
Paris, 32; Degas's working women of, 65; and Manet's *Masked Ball,* 77–80; Manet's murals "Le Ventre de Paris," 14; materialism in Monet's time, 91; and Pissarro's street scenes, 60, 71–73; Van Gogh and, 115
Passage at St. Paul's Hospital (van Gogh), 99; *100*
The Past, the Present and the Future (Gleyre), 5–7
Patience Escalier, Shepherd of Provence (van Gogh), 105
Patini, Teofilo, 133
Paulet, Alfred, 180
Paysans dans les champs, Eragny-sur-Epte (Pissarro), 67
Peasant War series (Kollwitz), 126
Peasant Woman Putting Corn in Sheaves (van Gogh), 24
peasants, artistic depiction of, 8, 24, 163; by Frédéric, 125–30; by Kollwitz, 126; and maternity theme, 133–34
Peasants of Flagey (Courbet), 8
Peasants Planting Cabbage (Pissarro), 163
Père Tanguy (van Gogh), 105
Perier, Casimir, 111
"petite sensation," 61, 64, 73
phalansteries, 7, 8, 11

Philip, John, 22
photography: Degas and
 Halévys, 154; to document
 Orientalist art, 39–41; Riis
 and slum life, 106; and use
 of cut-off view, 81
picturesque, the: and
 Delacroix, 51–52; and
 Gérôme, 35–38; Orientalist
 art and, 49–50
Pissarro, Camille, 28, 30, 60–73,
 156, 160; Degas hatred of,
 142, 149, 163; and Dreyfus
 Affair, 141–42; and freedom
 in art, 73; and
 Impressionism, 61–65; and
 natural vision, 61–62, 67–69,
 71–73; and
 Neo-Impressionism, 65;
 paintings of working
 women and peasant women,
 65–67; series of anti-Semitic
 drawings, 144–46
Pissarro, Lucien, 62, 71, 142, 163
place, sense of, 19–20; and
 Manet's Masked Ball, 78; and
 Oller, 22–32; in still life, 30
Place du Théâtre français
 (Pissarro), 72
Pointillism, 173–74, 180–82
Polichinelle, 76–77, 80, 84–85,
 91
Polichinelle (Manet), 76–77
Pont Neuf, Paris, 73
Pont Royale et Pavillon de
 Flore (Pissarro), 71–72
Portrait of Emile Zola (Manet),
 81; 82
Portrait of Friends in the Wings
 (Ludovic Halévy and Albert
 Cavé) (Degas), 142, 144, 146;
 143
Portrait of Kalif Ali-Ben Hamet
 (Ahmed) (Chassériau), 55–56
Portrait of Mrs. Madox Brown
 (Brown), 132
Portrait of the Painter Henri
 Michel-Lévy (Degas), 149–50
Poseuses (Seurat), 186–87
Post-Impressionists, 171–72, 181
The Postman Joseph Roulin
 (van Gogh), 105
The Potato Eaters (van Gogh),
 95, 123
Poultry Market at Gisors
 (Pissarro), 66

poverty-painting, 106, 123. See
 also work and workers
 theme
The Principle of Hope (Bloch),
 170–71
prostitutes, 43–47, 79, 86–87, 153
Proudhon, P. J., 9, 11, 25–26
provincialism, 30–32
Psst . . . , 156
Puerto Rico. See Oller,
 Francisco
Punch, 91
Puvis de Chavannes, Pierre, 7,
 176–78, 183, 186

The Race of the Wicked Rules
 over the Earth (Bézard), 7
Railroad (Manet), 76
Rain, Steam and Speed: The
 Great Western Railway
 (Turner), 64
Raising of the Cross motif, 131
Rappard, Anthon, 99, 115
Reade, Charles, 37
Realism: central concepts of,
 19; and Courbet, 3, 7, 12,
 20–21; and Frédéric's work,
 122; and Manet, 77, 79, 91; in
 nineteenth-century
 Orientalist art, 33–35
Reff, Theodore, 85, 160
Regamey, Félix and
 Guillaume, 97
regionalism, 20–21, 31–32
Regnault, Henri, 52
Religion, Philosophy, the Sciences
 and the Arts Enlightening
 Europe (Robert), 7
Renoir, Hilaire, 187;
 anti-Semitism of, 141–42;
 semi-Utopian paintings, 178
Renouard, Charles-Paul:
 depiction of Lyons weavers,
 95–97, 99, 102–10; range of
 subjects, 97–98; and working
 class, 125
The Return from the Meeting
 (Courbet), 23
Révolte de Canuts, 1831, 111
Rewald, 67–68
Reyer, Ernest, 149
Ricatte, R., 87
Rich, Daniel Catton, 180–81,
 185
Riches of Autumn (Jordaens),
 134

Riis, Jacob, 106, 110, 115
Ripe Plantains (Oller), 30; 31
Ris, Clément de, 1
Road to Calvary motif, 122
Robert, Victor, 7
Roberts, David, 38
Rochefort, 14–16, 98, 156–57
Rodin, Auguste, 122, 141
Romanticism, 3, 19–20
Romeo and Juliet (Brown), 132
The Roofs of Old Rouen, Gray
 Weather (The Cathedral)
 (Pissarro), 70–71; 70
Rosenthal, Donald, 33–34
Rouart, Henri, 156
Roudier, Paul, 84
Rousseau, Théodore, 1
Rouviere, Philibert, 80
Rubens, Peter Paul, 120, 131
Rude, François, 108
Ruskin, John, 4
Ryckebusch, 112

Sabatier, François, 11–12, 89
Sacred Grove (Puvis), 176
Said, Edward, 34
Saint-Simon, Henri de, 2
Salons: 1837, 7; 1843, 7; 1845, 3,
 53, 55–56; 1846, 7; 1848, 1;
 1850–51, 21; 1851, 8; 1866, 63;
 1867, 45; 1868, 63; 1874, 45,
 75–77, 91; 1882, 89
Sander, August, 127, 189
Sans travail (Renouard), 96,
 99–112, 114; 96
Sardanapalus, 42–43
Sartre, Jean-Paul, 53, 141, 157
Schapiro, Meyer, 174, 180–81
"Schlome the Fighter"
 (Clemenceau), 161–62
Seasons (Brueghel), 126
Seasons (Millet), 126
Segantini, Giovanni, 133
Seiwert, Franz Wilhelm,
 188–89
Self-Portrait with a Black Dog
 (Courbet), 24
Senatus Consulte of 1863, 53
serial paintings, 125–30
Seurat, Georges, 65, 67, 170–90.
 See also Grande Jatte;
 background of, 174; Grand
 Jatte as anti-Utopian
 allegory, 170–74; and
 mechanical techniques,
 181–85

sexes, relation of: in Frédéric's
 Worker's Life, 130–31; and
 Manet, 77
sexuality: black and white
 body contrasts, 49; of
 Manet's Masked Ball, 75–78,
 91; in Olympia and Nana,
 81–82; and Orientalist art, 35,
 41–45, 49; and women's legs,
 89
Sickert, Walter, 152
Siegel, Jerry, 89
Signac, Paul, 67, 141–42;
 response to Grande Jatte,
 178–79
Silas Marner (Eliot), 113
The Silesian Weavers (Heine),
 113
Silesian Weavers (Hübner), 113
Situations V (Sartre), 53
Six Friends at Dieppe (Degas),
 152
The Slave Market (Gérôme),
 44–47; 46
"slice of life" vision, 80, 88–89
Snake Charmer (Gérôme),
 34–37; 34
social martyr theme, 3–4
social progress notion, 61–62,
 174
Social Realism, 137
socialism. See Fourierism
society: and "avant garde,"
 12–17; and radical Realism, 3
Spain, 22–24, 30
spectacle/spectator
 relationship, 187
The Spectre (Siegel and Baily),
 89
The Stages of a Worker's Life
 (Frédéric), 120–21, 126; 121;
 discussion of, 130–39
Stages of Peasant Life
 (Frédéric), 126–30; 128, 129
"status anxiety," 158–59
Stendhal, 155
Stieglitz, Alfred, 89
still life paintings, 28–30
Stone Breakers (Courbet), 131
Straus, Genevieve Bizet, 149
Street in Algiers (Gérôme),
 37–38
Street in Meknes (Delacroix),
 37–38

Summer (Puvis), 176–78; 177
Sunday Afternoon on the Island
 of La Grande Jatte (Seurat),
 171. See also Grande Jatte
Sunday at Chelsea Hospital
 (Herkomer), 105
Surrealism, 120
Symbolisme, 131, 136–37
synecdoche, 47, 78–79, 89
"system," 67, 181–82

Tchelitchew, 137
The Temple of the Golden Calf
 from Turpitudes sociales
 (Pissarro), 145–46
Thoré, Théophile, 1–2
Three Sisters (Chekhov), 32
Töpffer, Rodolphe, 11
Toulouse-Lautrec, Henri, 187;
 illustrations for Au Pied du
 Sinai, 160–62
Très Riches Heures of the Duc
 de Berry, 126
triptych format, 120, 122–23. See
 also The Stages of a Worker's
 Life
Triptych of the Mine
 (Meunier), 122
True, Dorothy, 89
Turkish tile patterns, 35, 38,
 47
Turner, J. M. W., 64
Two Mothers (Segantini), 133

Un Canut à son métier
 (Renouard), 96, 105, 106, 108
Un Rêve de bonheur (Papety),
 7–8, 174–76; 175
under-painting, 62
Une Reunion d'ouvriers aux
 Folies-Bergère (Renouard),
 100, 106, 108
Ungher, Caroline, 8, 12
Universal Charity (Laemlein),
 7
Universal Exposition, 1855, 11
Utopian paintings, 172–76

Vaissière, Captain, 53
Vallès, Jules, 98
Vallotton, 141
Valpinçon Bather (Ingres), 47
Van Gogh, Theo, 95, 99,
 103–4, 115

Van Gogh, Vincent, 24, 103,
 112, 174; on art critics, 104;
 and "orphan men," 105–6,
 110; and Pissarro, 61; and
 Renouard's weavers, 95–97,
 99, 104–5, 114–15; and
 working class, 125,
Vermeer, Jan, 1, 61
Vernet, Horace, 53–54
View of Delft (Vermeer), 61
Vigny, Alfred Victor, Comte
 de, 3
Villot, 52
Voltaire, 52

The Wake (Oller), 21–23; 22
Waldeck-Rousseau Law, 1884,
 111–12
Wallis, Henry, 3–4
Wappers, Baron, 132
Ward, Martha, 180, 183
Warnier Law, 53
Watteau, Jean Antoine, 17
A Weavers' Revolt cycle
 (Kollwitz), 110, 114, 125–26
weaving industry and weavers,
 96–97, 99, 102–114, 125
Welty, Eudora, 20, 22
wet nurse image, 183–85
Wilson, Stephen, 157
Woman Serving Beer (Manet),
 81
women: and fecundity, in
 Frédéric's work, 130–31,
 133–34; in Manet's paintings,
 76–78, 86–87, 90; in
 Orientalist art, 42–45, 49
Women Sifting Grain
 (Courbet), 24
wood engravings, 96–97
work and workers theme. See
 also The Stages of a Worker's
 Life: Ford Madox Brown's
 Work, 132; Frédéric and,
 120–25; and German artists,
 113; Kollwitz depiction of,
 110, 114; in Renouard's Sans
 travail, 95–97, 99, 102–13, 125
Work (Brown), 132
The Worker's Day (Balla),
 137
Worn Out (van Gogh), 105

Zola, Emile, 60, 63, 141